MINDFUL ARTIST

SUMI-E
Painting

Master the
Meditative Art of
JAPANESE
BRUSH
PAINTING

Virginia Lloyd-Davies

Walter Foster

Quarto.com • WalterFoster.com

© 2019 Quarto Publishing Group USA Inc.
Artwork and text © 2019 Virginia Lloyd-Davies

First published in 2019 by Walter Foster Publishing, an imprint of The Quarto Group.
100 Cummings Center, Suite 265D, Beverly, MA 01915, USA.
T (978) 282-9590 **F** (978) 283-2742

All rights reserved. No part of this book may be reproduced in any form without written permission of the copyright owners. All images in this book have been reproduced with the knowledge and prior consent of the artists concerned, and no responsibility is accepted by producer, publisher, or printer for any infringement of copyright or otherwise, arising from the contents of this publication. Every effort has been made to ensure that credits accurately comply with information supplied. We apologize for any inaccuracies that may have occurred and will resolve inaccurate or missing information in a subsequent reprinting of the book.

Walter Foster Publishing titles are also available at discount for retail, wholesale, promotional, and bulk purchase. For details, contact the Special Sales Manager by email at specialsales@quarto.com or by mail at The Quarto Group, Attn: Special Sales Manager, 100 Cummings Center, Suite 265D, Beverly, MA 01915, USA.

ISBN: 978-1-63322-812-2

Digital edition published in 2019
eISBN: 978-1-63322-813-9

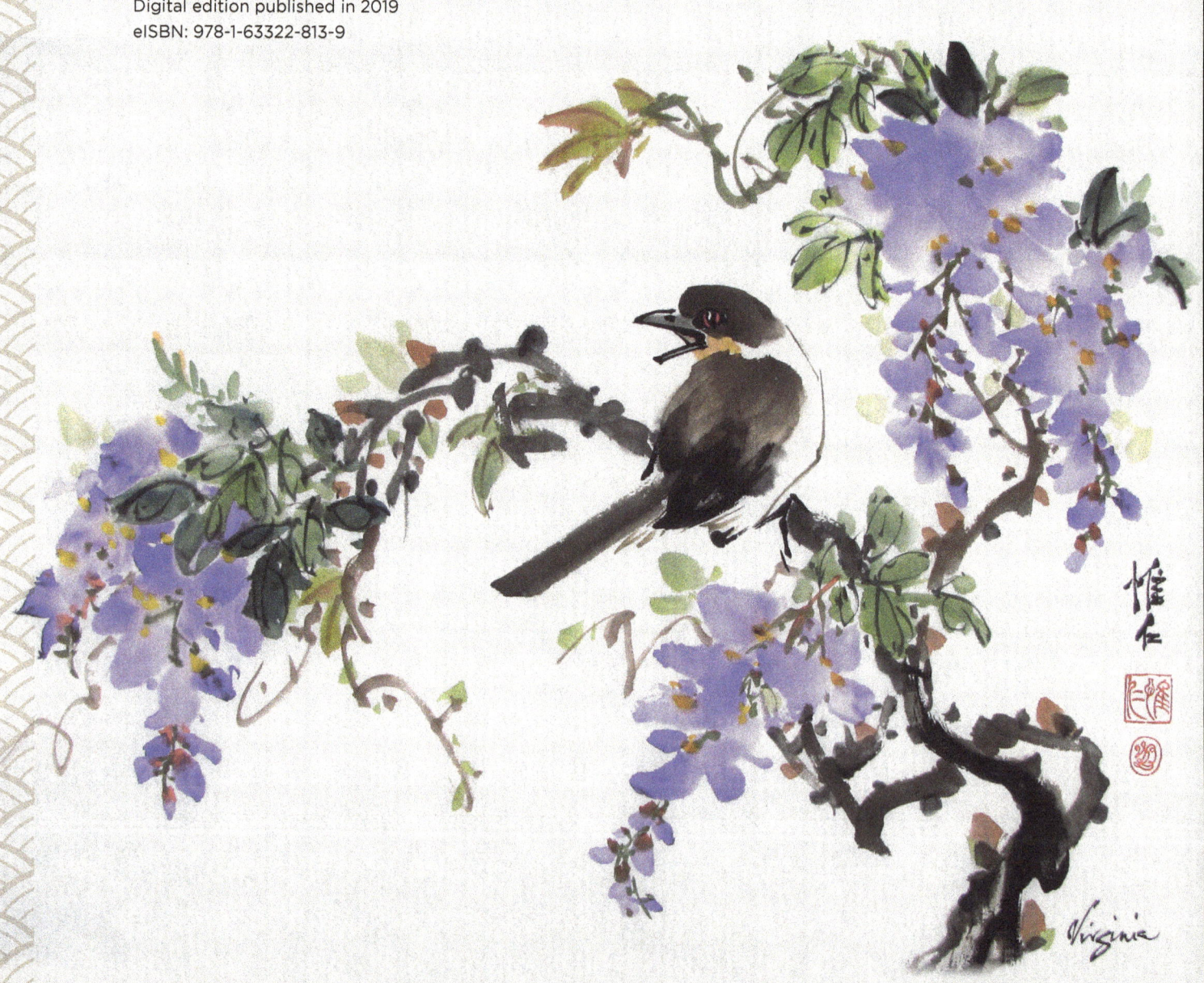

Table of Contents

Introduction ... 5
Tools & Materials ... 8
Preparing to Paint ... 12
Introduction to Brushes, Ink & Paper 16
Painting Subjects .. 19
 The Four Gentlemen .. 20
 Bamboo ... 24
 Orchid ... 32
 Plum .. 38
 Chrysanthemum ... 48
 Iris ... 56
 Peony .. 64
 Insects ... 74
 Wisteria .. 78
 Grapes .. 86
 Lotus & Kingfisher .. 92
 Bird Basics ... 102
 Bird Adventures ... 108
 Rocks & Waterfalls .. 114
Signing Your Painting ... 124
Suggestions from My Library 126
About the Artist ... 127
Dedication & Acknowledgments 128

Virginie

Introduction

I was first drawn to sumi-e (pronounced soo-mee-eh) painting more than 40 years ago. At the time, I was living in New York City and exploring different meditation techniques. Sumi-e, a Japanese form of quick-stroke painting that literally means "black ink picture," combined the beauty of painting with the spontaneity of dance and the depth of mindfulness.

I fell in love from the first brushstroke! The power of the black ink coupled with the immediacy of the movement mesmerized me. My first attempts lurched from uncontrolled squiggles to bloated blobs. In encouragement, my teacher, Paul Siudzinski, would say, "There are no mistakes, only happy accidents!" I continued splashing in the ink and feeling the cares of the outside world recede as I studied sumi-e.

Asian-style brush painting is based on the strokes used to write characters, or calligraphy, which is why Asian-style brush artists refer to it as "writing a picture." Instead of swishing the brush around to create an image, specific calligraphic strokes are used to build flowers, birds, and landscapes. This is where the concept of mindfulness comes in, keeping your attention fixed actively on what is—not what was and not what might be. Focusing on the process of painting strokes instead of the finished product requires you to stay in the moment.

> # "Ch'i," or "qi," is a Chinese word meaning life force, breath, or energy flow.

This active awareness is the essence of mindfulness. You may have a composition in mind, but a brush painting is a living thing. Sumi-e permits no presketching and doesn't allow for corrections once the ink is on the paper, so the composition evolves with each stroke. Your brush is like a dancer: You cannot take back the steps you have just performed. However, the advantage is that unlike a ballet performance, the dance of the brush leaves the vibrant trace of your ch'i on the paper and continues to delight viewers after the movement of the brush has stopped.

What does this mean for you, and how do you develop mindfulness through sumi-e painting? First, you will need lots of playful practice, paper, and ink! I have painted enough bamboo leaves to encircle the globe, and I still love to practice them. Painting strokes without a finished picture in mind is like warming up before exercising: It's not a competition, so you can remain calm. Use this preparation time to focus your awareness on breathing as well as the brush, ink, and paper.

I will show you the traditional way of painting subjects as passed down through generations of Chinese, Japanese, and Korean artists over hundreds of years and as taught to me by my teachers I-Hsiung Ju and Paul Siudzinski. Learning the strokes will allow you to express yourself with sumi-e.

But here's the secret: As you relax and enjoy practicing these strokes, you will also learn to express yourself in the moment, without self-judgment. This is also your mindfulness practice. Will your strokes look just like mine? Probably not. But are you having fun? Focusing your attention on the task at hand? Feeling the joy that comes from creating? Ah, now, those are treasures!

If you find yourself tensing up, return to the awareness of your breath. Close your eyes and listen to your body. Feel the life in your hands and how the brush extends your energy to fill the space around you. Ground yourself in the present moment. Breathe in again and exhale fully as you open your eyes. Trust the flow of life coursing through you, into the brush, and onto the paper. See how the attentive focus of your mind leaves the traces of your ch'i in visible, painted form.

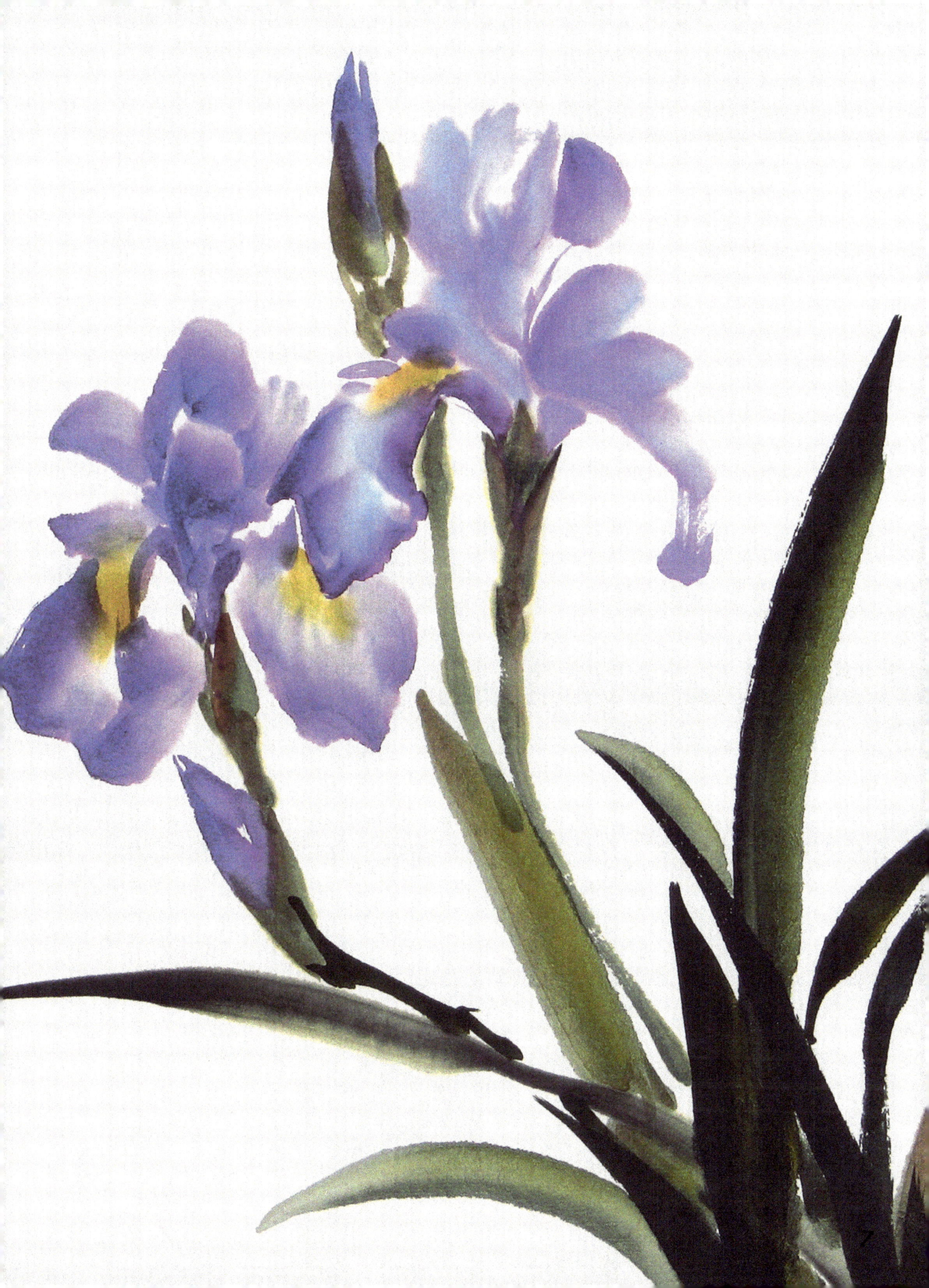

Tools & Materials

When Chinese Zen Buddhist monks first came to Japan, they brought with them many meditation disciplines. One was the practice of calligraphy writing and sumi-e. For painting or calligraphy, the monks used what were referred to as "The Four Treasures," which were held in deep reverence.

> The Four Treasures:
> ink stone, ink stick, paper, and brush

Ink

You can grind your own ink using an ink stick and ink stone. Ink sticks are made from pine soot or oil soot, bound together with glue and incense. Pine-soot ink sticks create a warm brown-black ink that's great for landscapes; oil-soot ink sticks produce a cooler, blue-black ink preferable for calligraphy.

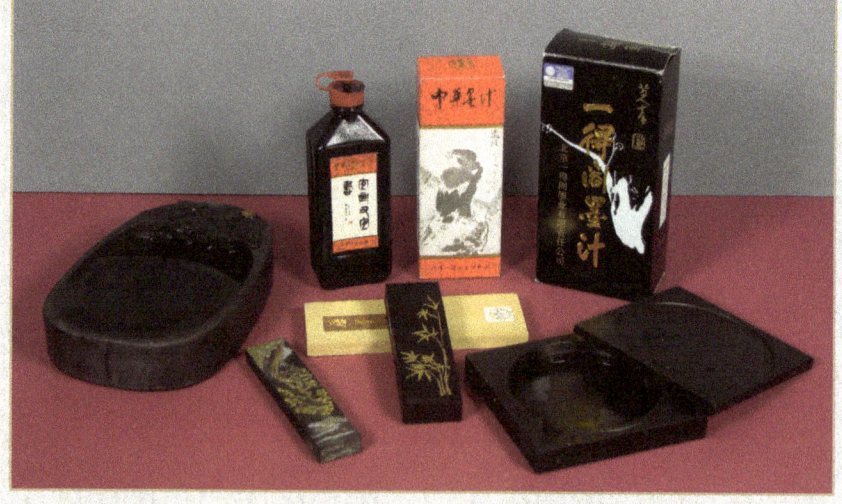

Bottled ink is very concentrated. Many professional Asian-style artists do not use bottled ink, because they say it is less subtle and doesn't work as well for shading as freshly ground ink. However, bottled ink is acceptable when you are just starting out and learning sumi-e strokes. Many artists use ground as well as bottled ink for different subjects, as both have their own advantages.

Colors

Although traditional sumi-e painting used color only sparingly, some modern-day painters consider painting in color a delightful exercise. Asian colors come in dried chips, powders, or tubes. Avoid Western watercolors; the binders and glues are different, so most won't mix well with Asian colors and many will run if you re-wet your paper. Japanese, Chinese, and Korean colors will not run once dry.

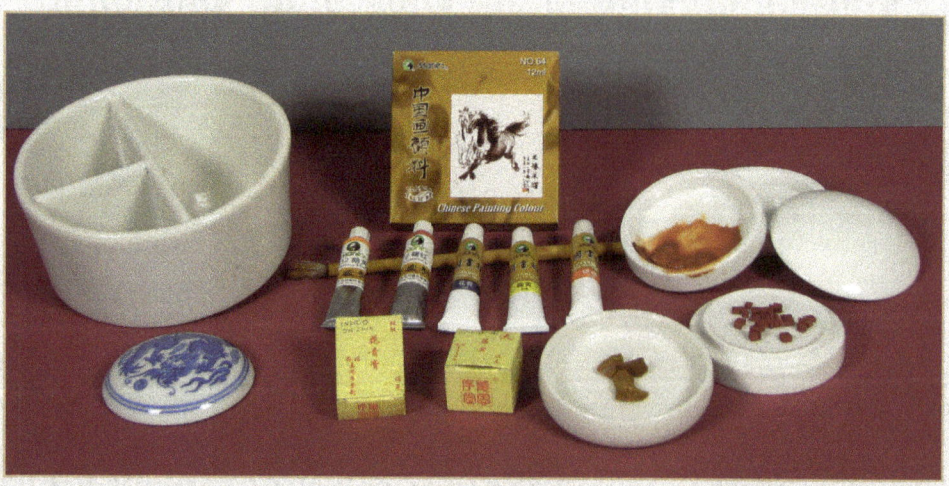

I'm happy with how this painting turned out, but it was created on newsprint, and it deteriorated and turned yellow after only a few months.

Paper

Asian papers come in various finishes (raw, semi-sized, and sized) and are made from natural fibers, including mulberry (semi-sized), cotton, hemp, bamboo, and tree bark. Curiously, they are not usually made entirely from rice, even though in the West we refer to all Asian papers as "rice papers."

Traditional calligraphy and sumi-e paper is handmade, but you don't need to use this from the start. Machine-made rolls of practice paper are available at a lower cost. Avoid newsprint, even though it's cheapest, because your painting may yellow and turn brittle. Also avoid Western watercolor paper; it will not give you the surface you need to create subtle gradations of color.

Brushes

For sumi-e painting, work with Asian brushes, not Western ones. The best Asian brushes are handmade from animal hair, such as weasel, goat, deer, sheep, wolf, and horse, and constructed hair by hair. These brushes are not hugely expensive and are available from reputable online art suppliers. Brushes that are mass-produced by machine may be cheaper, but they aren't as good. A small investment is worth it for something that will last you 10 years.

9

Recommended Shopping List

You can find many sumi-e suppliers online by searching for "Asian art supplies" or individual items like "sumi-e," "bamboo brush," or "rice paper."

Ink stone: Buy one that comes with a lid so you can keep your ground ink from evaporating while you paint. To save money, you can make your own lid out of cardboard wrapped in foil.

Ink stick: Avoid the cheapest ones, as you may find yourself grinding for a long time and still end up with a watery gray.

Liquid black ink: Chinese, Japanese, or Korean inks will all work. A bottle will last you months, and there are different grades. Select one for painting rather than calligraphy.

Brushes: Buy a medium-sized bamboo and orchid brush (also called a "hard bristle brush" and sometimes identified as "wolf hair" or "weasel"), a Happy Dot brush, and a small soft brush for flower petals. You may also want a large bamboo and orchid brush for creating big leaves. As you progress, try a flow brush as well as a horse-hair brush.

To create a stronger black, add a few drops of bottled ink to your ground ink.

Colors: Start with a small set of Marie's Chinese Watercolor tubes. They are quite inexpensive and easy to use. Alternatively, you could buy an assortment of dried color chips from an Asian art supplier; gamboge/rattan yellow, indigo, sky blue, vermilion, red, rouge, and burnt sienna or umber make for a good basic collection. A jar or tube of Chinese white is also handy.

Paper: First, purchase a couple of rolls of machine-made practice paper, selecting ones that are at least 15 to 18 inches wide. If you do an online search for "Moon Palace Paper," you will find plenty of sources.

As you get more adventurous, you may want to try handmade paper. For the spontaneous sumi-e style I am demonstrating in this book, you will want papers called "raw" or "unsized." These papers are called "shuen" or "xuan" papers in China and "washi" in Japan. They come in different thicknesses, from thin (which will require painting quickly and produces brilliant but runny colors) to "double xuan" (which is a bit safer and more forgiving; you can move slower with the brush and will produce fewer water blobs, but the colors will be less brilliant).

Additional items: You will also need white ceramic dishes, mixing bowls, a water container large enough to clean your brushes, a small container with a lid for liquid ink, paper towel, and a blanket, piece of felt, or newspaper to place under your painting paper.

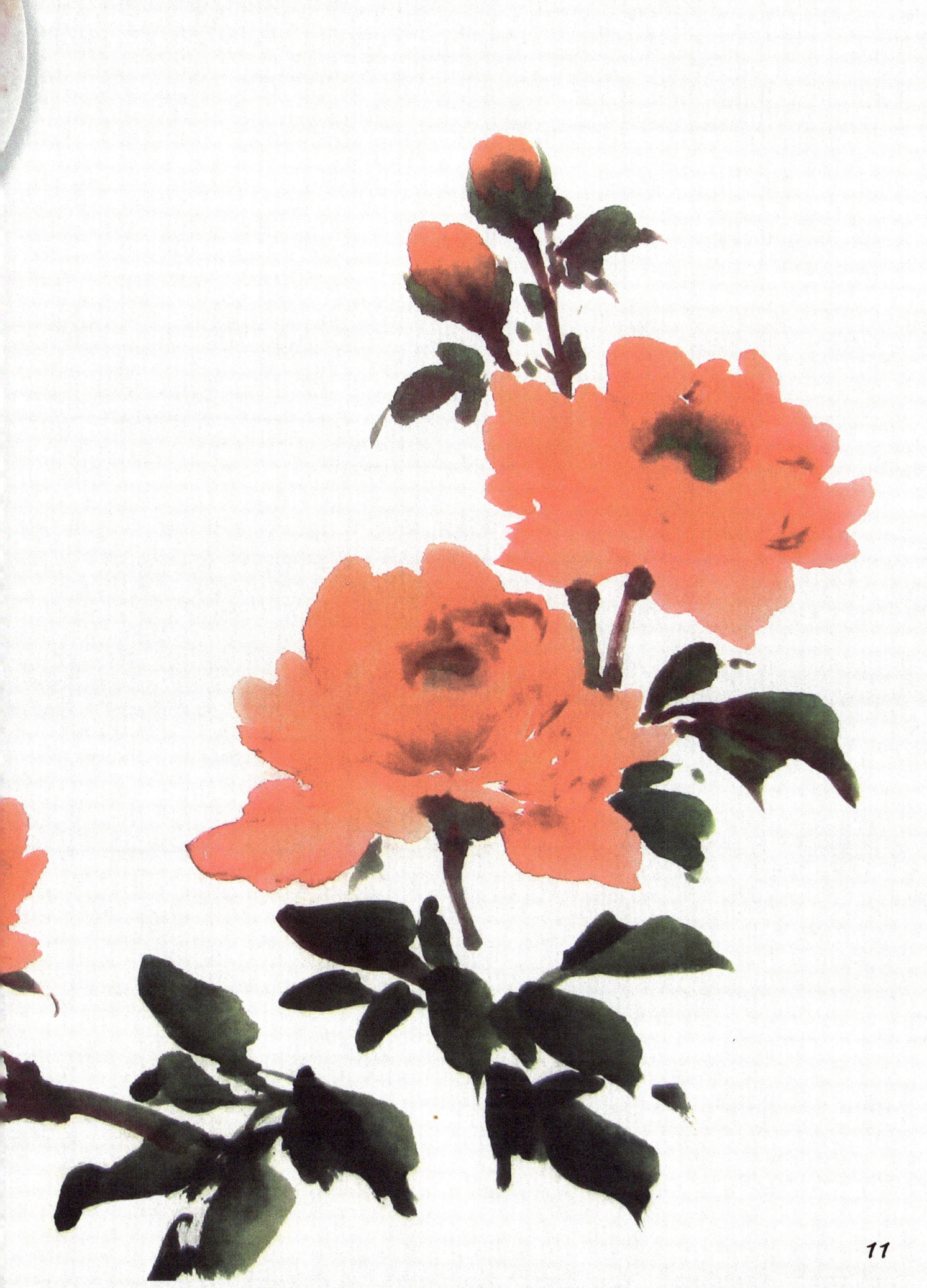

Preparing to Paint

Use your prep time to bring yourself to the present moment. Nothing else matters now except for calm attention to the details. Be aware of your breathing as you organize your space.

Ink Stone

If you are using your ink stone for the first time, soak it in cold water for a few minutes. The stone will absorb some of the water and make your grinding surface kinder to your ink stick. If you have used your ink stone before, make sure the surface is clean.

Ready to Grind Ink?

Put a teaspoon of cold water in the well of your ink stone. Holding your ink stick vertically, gently rub it in circles on the wet stone until you have the amount and depth of black that you want. This will take several minutes.

When it feels sticky as you grind, you will know that your ink is rich. Add a few more drops of water as needed; then dip a moistened brush in the ink and test it on scrap rice paper. Not dark enough? Keep grinding!

When you have ground enough ink, place the ink stick on its side on the edge of the ink stone or on paper towel. Never leave an ink stick standing in ink; the glue in the ink will make the stick adhere to the ink stone, ruining both.

If you are using bottled ink, pour one or two teaspoons of ink into a small, flat container, preferably one with a lid so you can keep it covered while not in use.

Working with New Brushes

New brushes come with the hairs glued together and a little plastic cover. Discard the cover; then soak off the glue protecting the hairs using cold water in a container. Some brushes must soak for a half-hour.

The brushes may stiffen again the first few times you use them, but they will only need a little gentle swishing in clean, cold water to resoften.

Using Color

If you plan to use color, you may want to put your colors in small dishes and add a few drops of water to soften them. Tubes sometimes require shaking to mix the color. If you hear liquid sloshing around when you shake a tube, keep shaking until the sound goes away.

If you are using chips, I recommend wetting just a few in a dish with a few drops of cold water. Frequently rewetting the colors can make them brittle and crumbly.

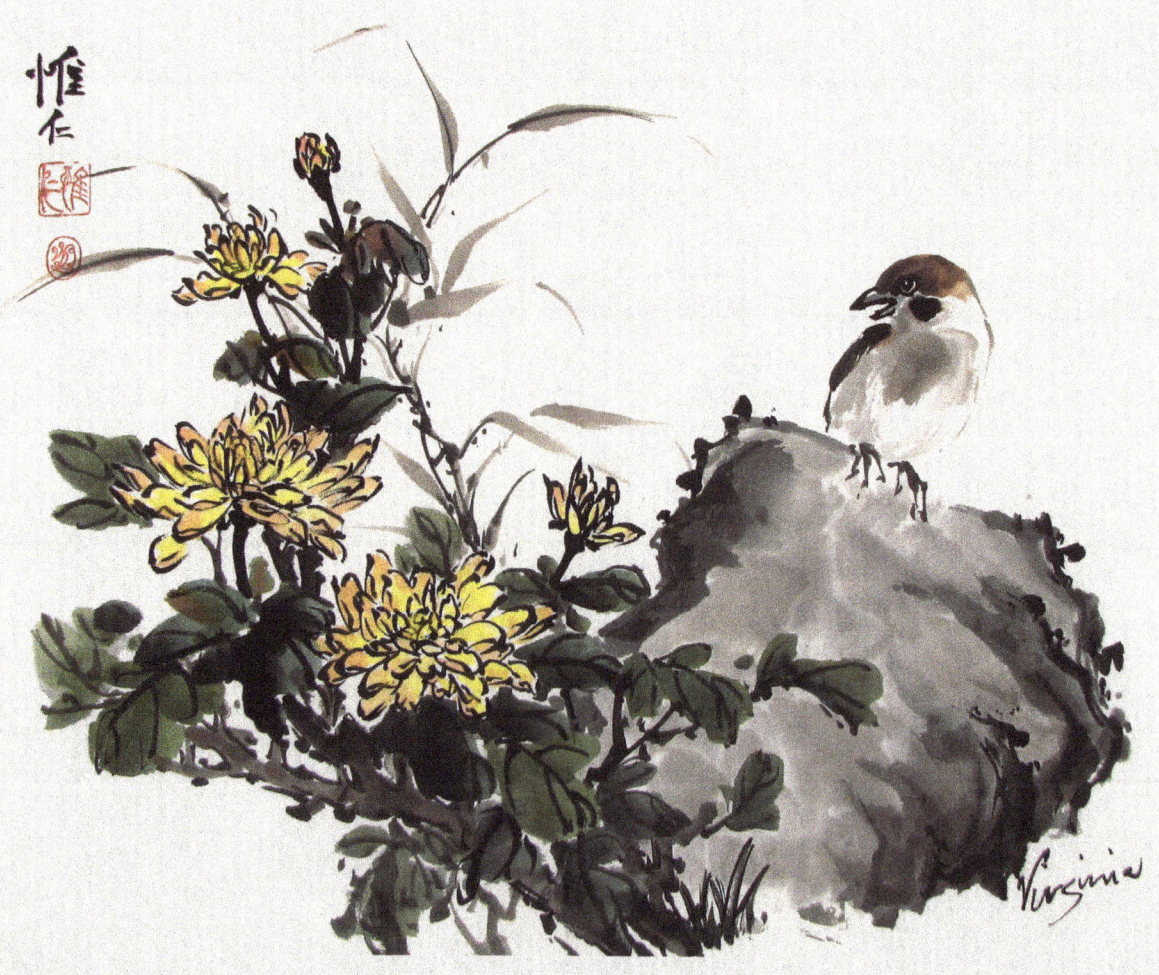

Setting Up Your Painting Space

Most brush painters paint on a flat surface, such as a table or the floor. Some use an easel or a wall, particularly for landscapes. Place a piece of felt, blanket, or newspaper under your painting paper to absorb the moisture. Whether you are using practice or handmade paper, paint on the smooth side.

Do you like to listen to music while you paint? I do! Keep in mind that the style and rhythm will affect your painting. Whatever you choose, whether it's music or silence, select something that helps you be present in the moment.

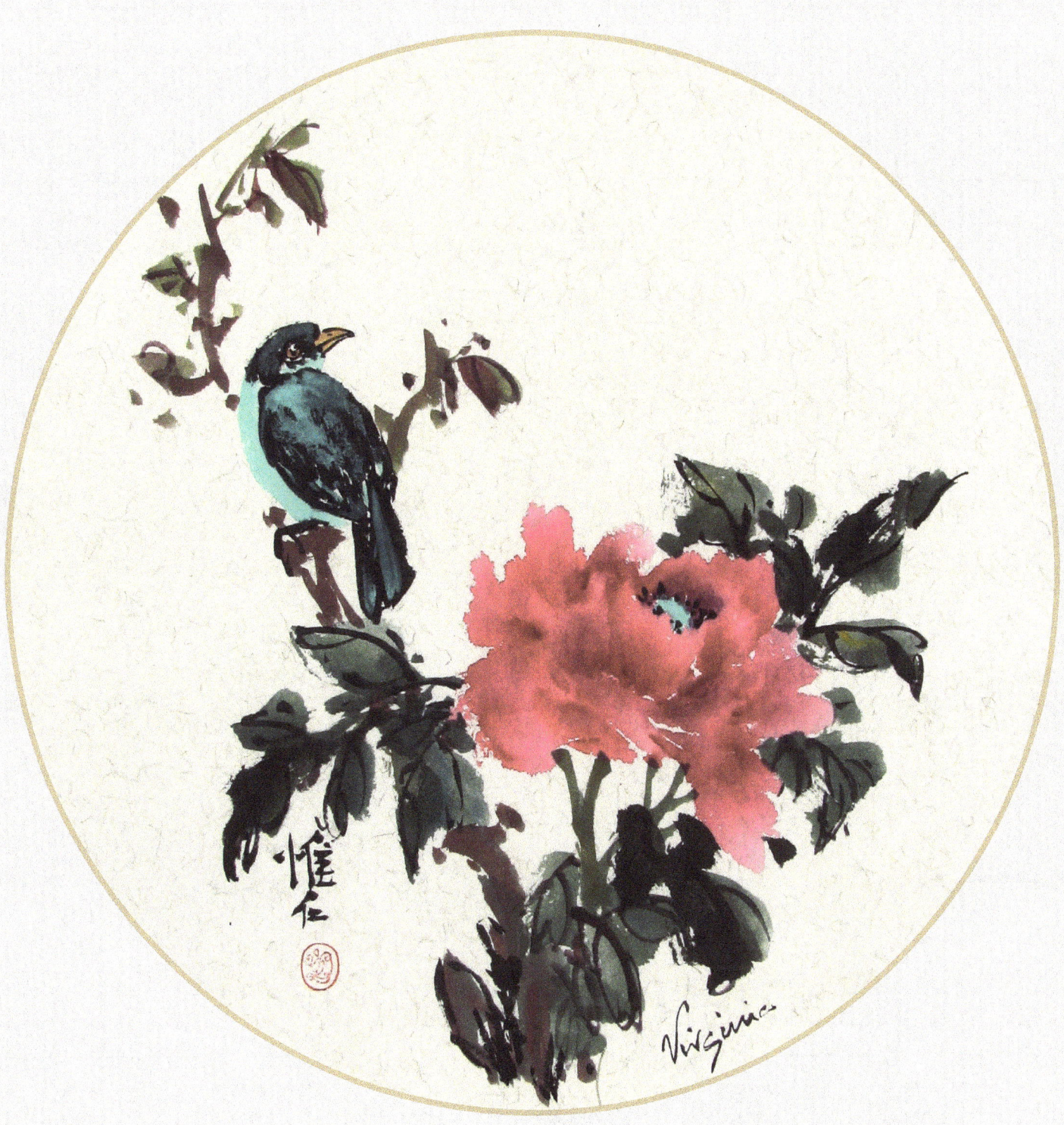

Introduction to Brushes, Ink & Paper

If this is your first foray into sumi-e painting, start with playtime! Follow this routine when you're ready to begin painting. (Step-by-step painting projects start on page 24.)

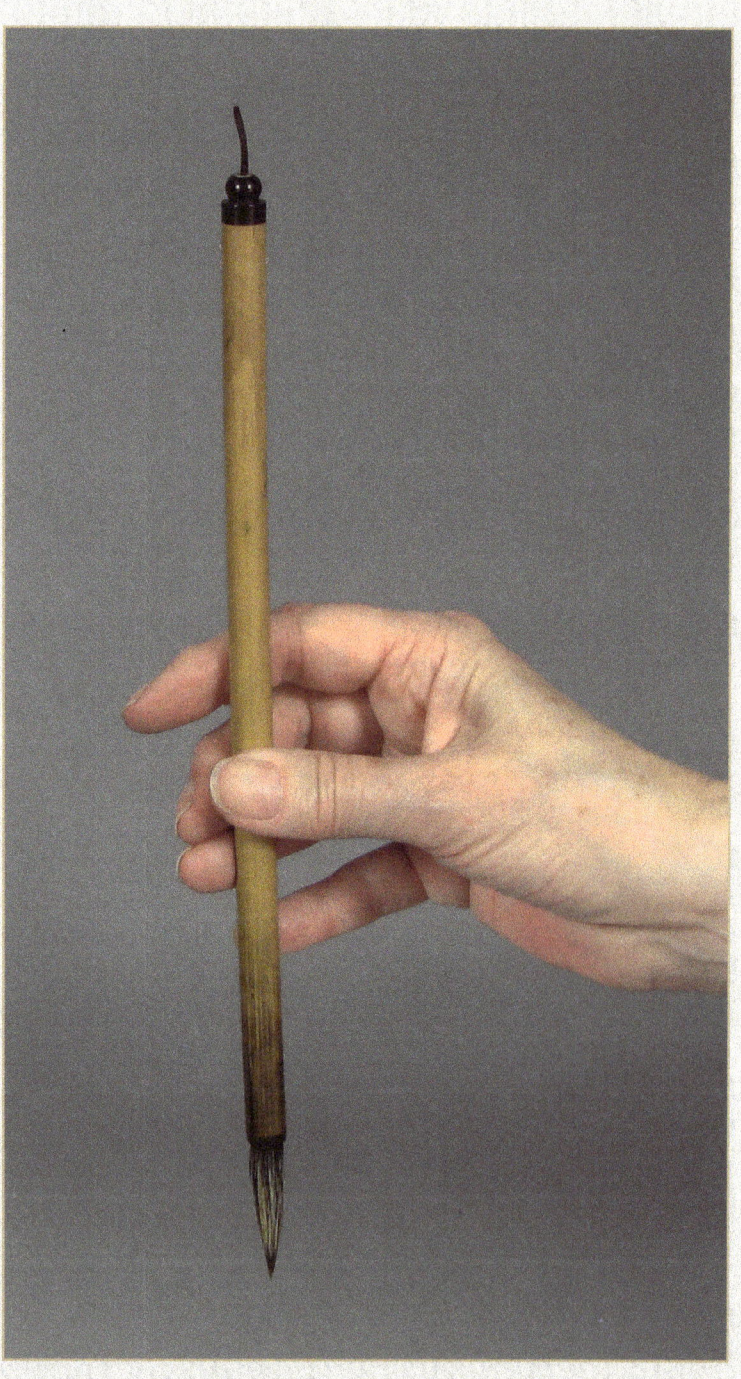

1 Begin by using black ink. Not only is this the traditional way, but it is also the easiest. In addition to strong black ink, you will need a saucer in which to create gray tones. Put about a tablespoon of water in the saucer, dip the tip of your wet brush in the black ink, and mix. Try it out on scrap paper and add more water or ink, depending on how light or dark you want the mixture to be. Then rinse the brush.

2 Dip your brush partway into the gray; then dip just the tip in the black. Holding the brush perpendicular to the paper, make several strokes. They can go in any direction and may be thick or thin, straight or wiggly. Move your whole arm as you paint, keeping the brush upright. There is no wrong or right way, just exploration.

3 Next, rinse your brush and load it again with gray and then black at the tip. This time, slant your brush handle as you move the brush sideways. You will see a gradation of tones from light to medium gray, and then shades of black where the tip touches the paper.

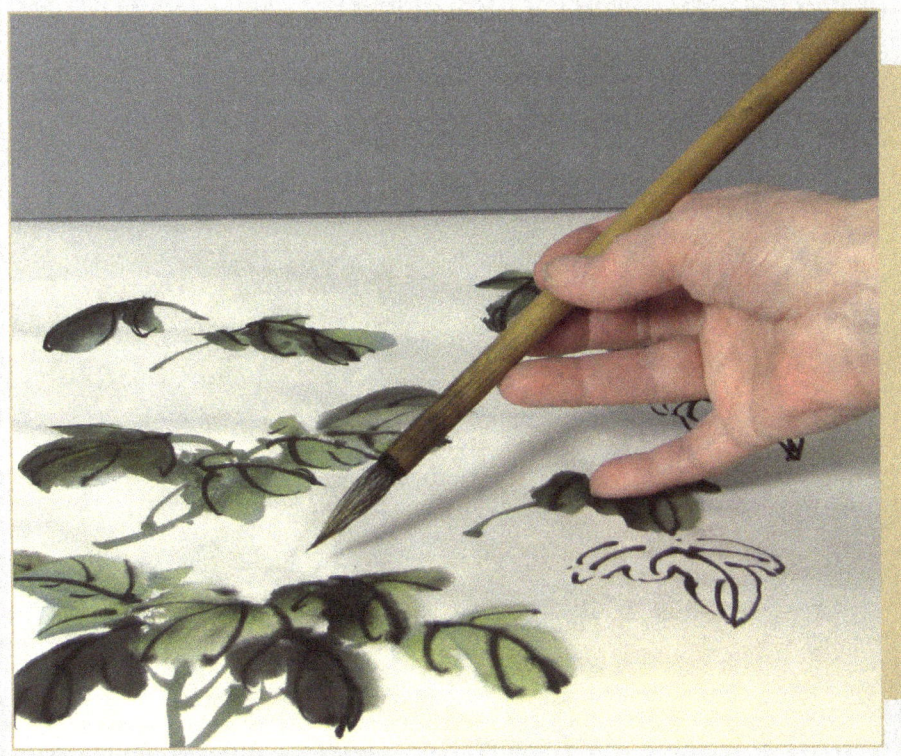

Observe the differences between the strokes you make with a vertical brush versus a slanting one. Keen observation will improve your painting and keep your mind in the present.

4 At this point, you might notice that some of your strokes look dry and broken, while others are blobby and fuzzy. As you get used to the brush and the paper and how much moisture is on the brush, this will become less tricky. The wonderful thing about spontaneous sumi-e painting is that it is not about being neat; what matters is conveying an idea or a mood through rhythm and energy. Just relax and get used to the movements you can make with the brush. Engage your whole body and move the brush from your shoulder, not flicking from the wrist. Cover as many sheets with strokes as you like.

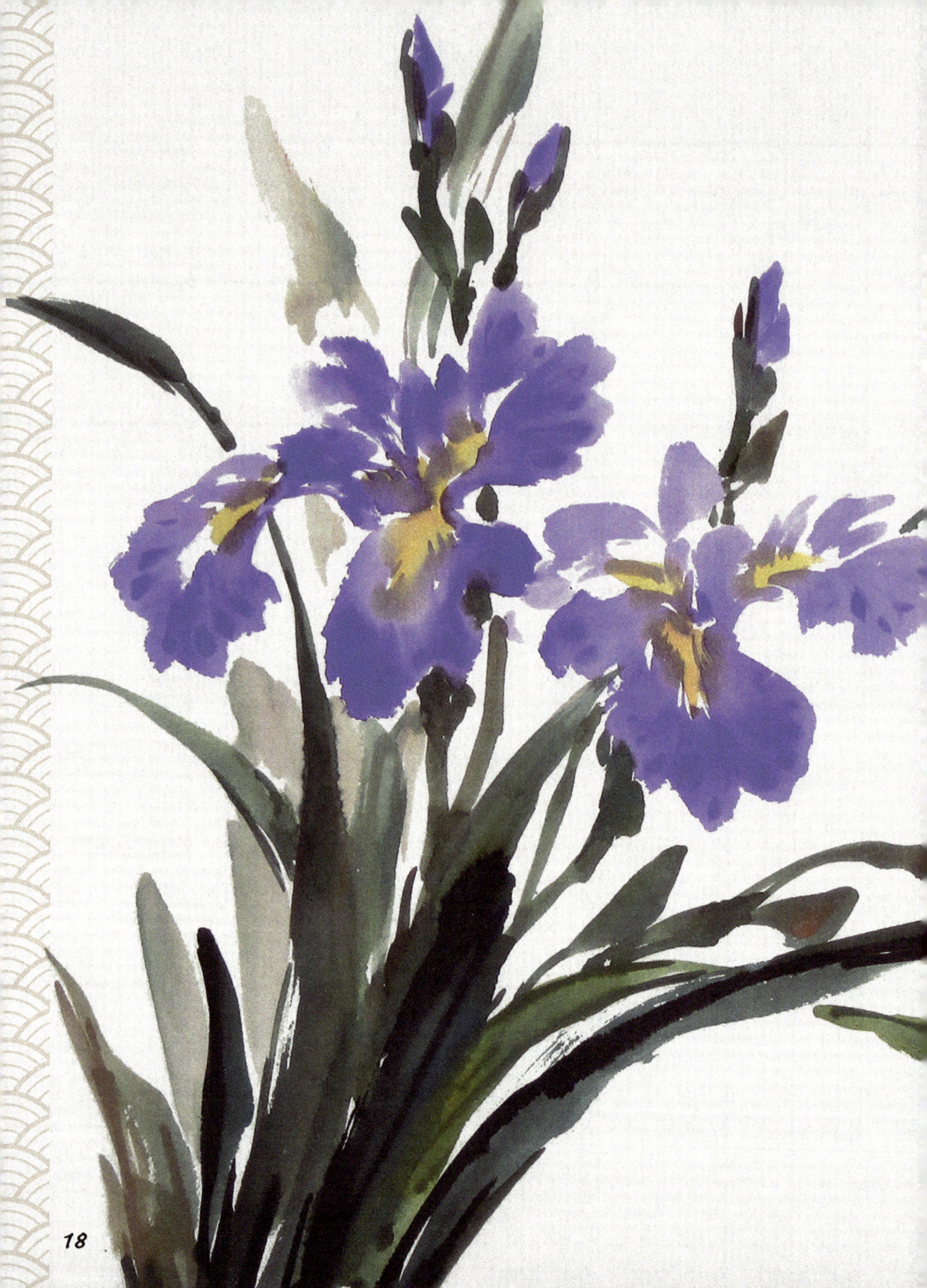

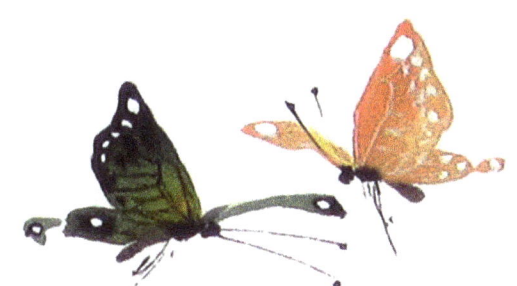

Painting Subjects

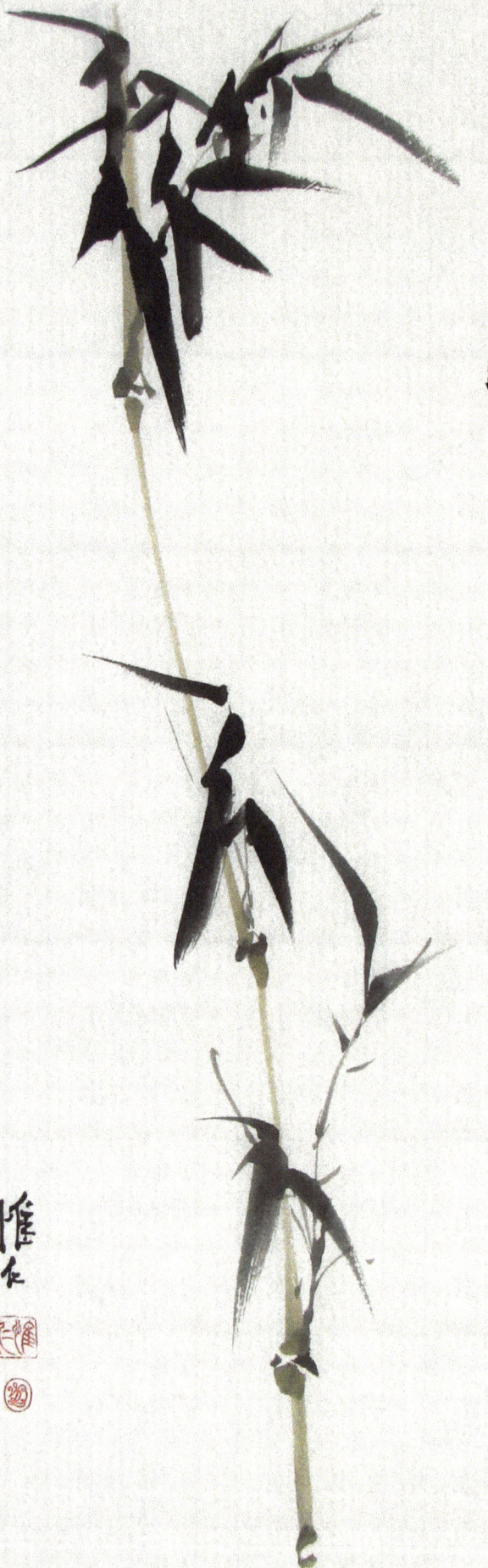

The Four Gentlemen

Sumi-e (Japanese) or shuimo (Chinese) quick-stroke painting is based on Chinese calligraphy and was brought to Japan by Chinese Zen Buddhist monks. The Four Gentlemen are bamboo, orchid, chrysanthemum, and plum. They represent the four seasons and are traditionally the foundational subjects for those studying Asian brush painting. Studying these four subjects will help you familiarize yourself with all the calligraphy strokes that sumi-e painting is based on so that you can form an understanding of all the other painting subjects as well.

Bamboo

Symbolizing summer, vigorous growth, and upright posture and integrity, bamboo combines strength and beauty. To paint bamboo, hold the brush vertical to the paper and move in straight lines with vigorous intent. (See pages 24–31 for complete step-by-step instructions on painting bamboo.)

Orchid

The orchid represents spring, hope, and new beginnings. As you paint an orchid, keep the brush vertical, but also develop curved, wavy leaves and sweet, delicate flowers. (Go to pages 32-37 to learn how to paint an orchid.)

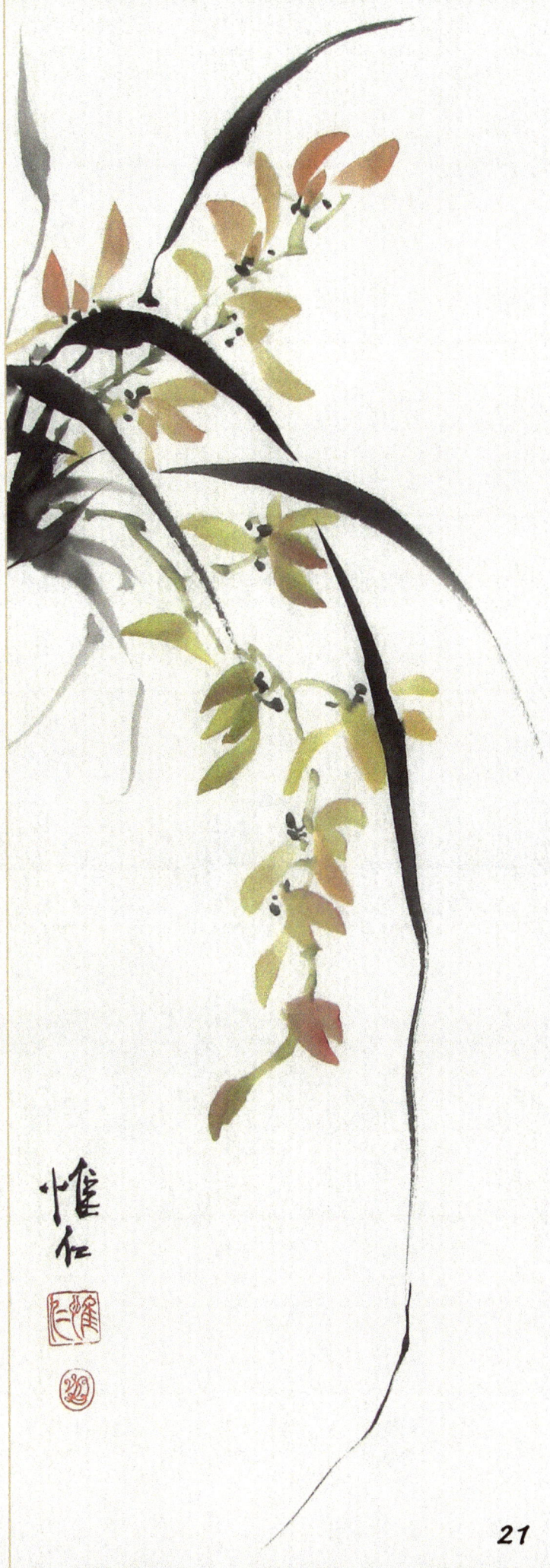

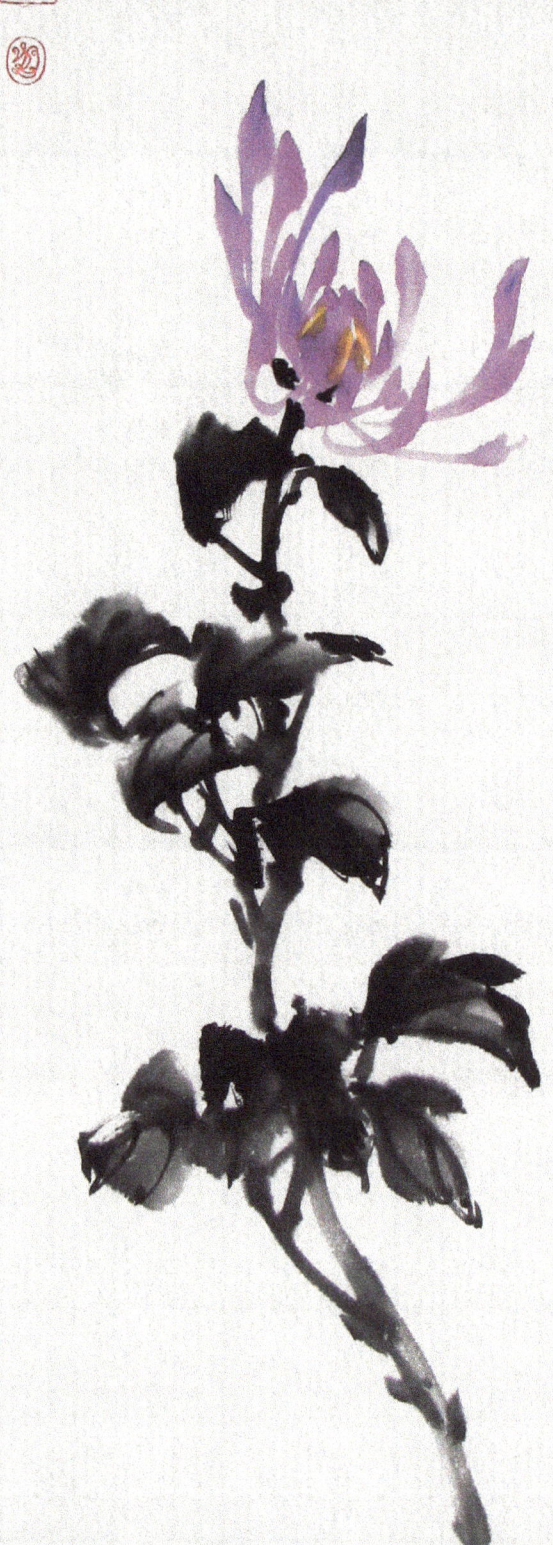

Chrysanthemum

The chrysanthemum is the symbol of autumn and braving the frost, as well as moving forward and blooming despite fear. Combine vertical tip strokes for the flowers with side strokes for the leaves, developing your technique to include outlined petals. (Visit pages 48-55 to paint a chrysanthemum.)

Plum

In sumi-e painting, the plum is the symbol of winter, tenacity, and rugged perseverance in the face of hardship. Carve the old branches into the paper; then add new branches and tender blossoms to represent the promise of new life and inner beauty despite adversity. Study of plum creates a bridge between floral painting and the study of trees for landscape painting. (For more instructions on painting a plum, see pages 38-47.)

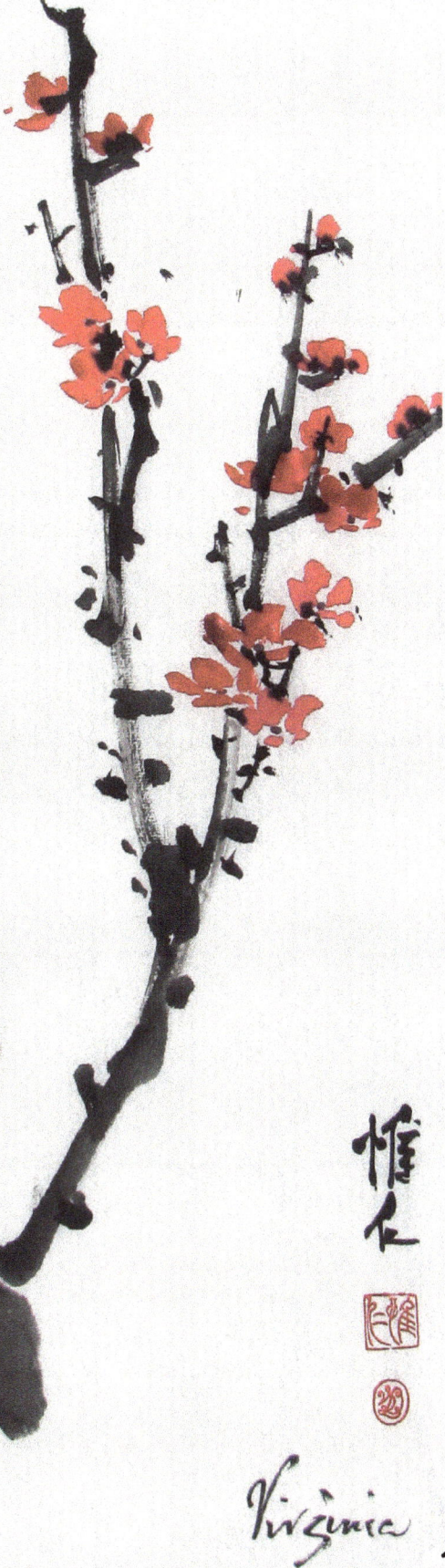

Bamboo

Artists new to sumi-e begin by studying bamboo, a subject that will continue to challenge and inspire them decades later. Some artists even spend their whole careers painting nothing but bamboo in black ink. A painting of just a few leaves and a stem can evoke a sense of nature and may be used to convey your emotions.

It may be tempting to go back over a stroke to improve it—but try to resist this urge! You might make your stroke more accurate, but the energy of the original stroke will be lost.

To understand how to paint the strokes shown here, you can watch me demonstrate bamboo leaves and full paintings of bamboo (as well as other subjects) on my YouTube channel @Virginia Lloyd-Davies.

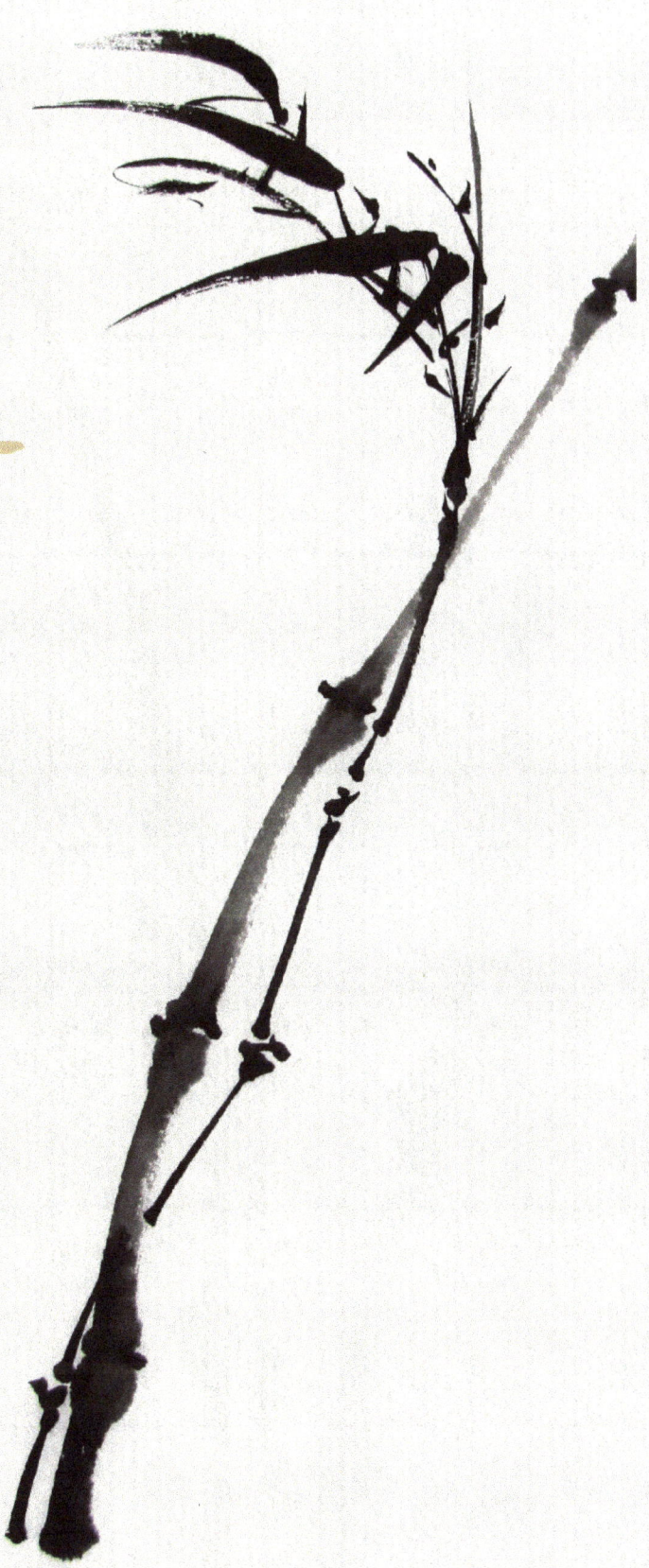

Grind the ink or pour about 2 tablespoons of liquid ink into a shallow container. Lay out your paper with the smooth side up. Practice creating trunks, branches, and leaves separately at first, remembering to relax. The goal is to be present in the moment, sensing an energetic flow with your brush, ink, and paper. Mastering mindfulness and sumi-e requires awareness and practice.

Trunk

The traditional way to paint the trunk is by holding the brush upright (page 16) and moving from bottom to top. In nature, the segments start short and lengthen as bamboo grows up.

1 Load your orchid/bamboo brush with diluted gray halfway up and a little black on the side of the brush. Keeping the brush upright, press it gently on the paper and pause to create the swelling at the beginning of the segment. Release the pressure a little while keeping the brush on the paper. Move in a straight line upward; then pause, pressing down on the paper again. Pick up the brush and repeat. At the top, you can either fade away or continue right off the paper. Do not reload the brush with ink while you paint the trunk.

2 If you paint more than one trunk, vary their thicknesses and shading, making some dark and some light. Start the trunks in the same general area and angle them differently. If one trunk crosses another, lift your brush where they cross and jump over the trunk in the front. Avoid lining up the trunks; let them bend and move in the wind. Also, vary the lengths of the bamboo segments so that the nodes sit at different heights.

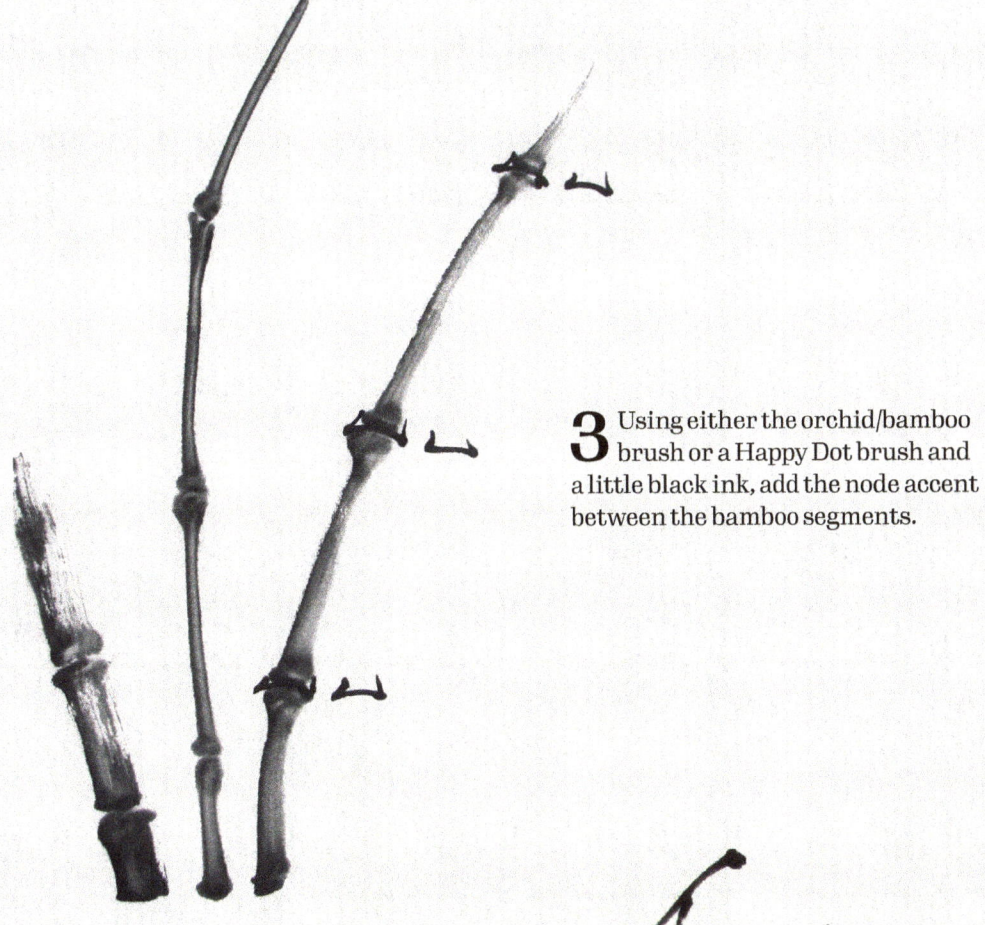

3 Using either the orchid/bamboo brush or a Happy Dot brush and a little black ink, add the node accent between the bamboo segments.

Branches

Bamboo leaves grow from small, thin branches that sprout from the nodes. Paint these in dark gray ink using either an orchid/bamboo or a Happy Dot brush, keeping your brush upright and fairly dry. Formations that feature one branch in the middle and one on each side, or one in the middle and two on one side, are called "horn of the deer" and "dragon's horn."

The Happy Dot brush creates a thinner line and is easier to control.

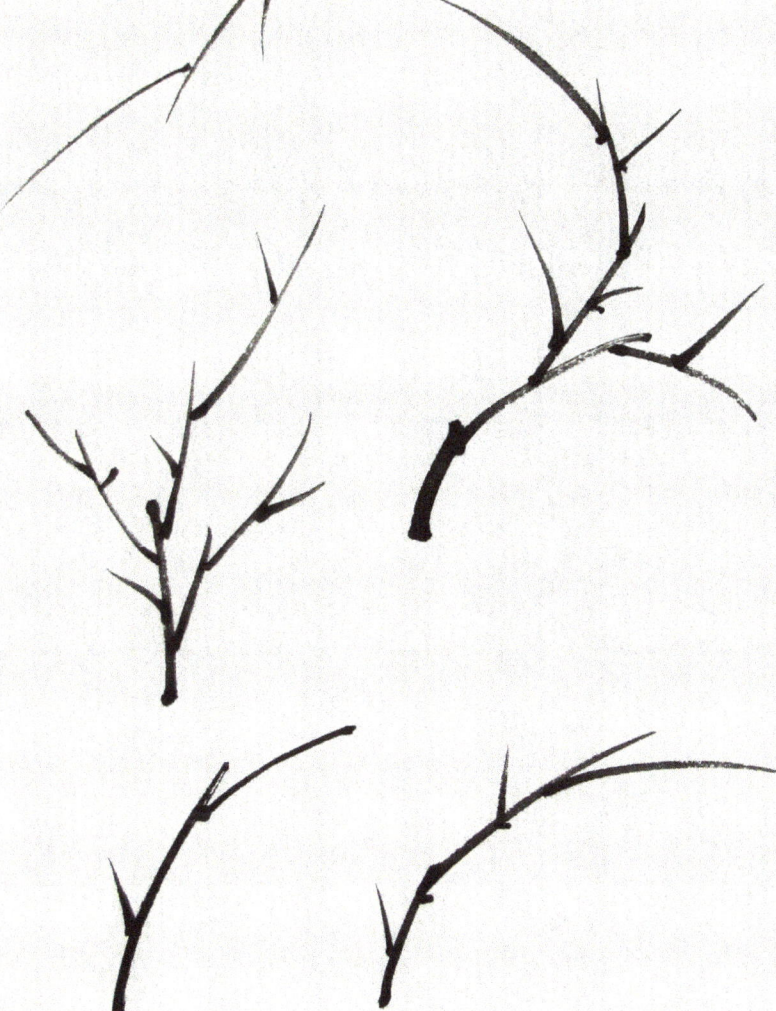

27

Leaves

Load your orchid/bamboo brush with black ink. With the brush perpendicular to the paper, start the leaf in the air and create an arc, with the bottom of the arc touching the paper and then lifting off gradually as it continues. Make a confident movement without hesitation, and don't flick the end of the leaf. The movement should come from the shoulder, not the wrist.

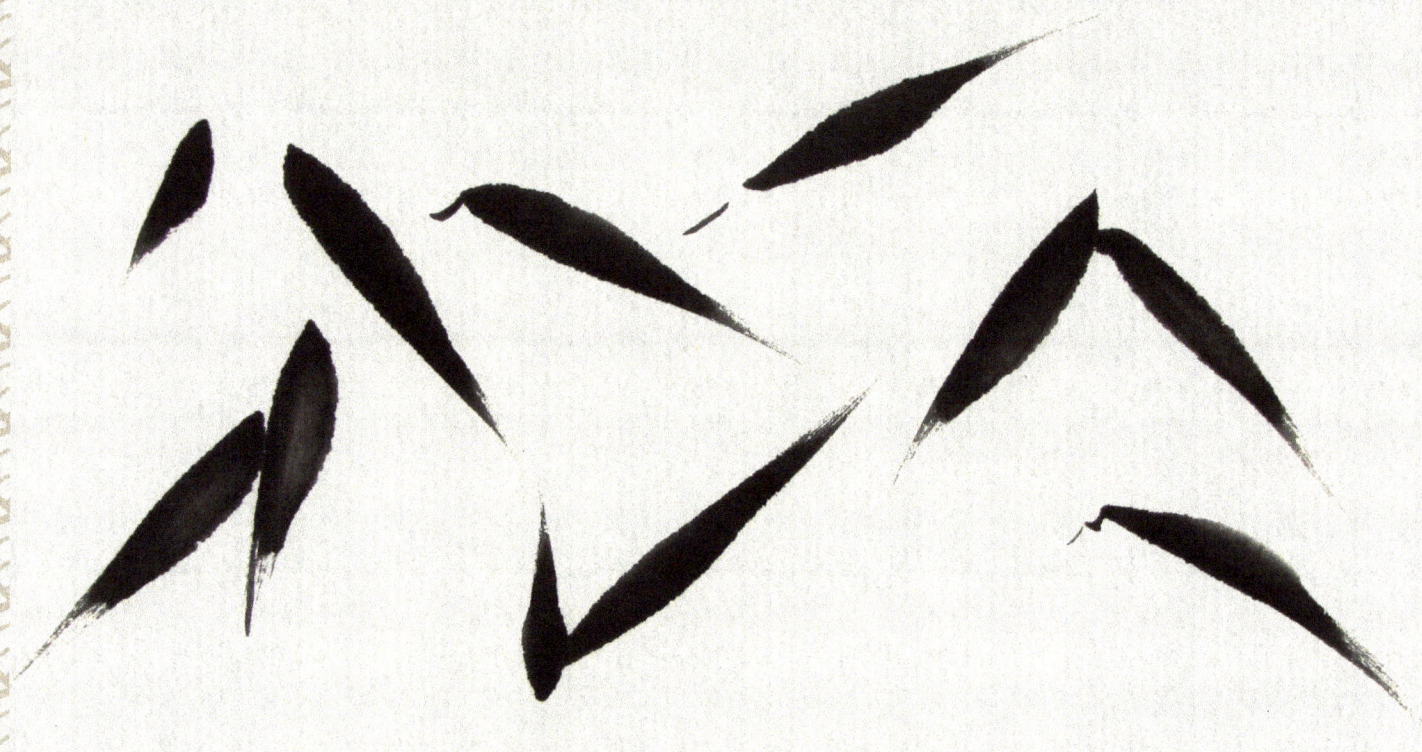

Once you feel comfortable painting individual leaves, you can combine them to create many variations. A group of leaves can make a finished painting.

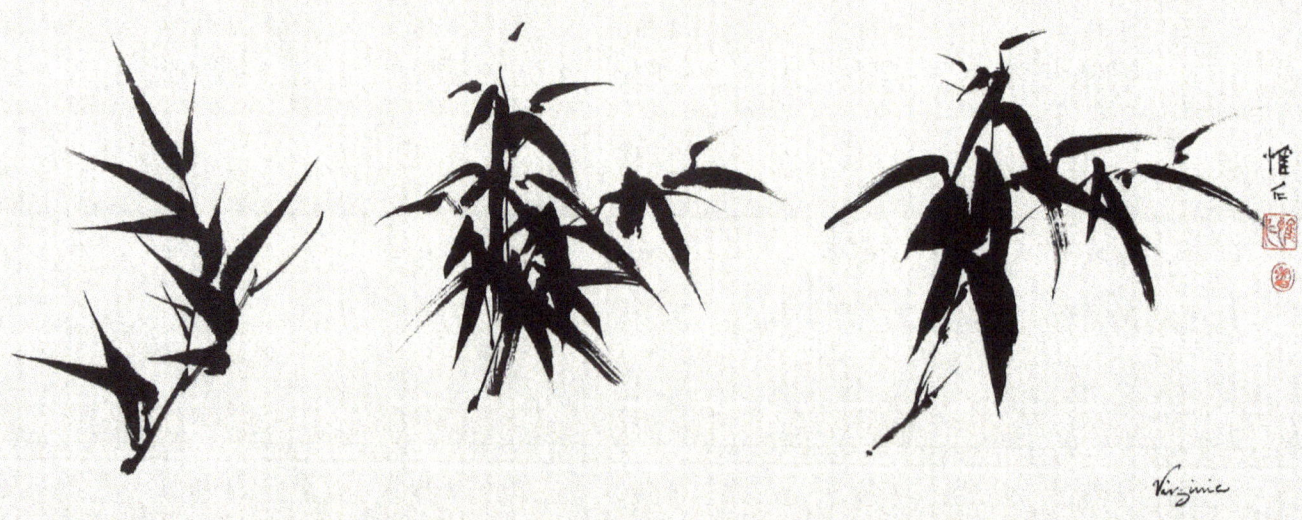

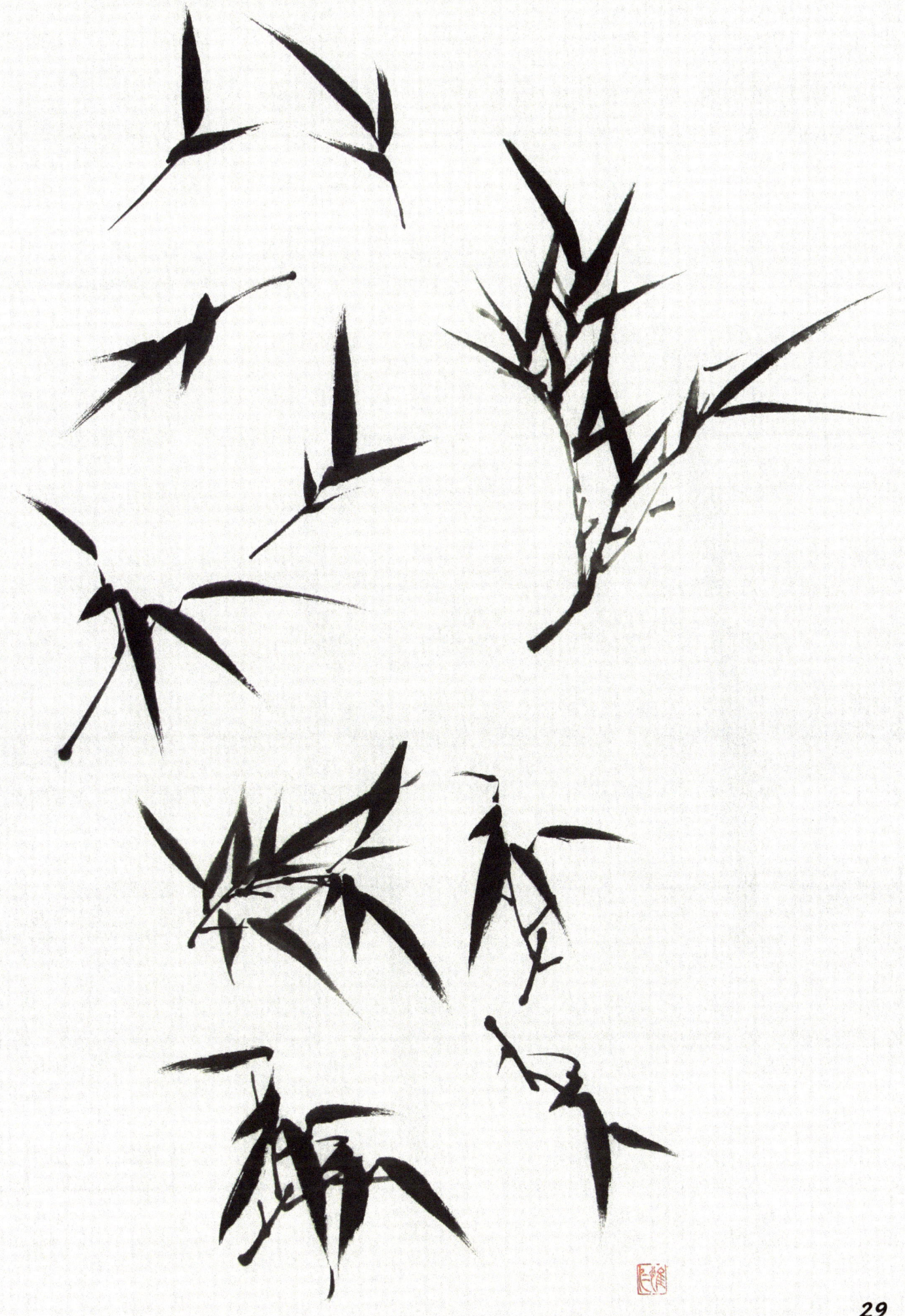

Bamboo Painting Progression

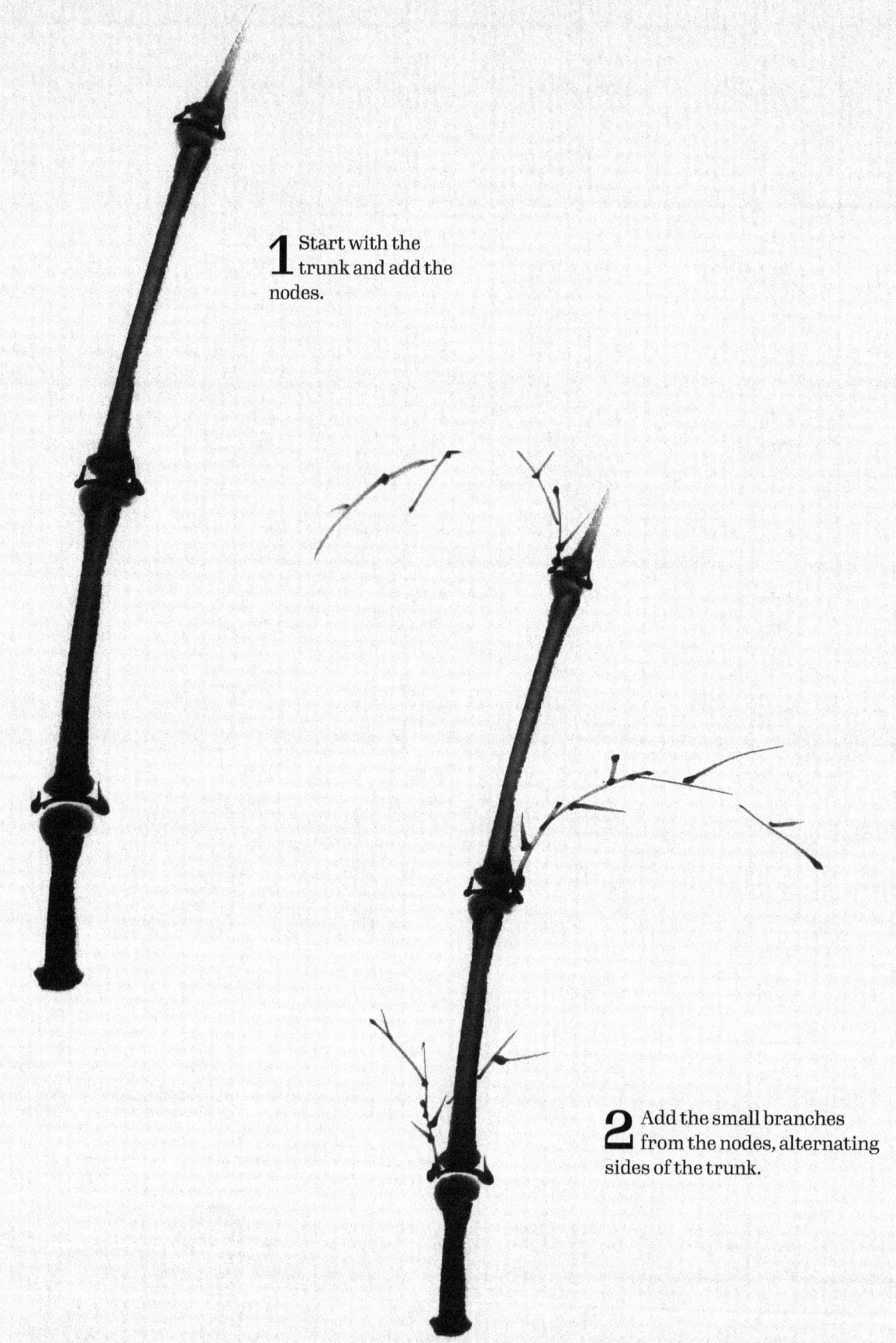

1 Start with the trunk and add the nodes.

2 Add the small branches from the nodes, alternating sides of the trunk.

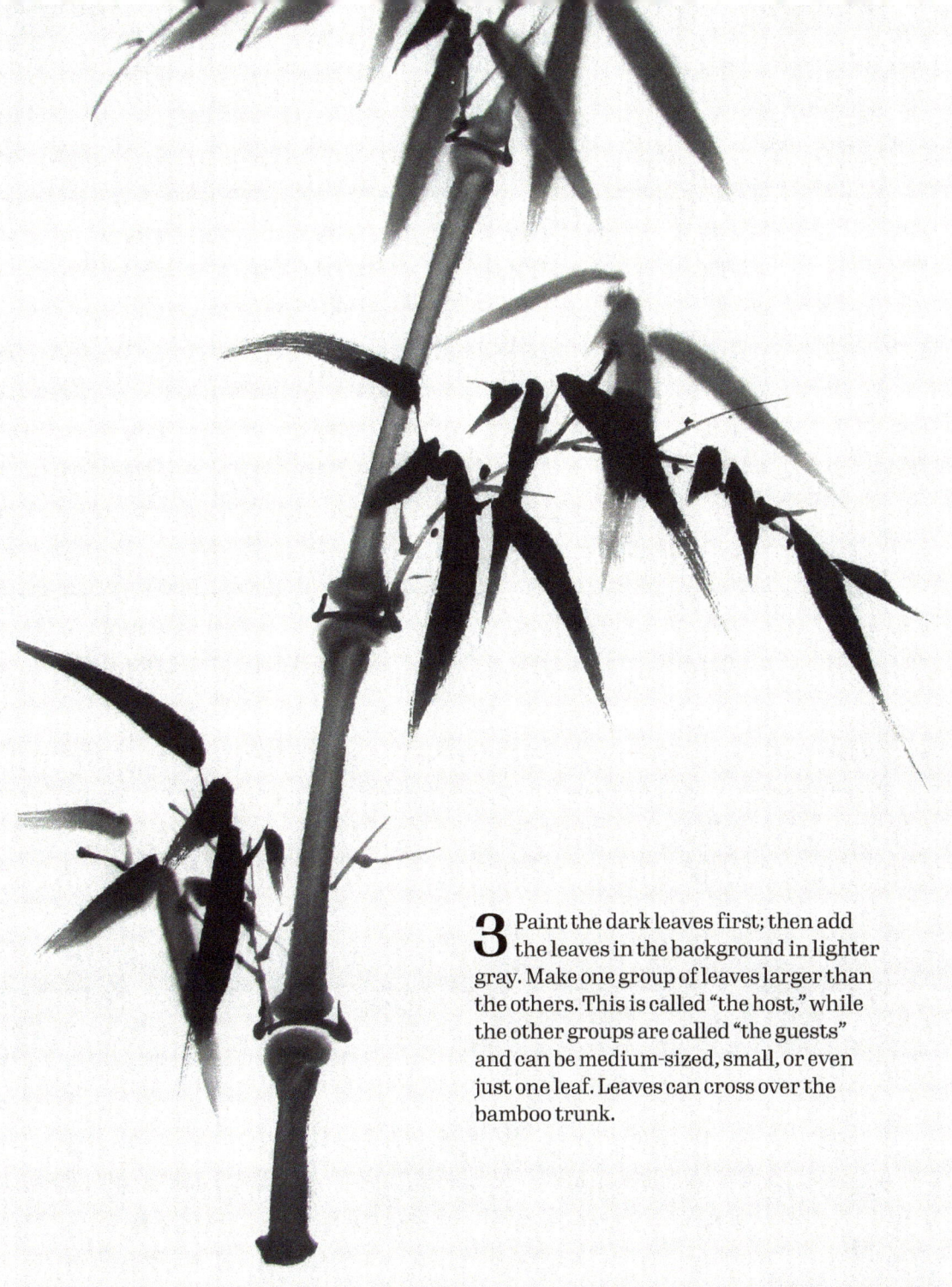

3 Paint the dark leaves first; then add the leaves in the background in lighter gray. Make one group of leaves larger than the others. This is called "the host," while the other groups are called "the guests" and can be medium-sized, small, or even just one leaf. Leaves can cross over the bamboo trunk.

A word about following or copying the work of other artists: In Asian art, this does not have the pejorative connotation that "copying" does in the West. Because Asian painting is based on calligraphy strokes, it is expected that your strokes will follow certain rules. As you become more confident in your strokes, you will put more of your personality into them and your paintings will be recognizable as yours. On page 126, you can find suggestions for books and videos that will provide models and insights into both sumi-e and mindfulness.

Orchid

As one of the Four Gentlemen (pages 20-23), the orchid is a popular, essential subject in sumi-e painting. Here we'll divide the subject into elements before combining them all to complete a painting of an orchid.

Leaves

The painting project on pages 24-31 shows you how to paint bamboo leaves by holding the brush upright, pressing down in the center and then slowly lifting to a point. Orchid leaves are painted in the same way, only with a little curve.

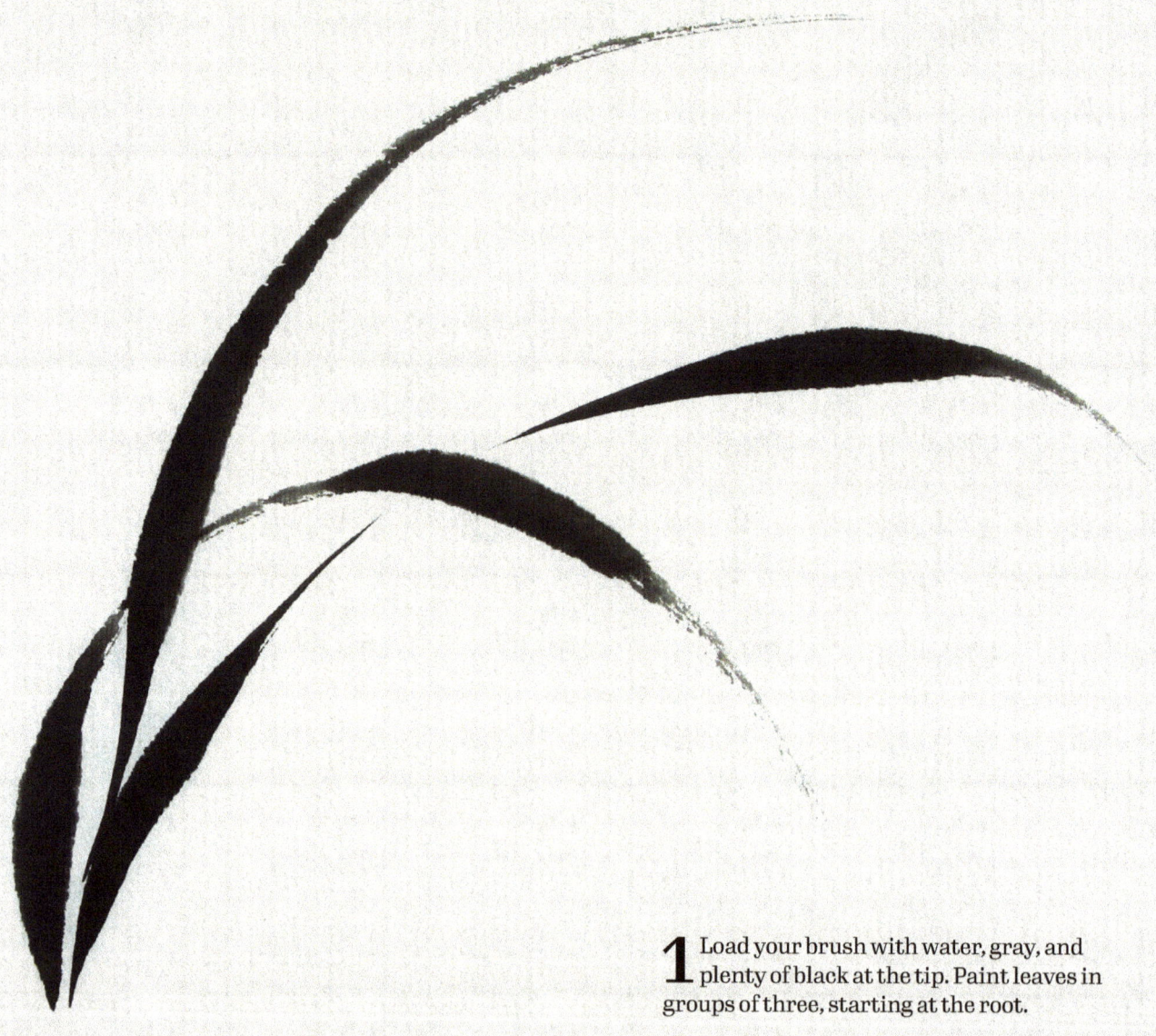

1 Load your brush with water, gray, and plenty of black at the tip. Paint leaves in groups of three, starting at the root.

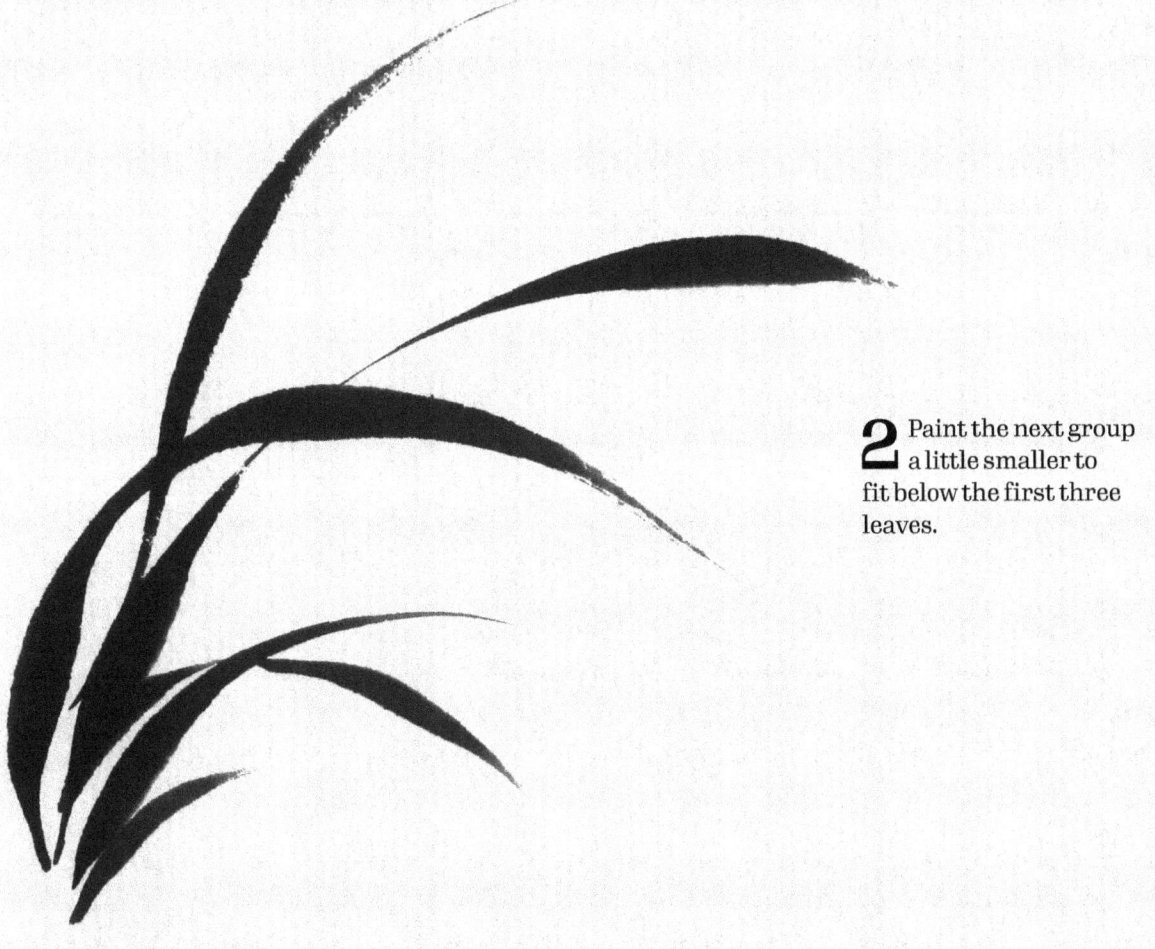

2 Paint the next group a little smaller to fit below the first three leaves.

3 Complete the formation with another group of leaves on the left or by adding small leaves at the bottom on either side. Make sure that all the leaf groupings angle toward the plant's common root.

Flowers

Rinse your brush and reload it with gray and a little black at the tip. The brush should be a bit dryer now. Holding your brush upright, start at the top bud and paint two small crescent moons facing each other. Work your way down, building more flowers and adding a new petal until you have added five. Add a central stem and join each flower to it. Create two or three small stamen dots at the base of each flower.

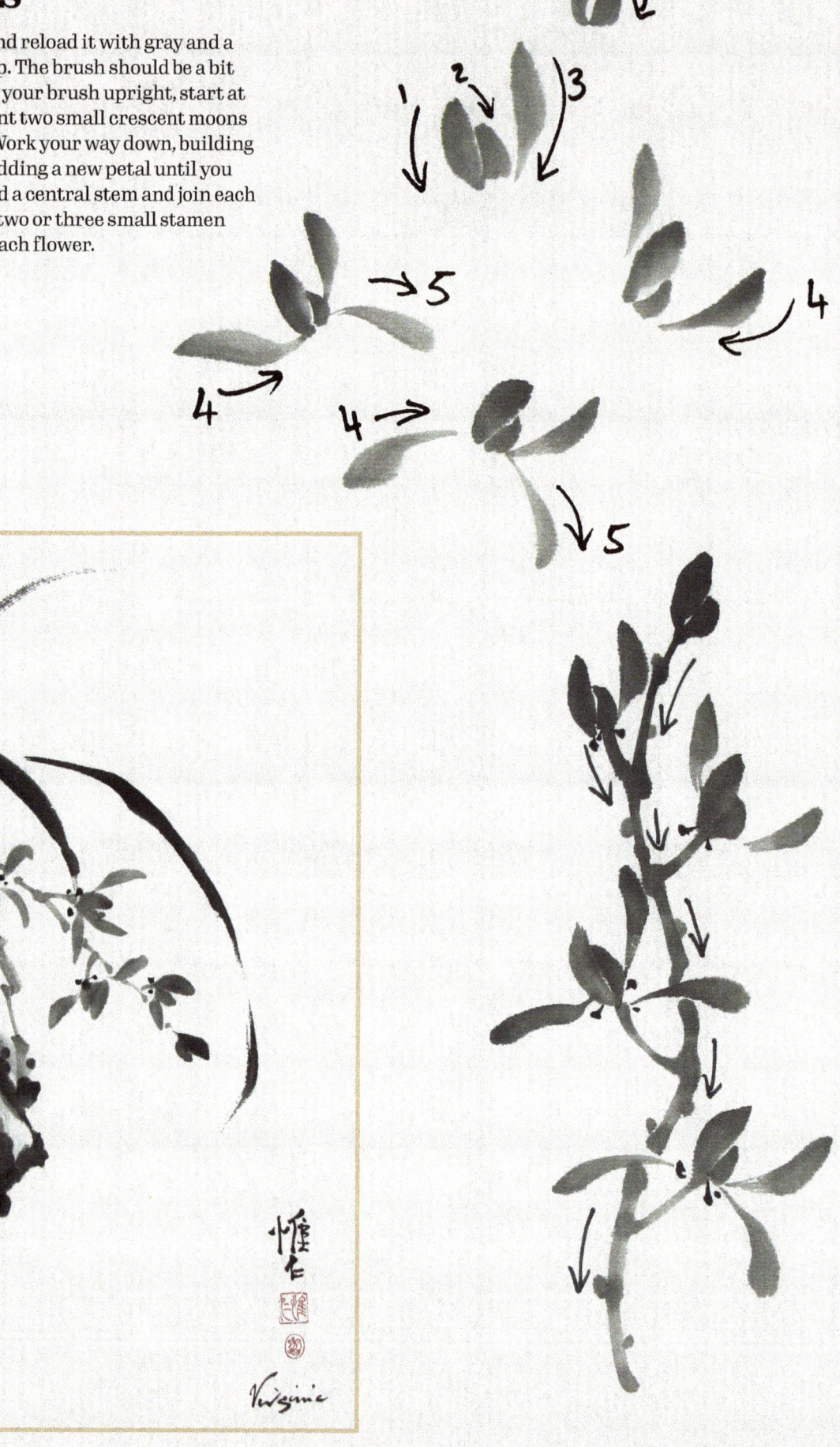

Color

After practicing with black ink, you may want to use color to paint orchids. To paint the leaves, load your brush with blue and yellow blended to make green, and then a lot of black. As you paint, you will see variations in color on the leaves as the black is used up and more of the green appears.

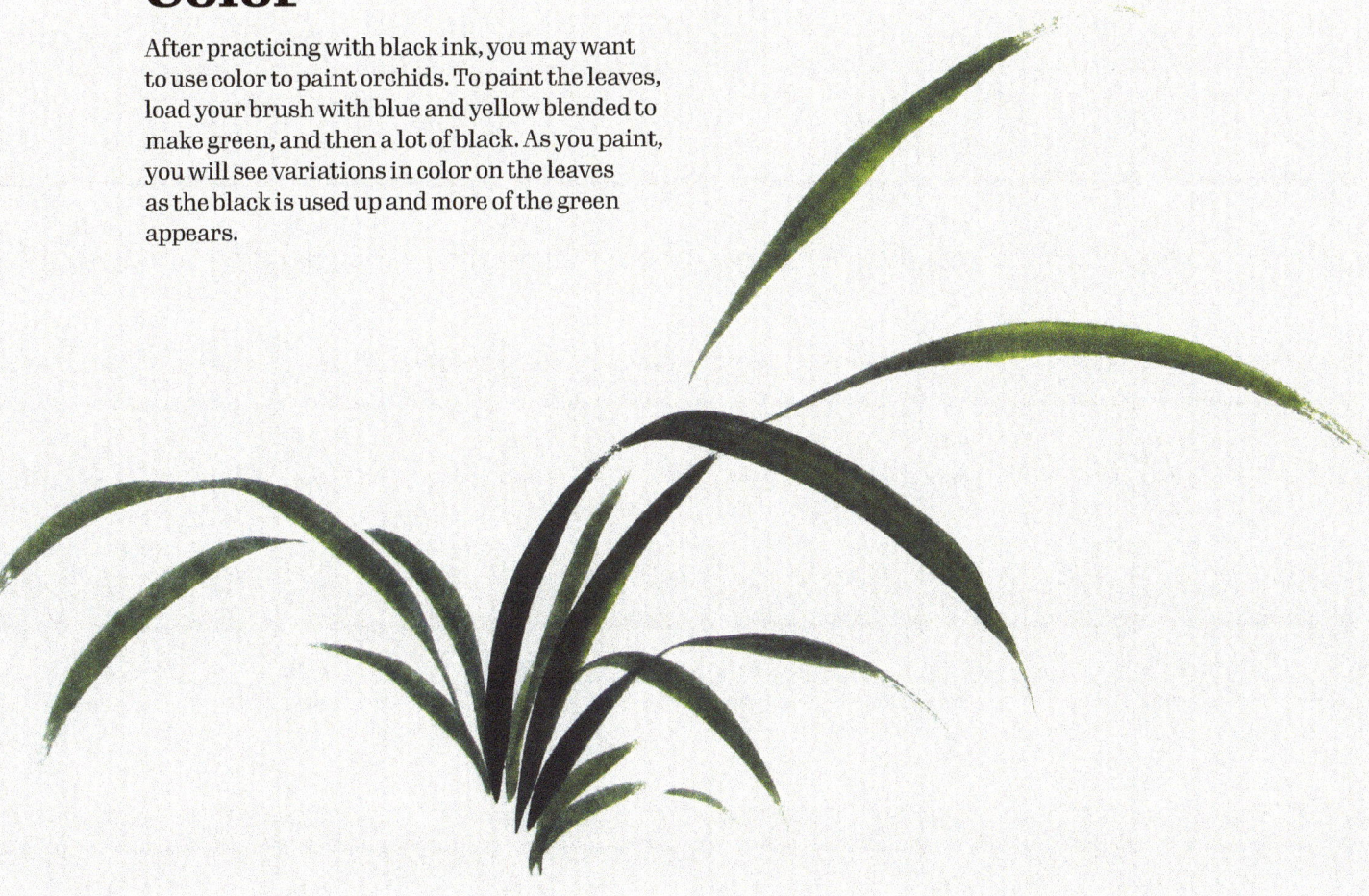

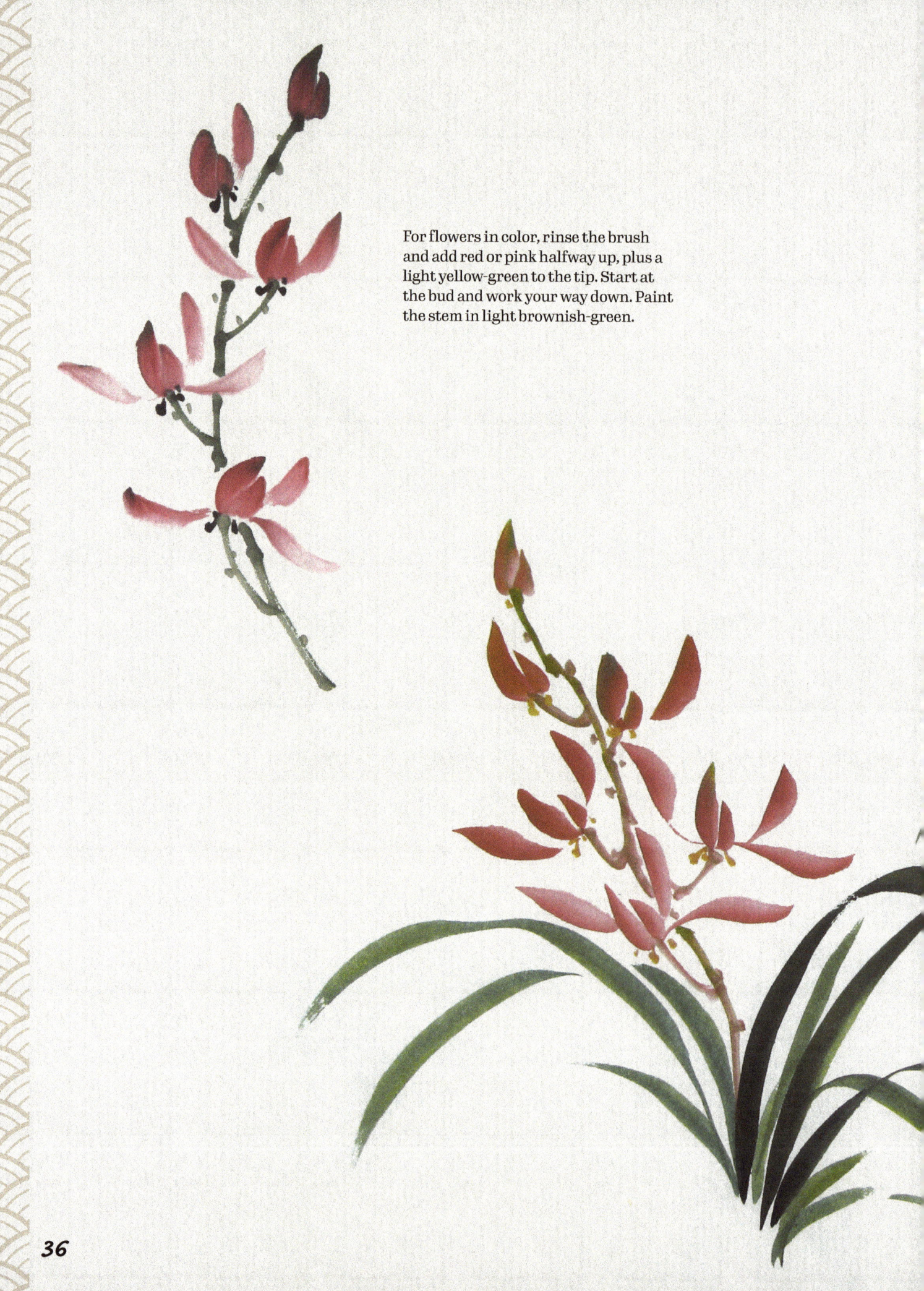

For flowers in color, rinse the brush and add red or pink halfway up, plus a light yellow-green to the tip. Start at the bud and work your way down. Paint the stem in light brownish-green.

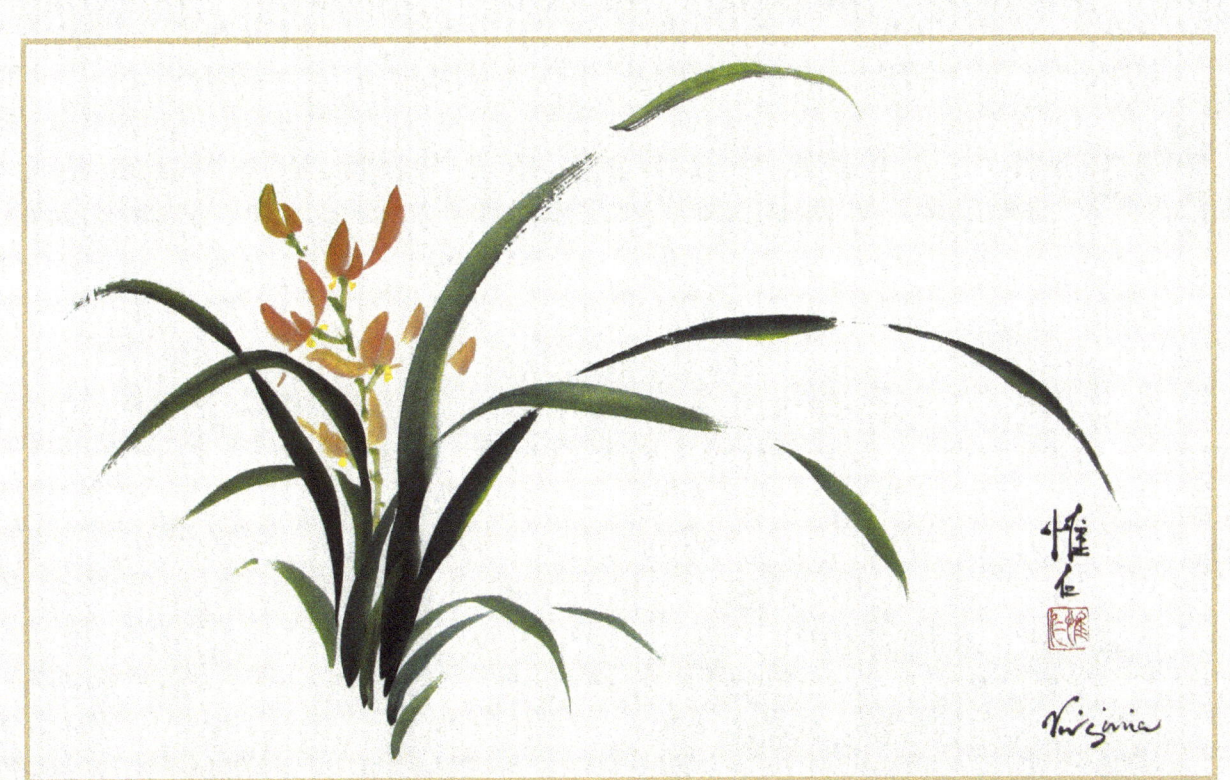

Plum

Plum paintings are all about angles, which may surprise you since their most noticeable element is usually the flowers. Those are just the decorations, however. With a well-composed branch, you can add just one or two flowers to create a powerful, satisfying painting. One small plum branch represents a whole tree.

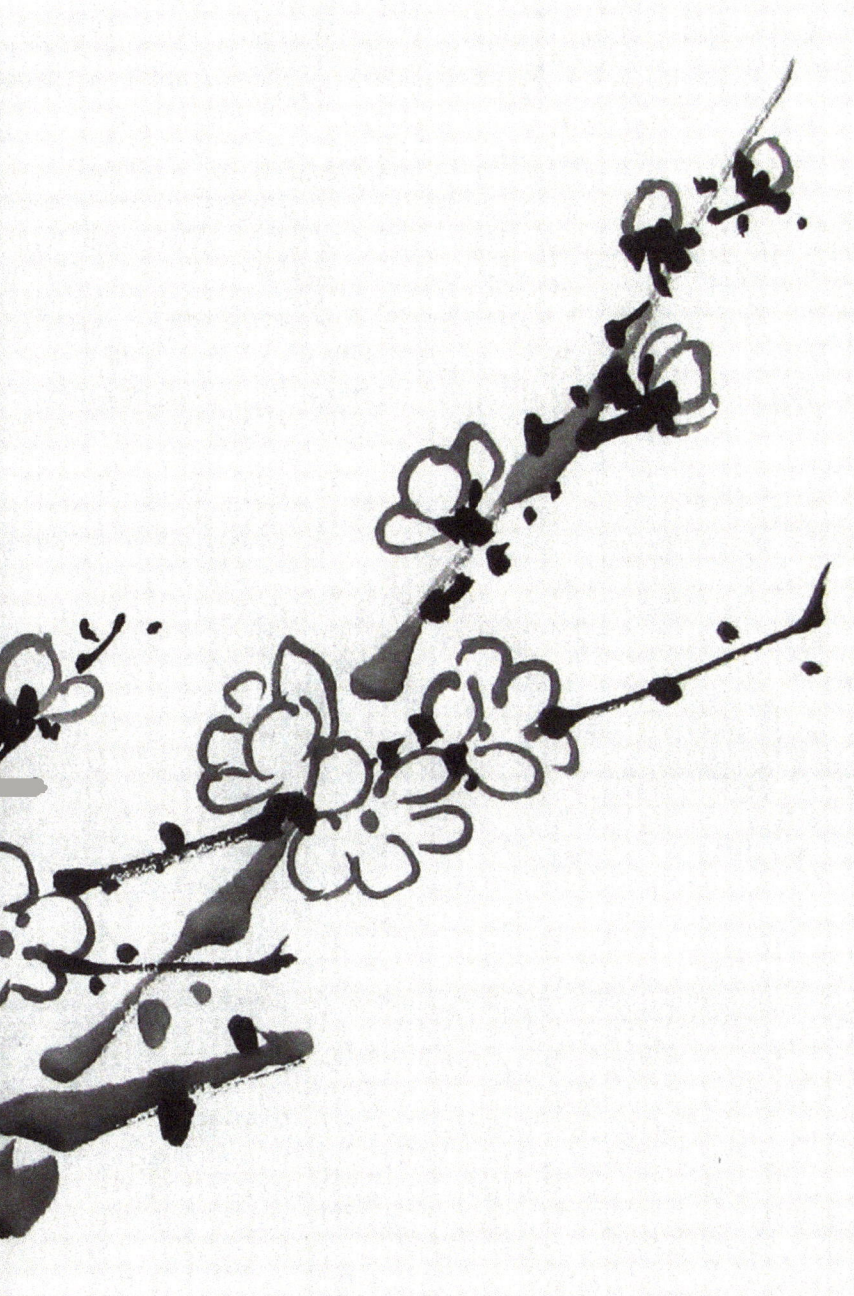

Why is it that less is more? You might want to think of it in terms of mindfulness training: The jumble of thoughts, plans, and ideas that usually occupies the mind is colorful. We flit from one thought to another. There's nothing wrong with this. This book seeks to help you focus your mind, however—how to pair the "be here now" of mindful attention practice with the quick stroke practice of sumi-e painting to enhance both disciplines.

When your mind is fully and actively present while you paint, you channel that power into your strokes. You may chant rules to yourself as you paint, such as "long, medium, short" to vary the length of your branches, or "groups of three" to keep yourself from mindlessly dabbing leaves all over the page. After a while, you will internalize these rules and muscle memory will take over.

Branches

Big, old branches have no flowers growing from them, but they contain the energy of your painting coiled up, ready to spring forth with new growth. Paint them as though you are carving the old trunk into the paper.

1 Load a bamboo/orchid brush with medium gray and black blended at the tip. Then use the side of the brush to create a strong, short, and gnarly branch. Next, holding the brush vertically and keeping it dryer to avoid blobs, add a medium branch crossing in front of or behind the bigger branch. This will add depth to the painting.

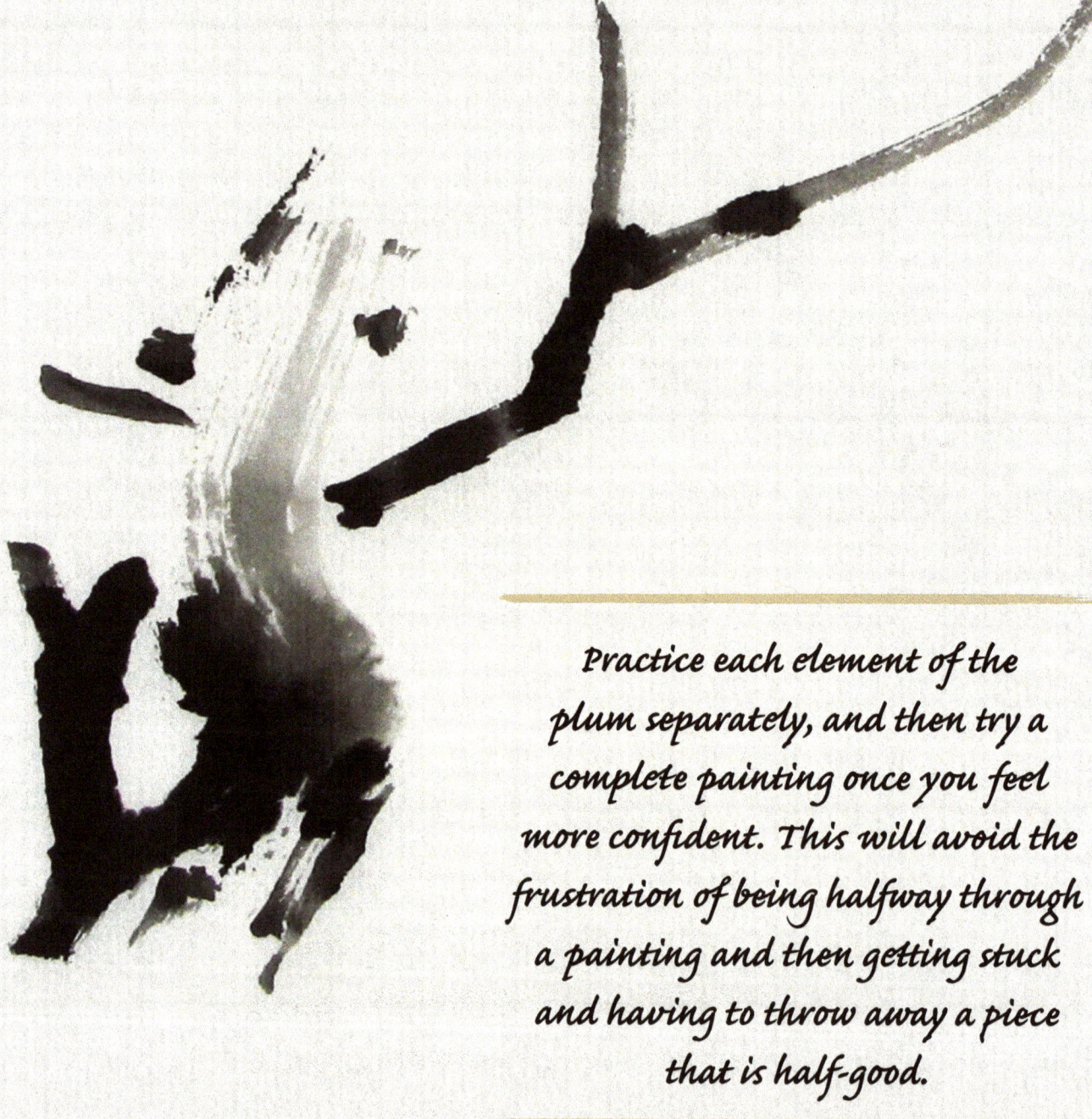

Practice each element of the plum separately, and then try a complete painting once you feel more confident. This will avoid the frustration of being halfway through a painting and then getting stuck and having to throw away a piece that is half-good.

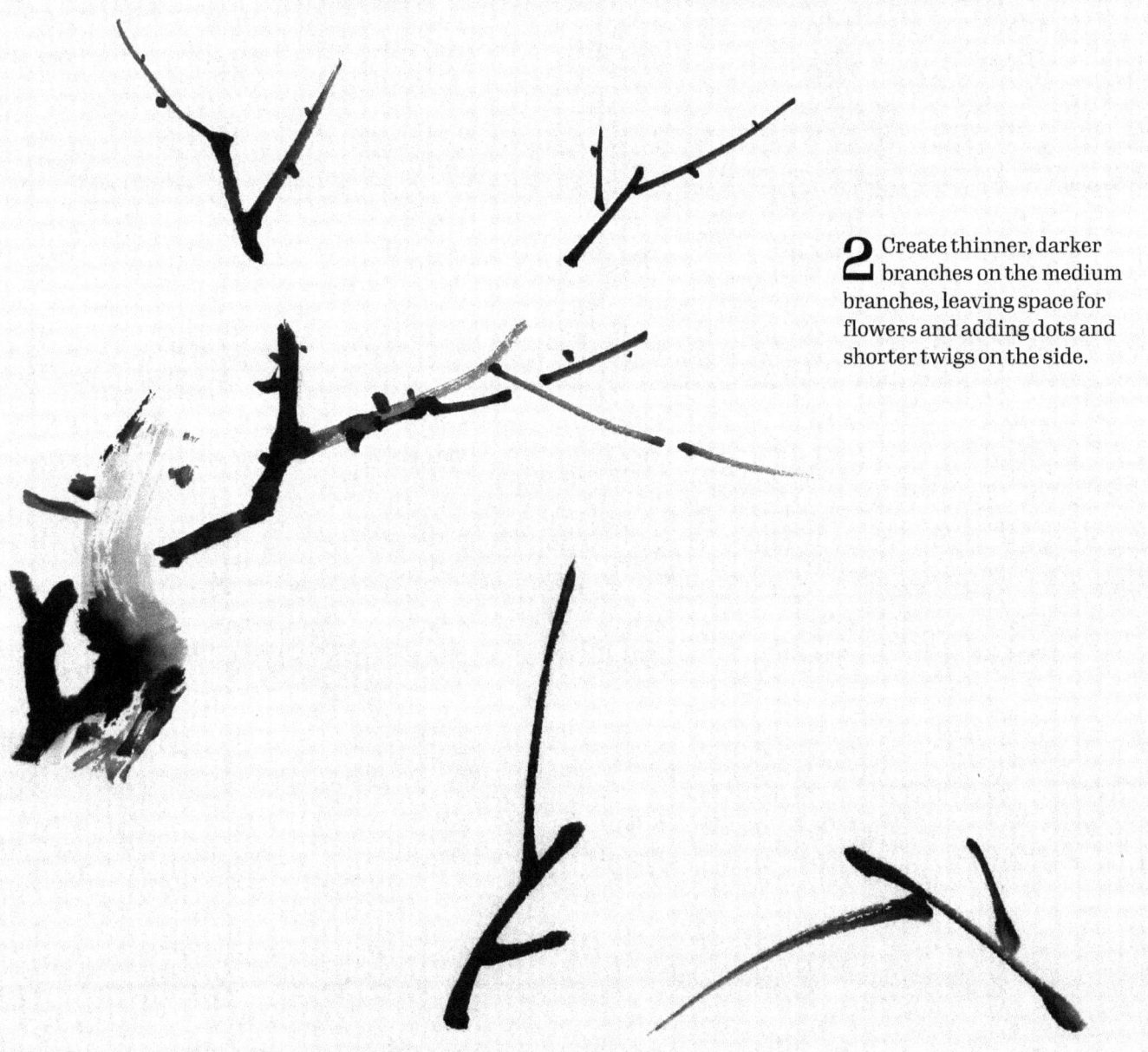

2 Create thinner, darker branches on the medium branches, leaving space for flowers and adding dots and shorter twigs on the side.

Practice creating these sample side formations, called "horn of the deer" and "dragon's horn."

41

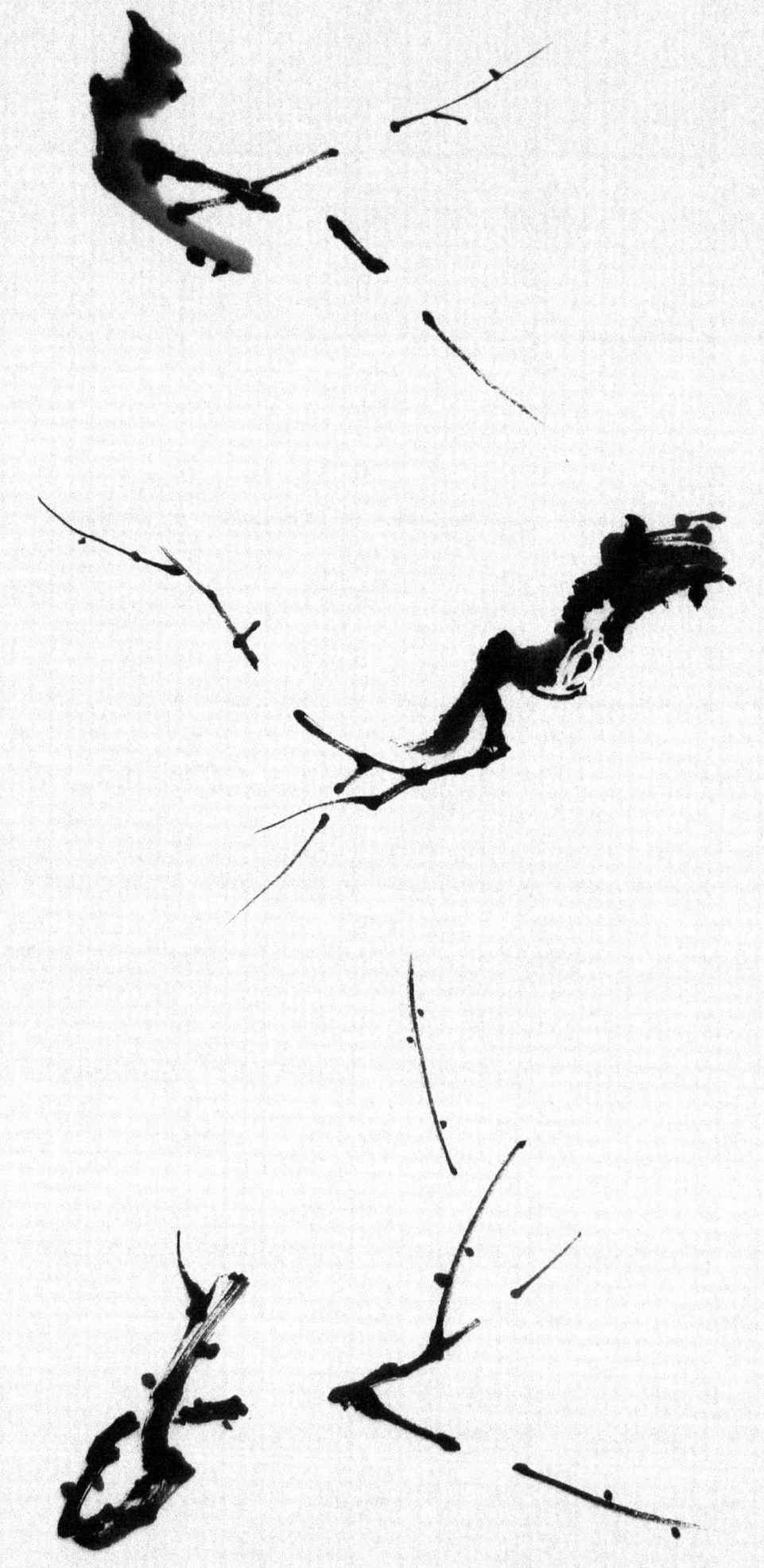

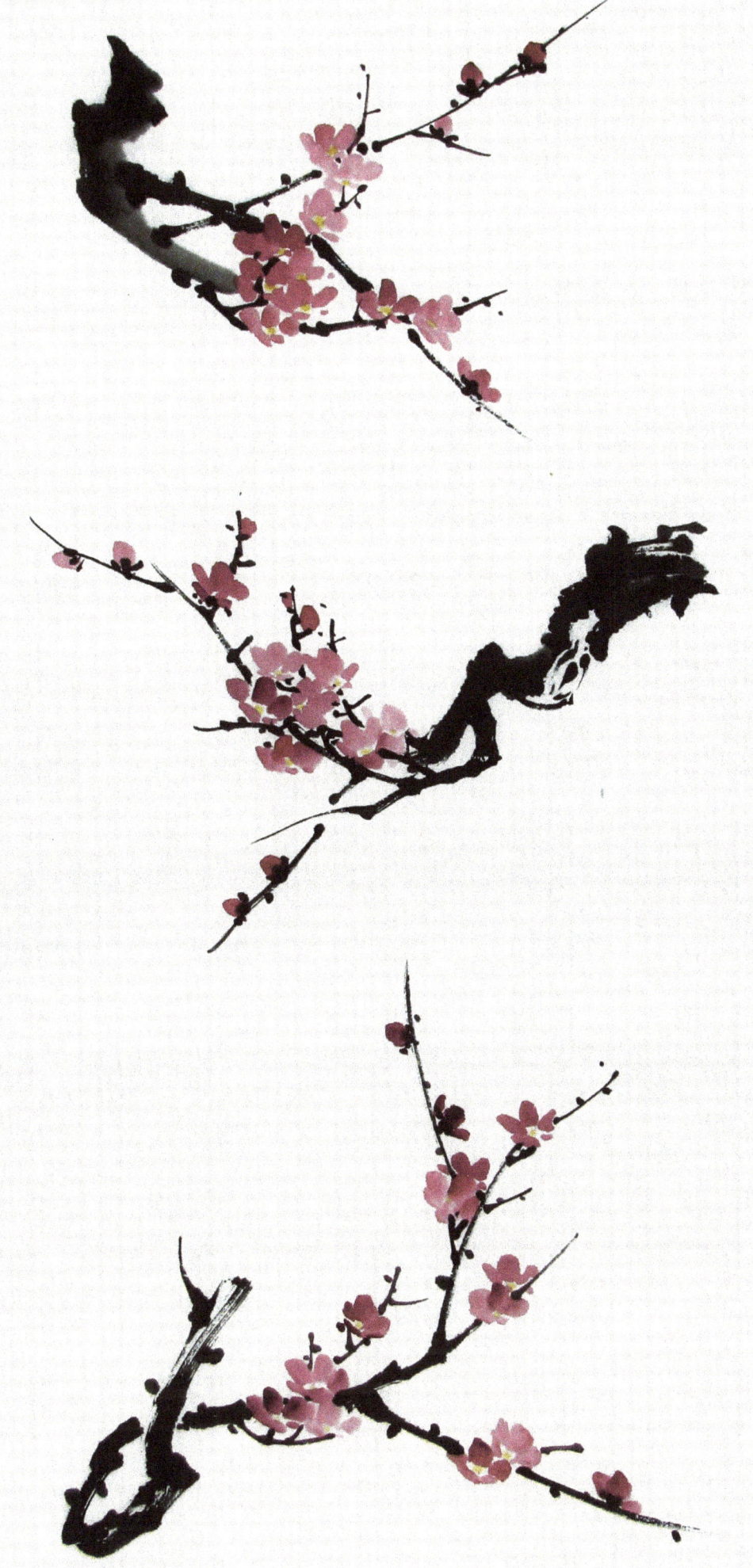

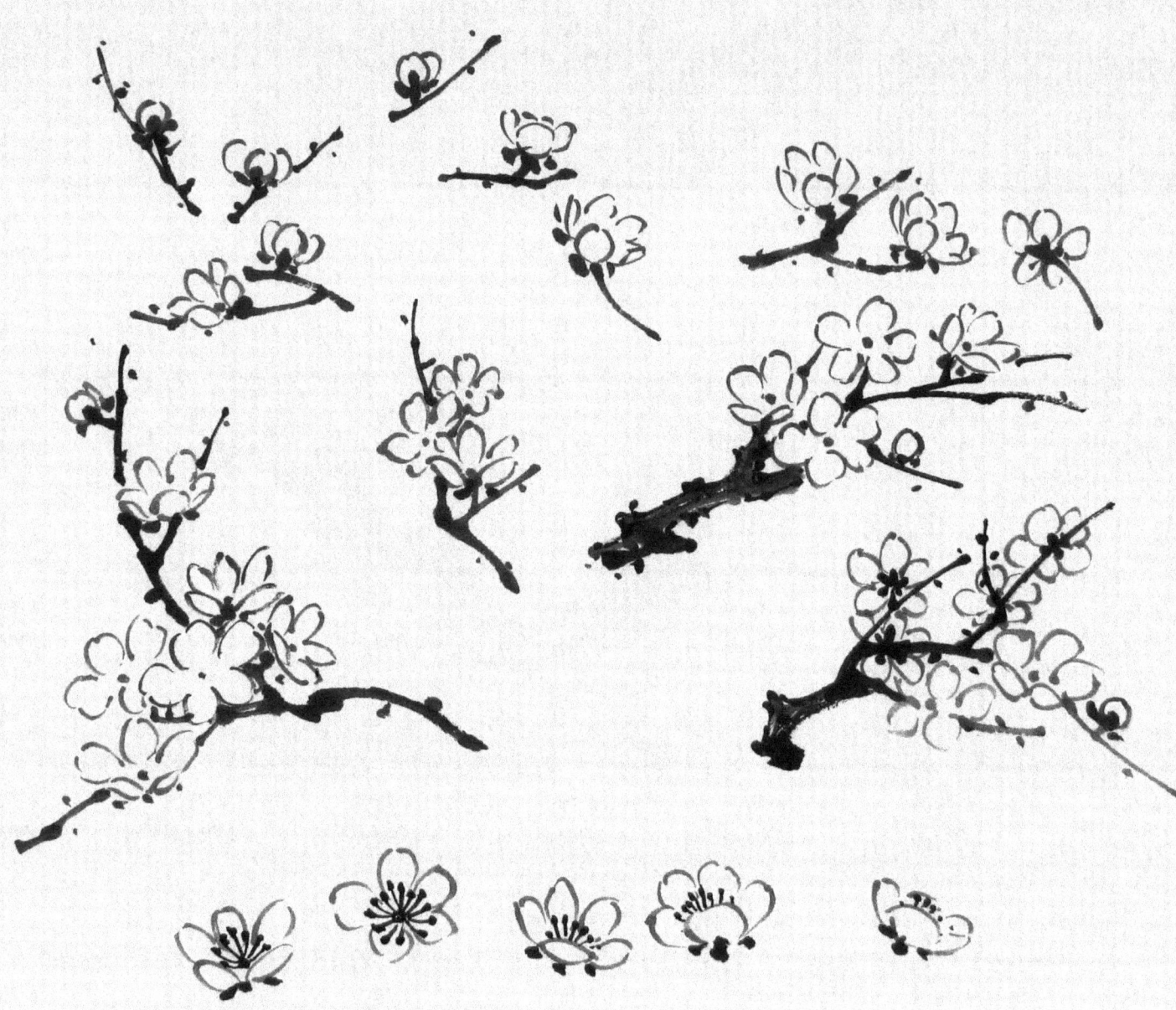

Flowers

You can paint the flowers in two styles: with outlined petals or as boneless (no outline) petals. Flowers have five petals when fully open; sometimes you can only see two or three, however.

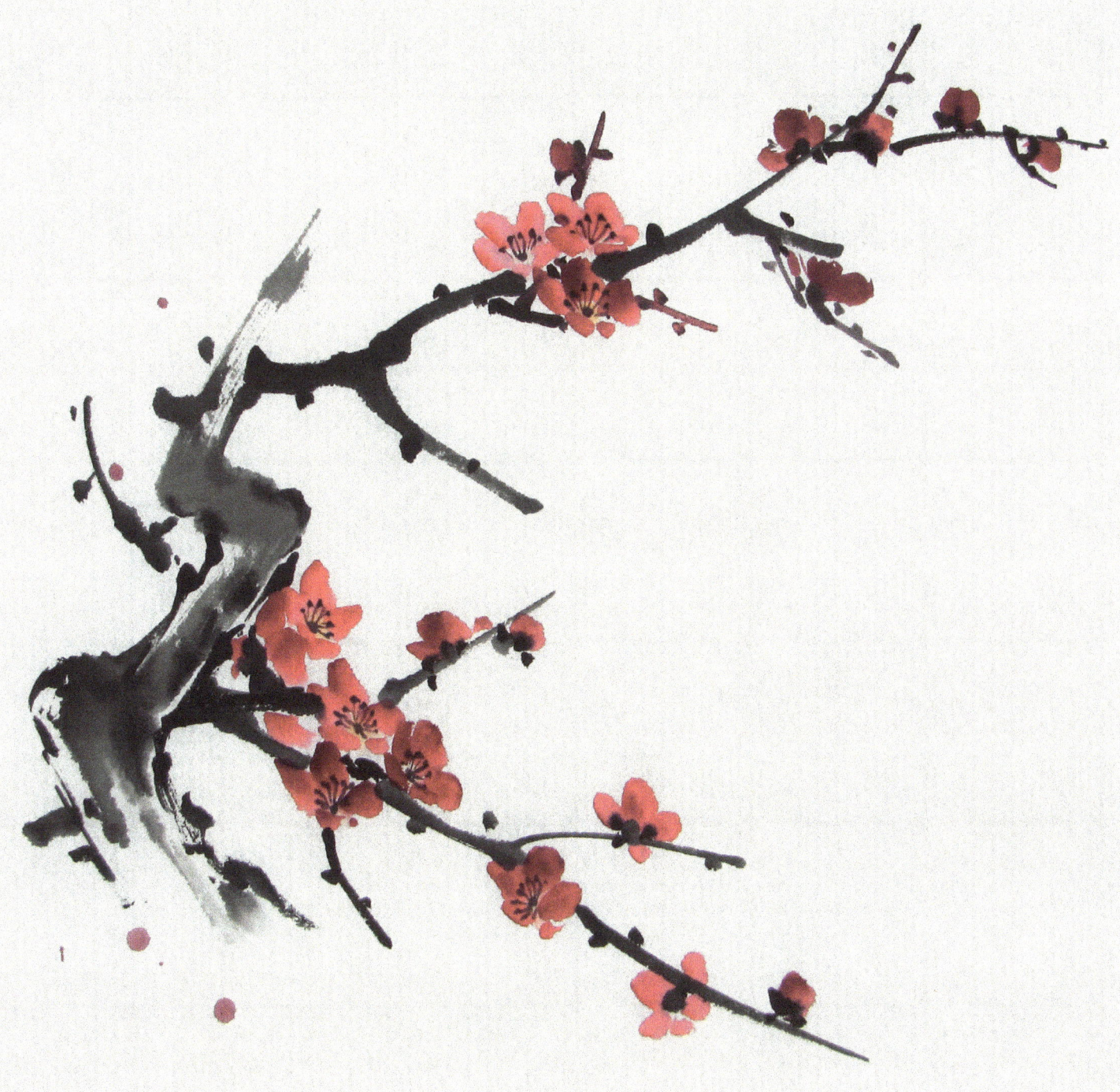

1 Paint outline flowers in medium gray. If you find the ink runs too much, use less moisture on the brush and add a little yellow to the gray.

For boneless flowers, load carmine wash onto your Happy Dot brush, and then add a little rouge to the tip. To create larger flowers, use a small soft brush. Make a circular stroke with the side of your brush for each petal. Add a small dot of dilute yellow in the center of each flower.

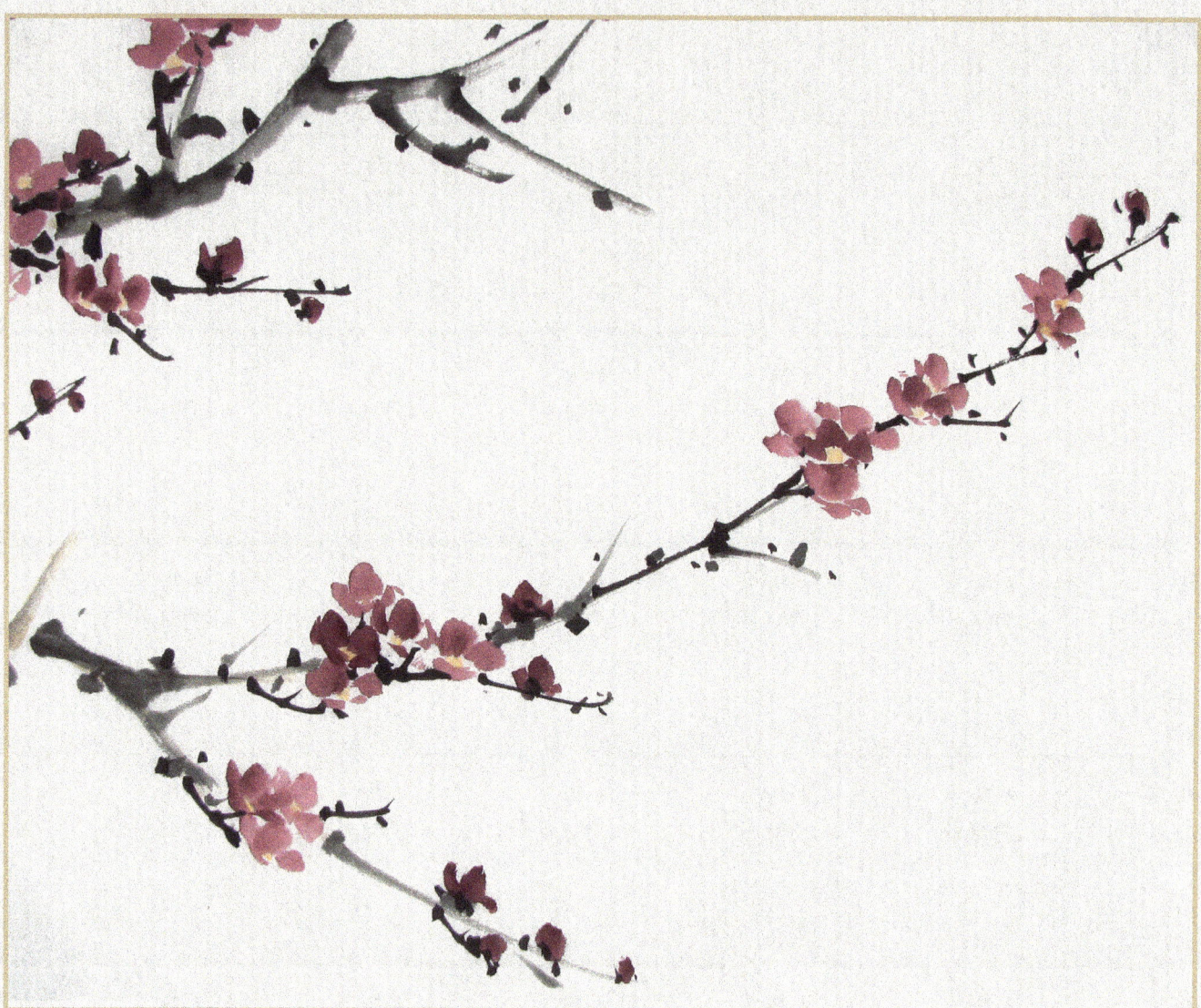

2 To attach the flowers to the branches, use rouge mixed with black or black-brown on your Happy Dot brush. Paint these thin, springy twigs with vitality!

COMPOSITION

Start off with small, simple plum paintings. One small branch holds the essence of the entire tree. Paint your branches in diagonals, rather than vertical or horizontal lines, and think in triangles. If you start off with a bulky old branch, then the rest of the branches should be sparse and long. If you start off with a smaller old branch, your point of interest could be a bird or pair of butterflies flying into the picture, or many flowers. Avoid placing the main branch in the center of the paper; this will split your image in two. Also, there is no need to fill the entire sheet! The negative space (the blank areas of the paper) is just as important your strokes.

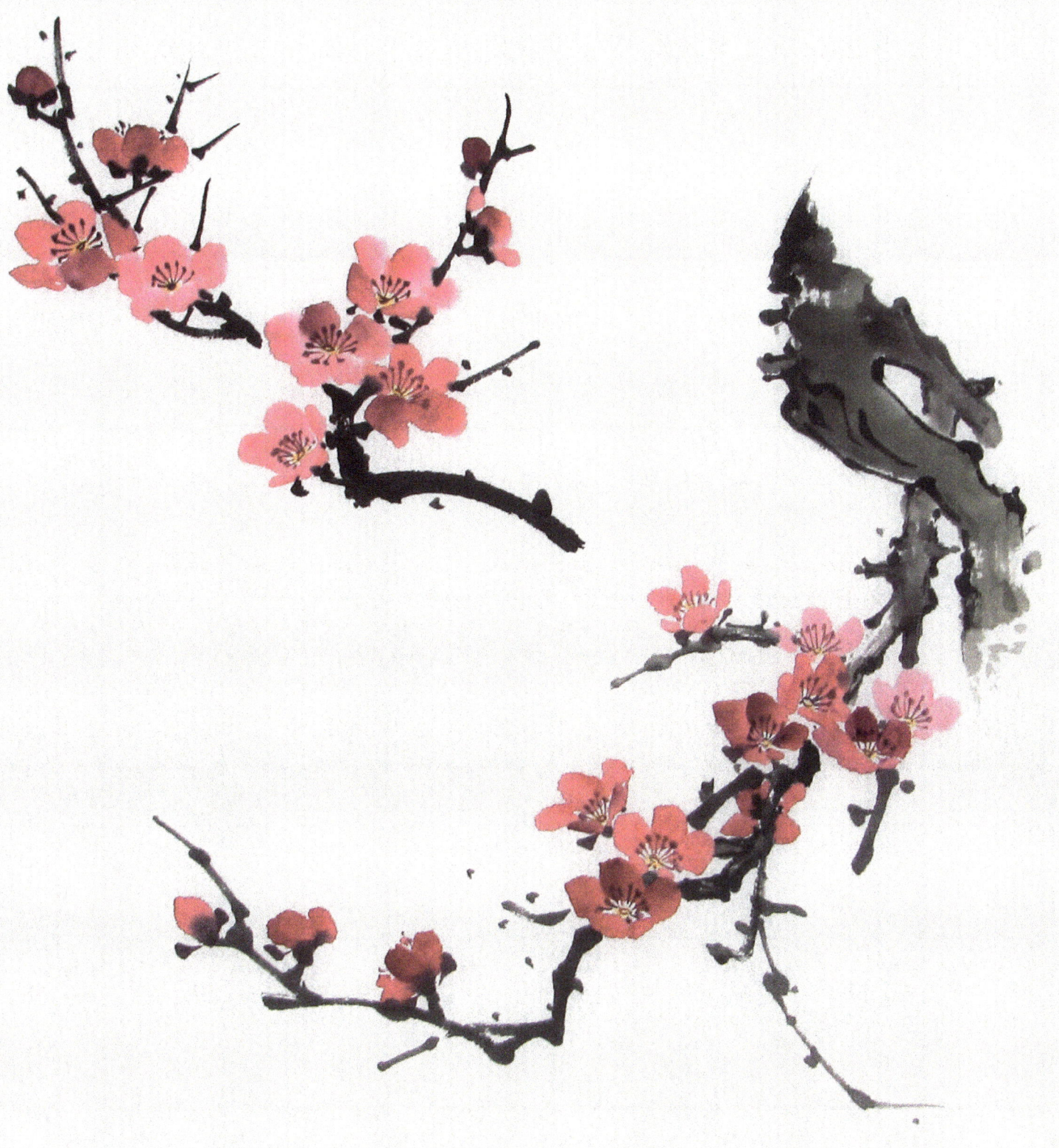

3 To create the stamens, wait until the flowers are dry, and then load your Happy Dot brush with a light mixture of rouge or brown mixed with a little black. Paint the stamens in a circle fanning out from the center of the flower, and add dots on the ends.

Chrysanthemum

With the chrysanthemum, one of the "Four Gentlemen" (pages 20-23), you will need to keep the brush upright for the flowers while also using a side stroke for the leaves.

There are many varieties of chrysanthemums, including pom-pom, spider, spoon, and daisy. For some, you will paint the outline first before adding color, while for others you will use a quick stroke that looks like an upside-down orchid leaf. Let's start with traditional black ink sumi-e, and then explore color.

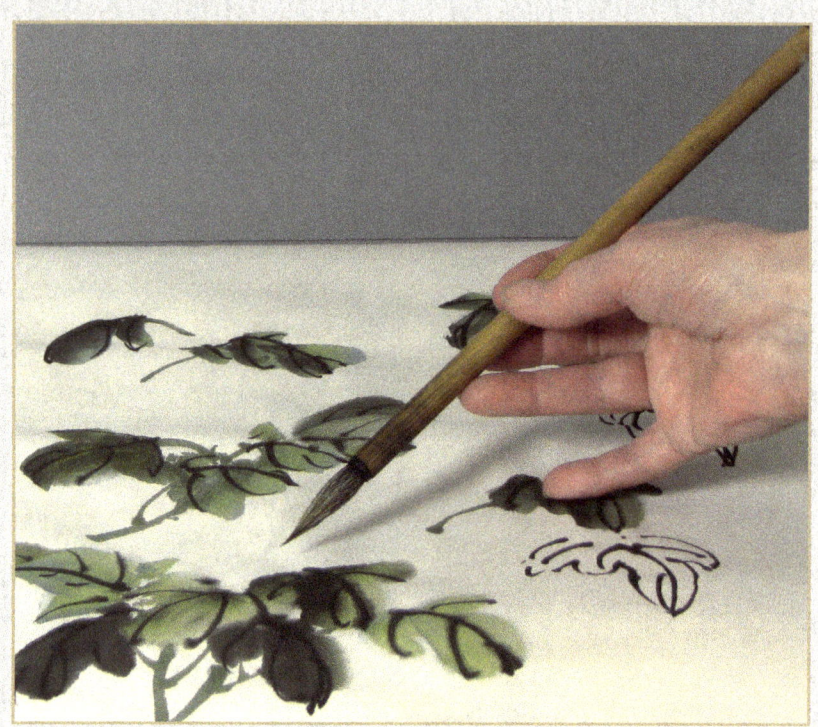

Spider Chrysanthemum

Use your preferred brush type, depending on how thin you want the petals. Rinse your brush and load it with gray and black. Start with the center petals and work your way out toward the longer petals. Paint them in groups of three, crossing like orchid leaves (pages 32-33). Keep your brush upright and make sure the petals join at the center of the flower.

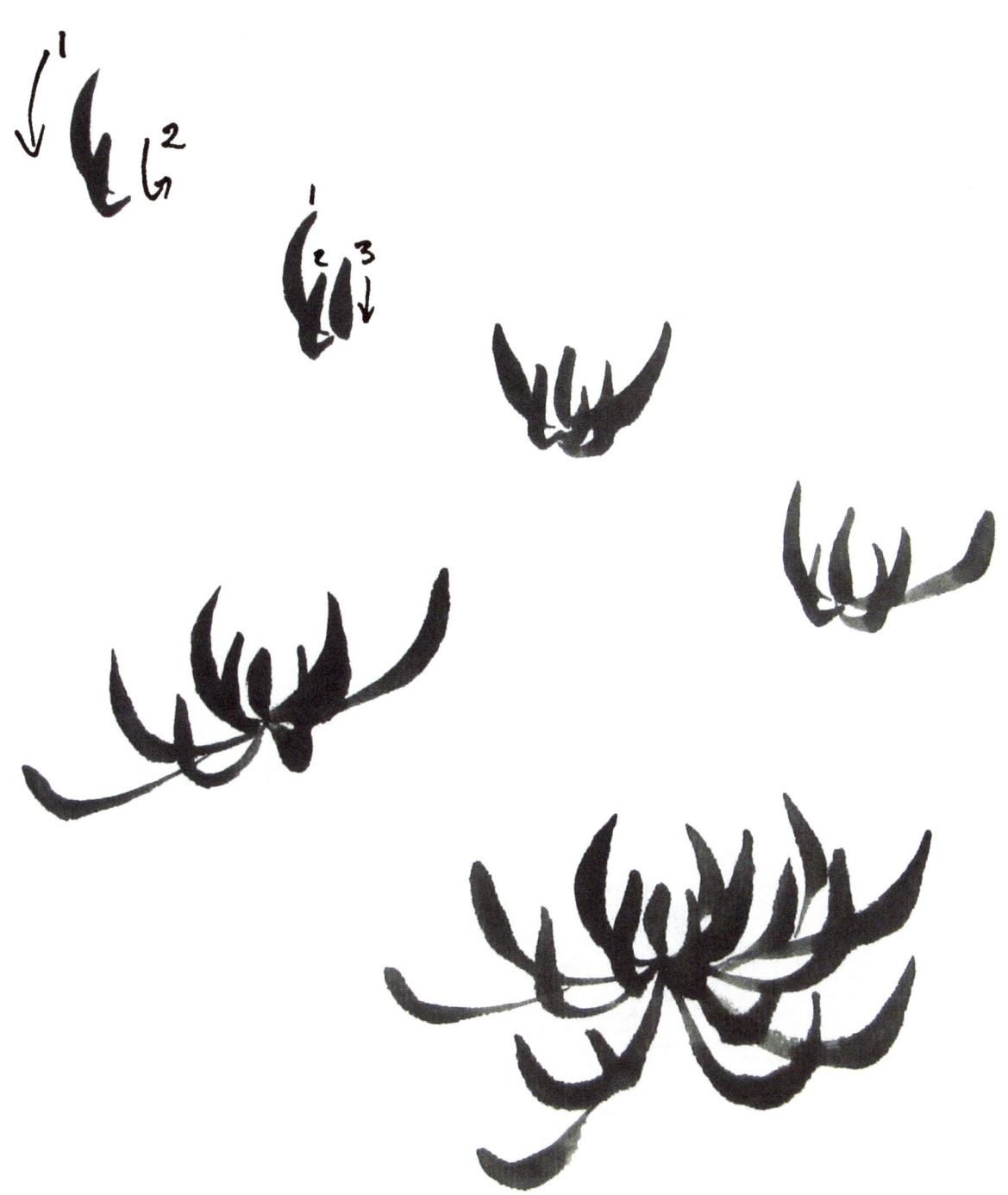

LEAVES

1 Load your brush with gray and then black at the tip, and slant the brush handle down toward the paper. Paint the central lobe as an oval; then add the side lobes.

2 Paint the leaves in groups around the central stem. Finish by adding the stem with a mostly dry dark gray, painting from top to bottom and holding your brush upright. Add the veins with dry black ink while the leaves are still damp.

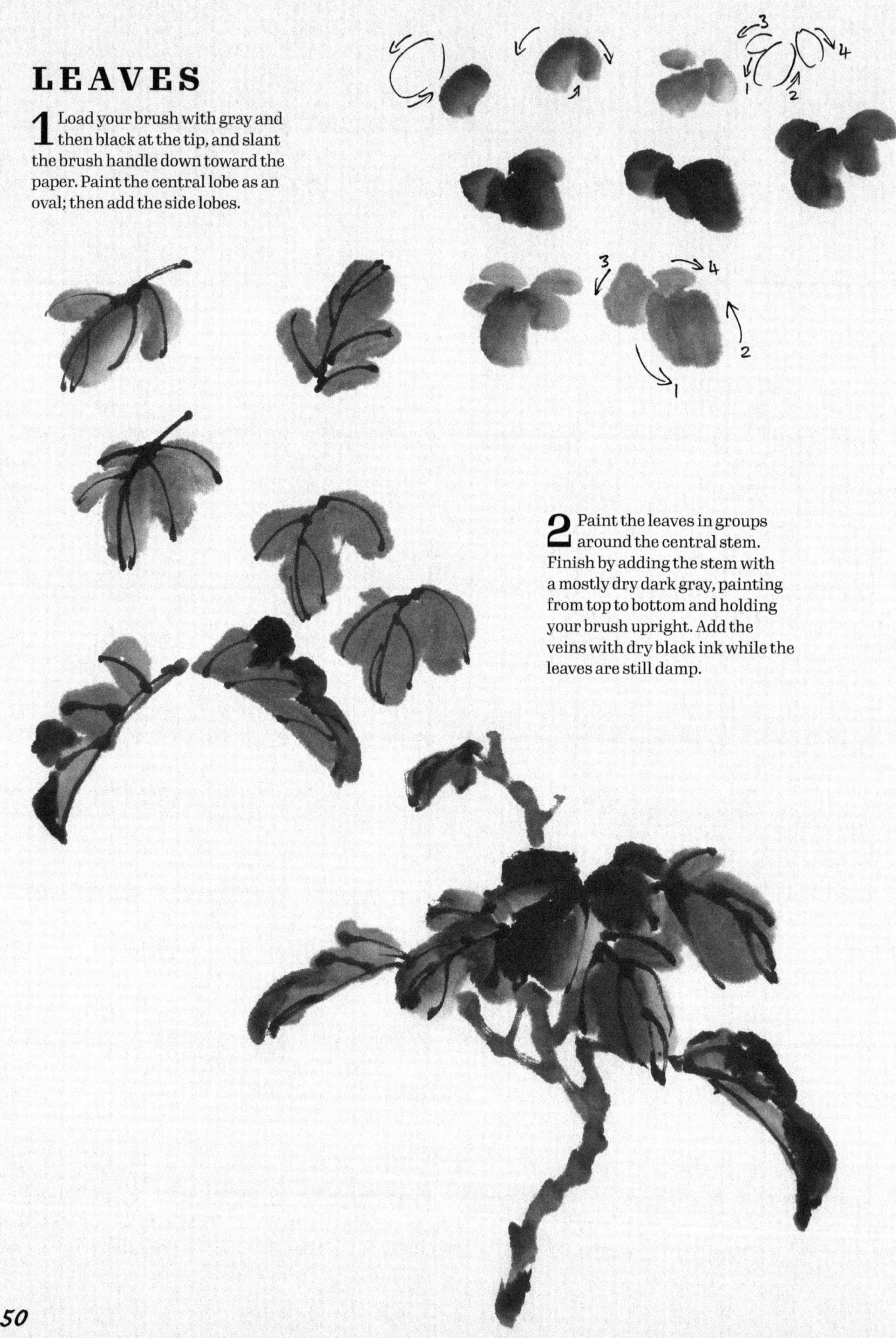

Pom-Pom
OUTLINE PETAL STYLE

Using a mostly dry dark gray, start at the center of the flower and allow the outline to dry before adding color.

LEAVES IN COLOR

Rinse your brush and add a blend of yellow and blue halfway up. Blend black on the tip.

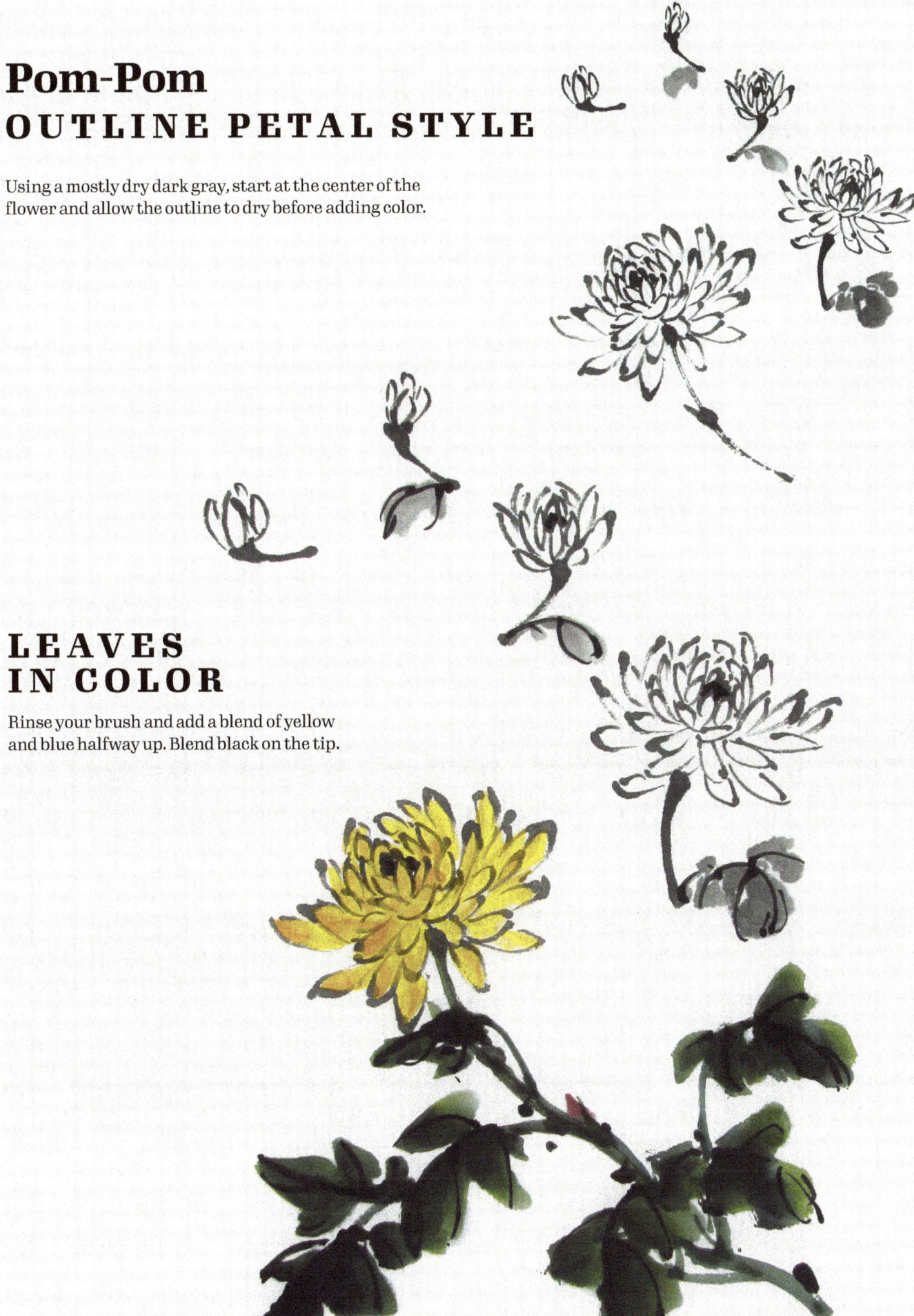

51

Spider Chrysanthemum

Mix orange and a little red on the tip of your brush. Paint flowers in different directions, with buds at the top.

LEAVES

1 Rinse the brush and add a blend of yellow and blue halfway up. Blend black on the tip.

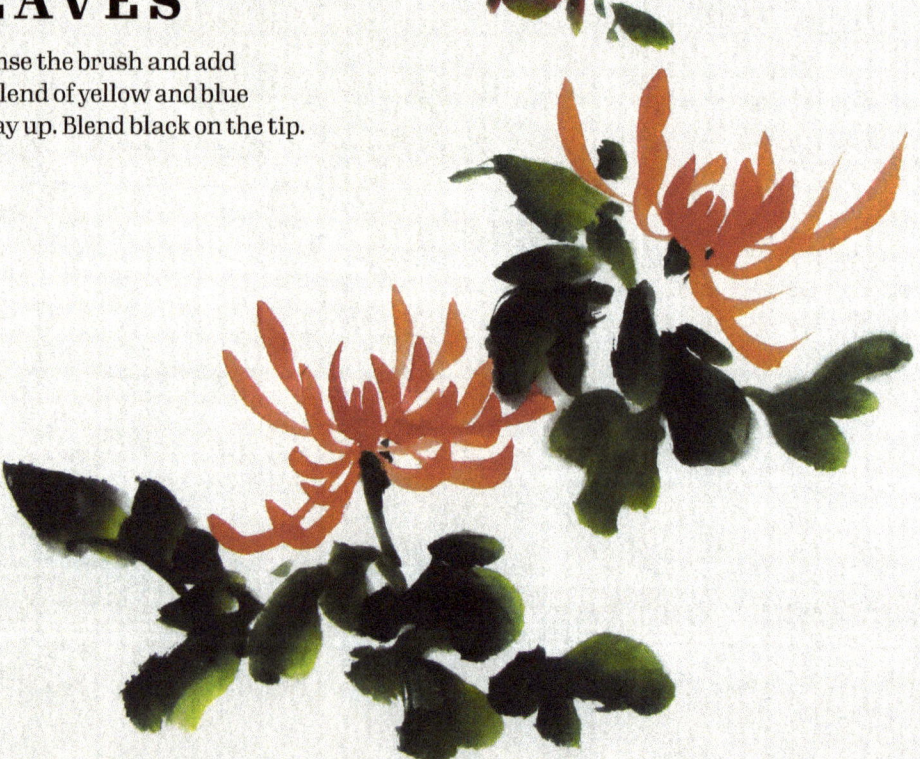

2 Finish by adding stems and bees in a graceful curve.

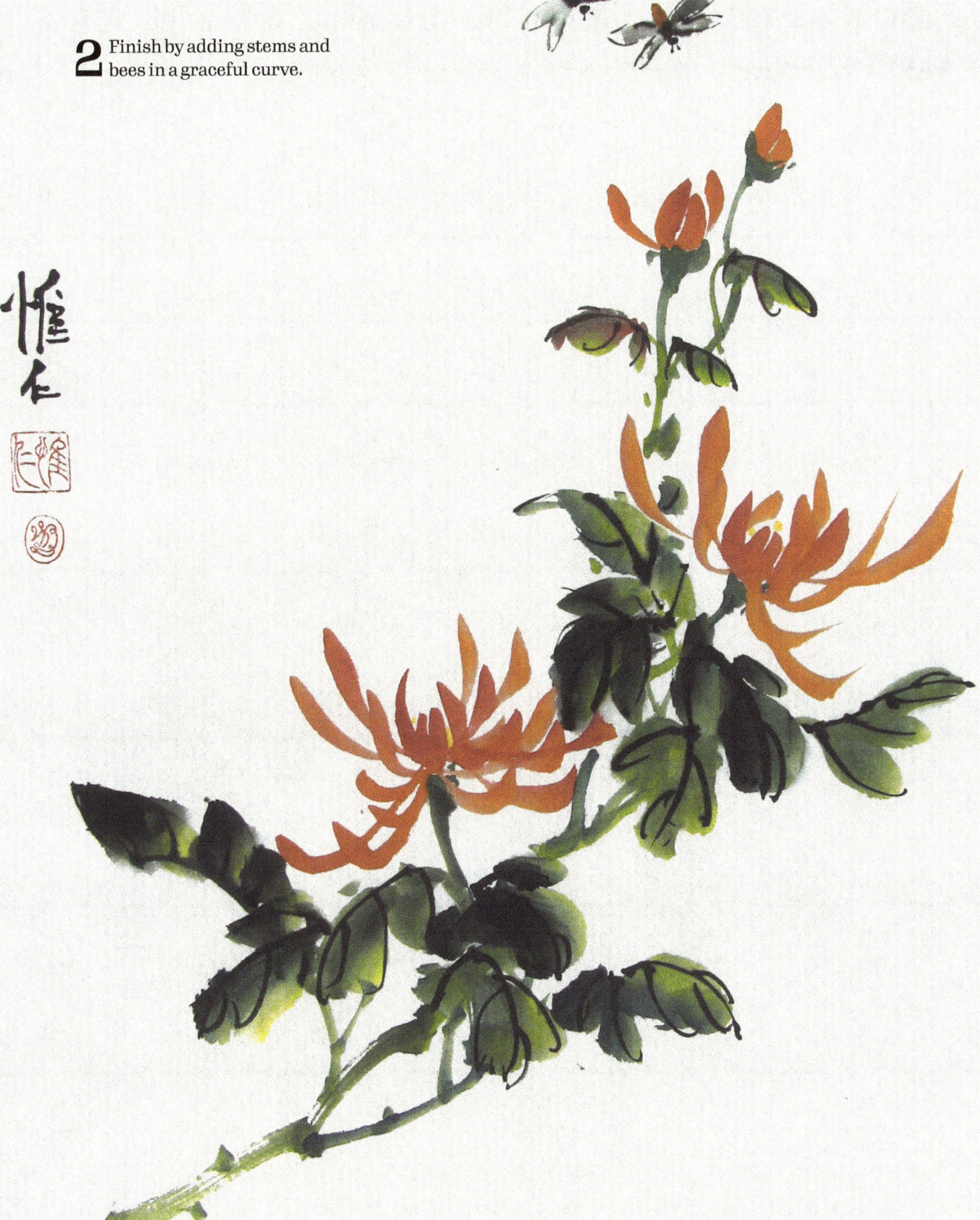

Additional Chrysanthemum Varieties

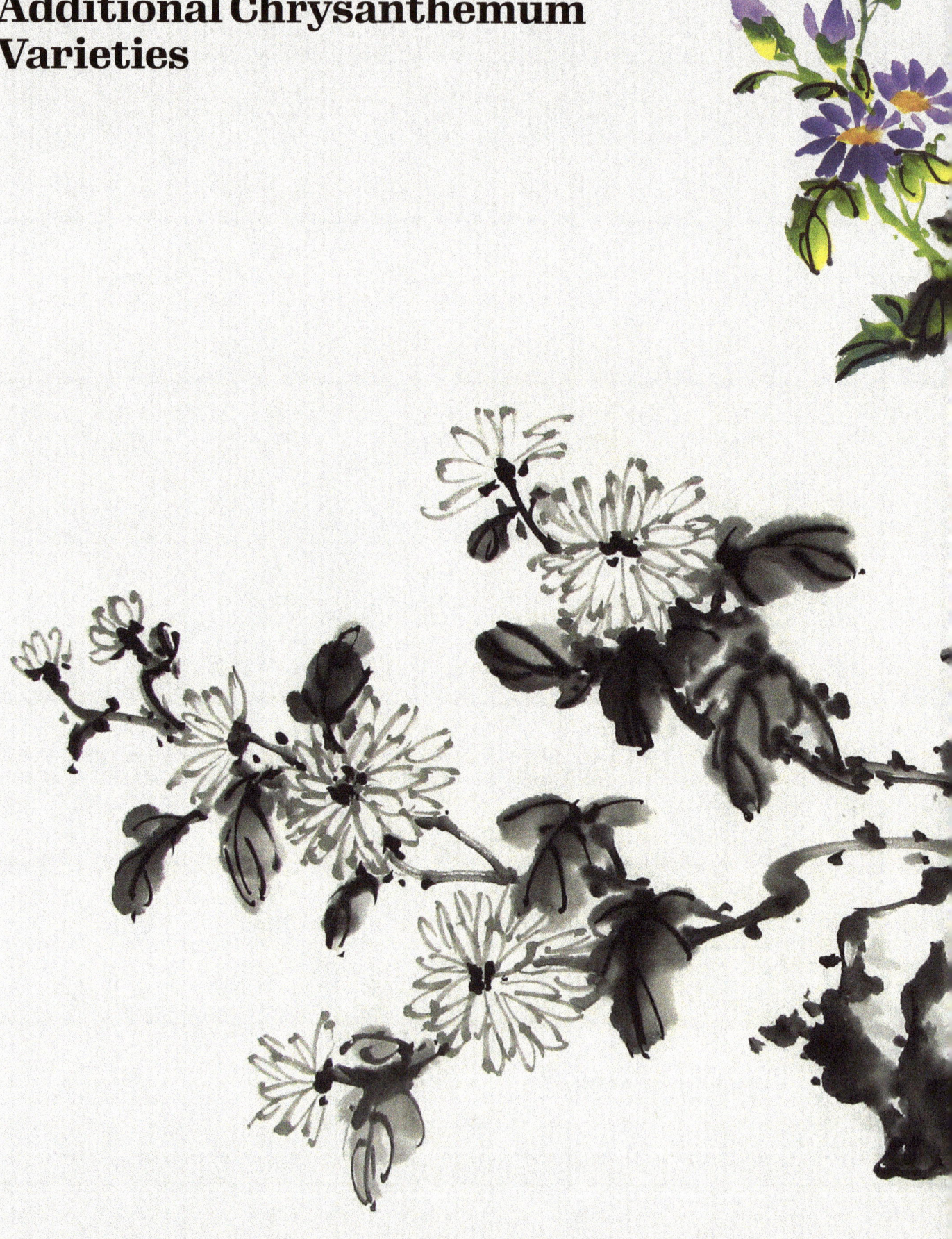

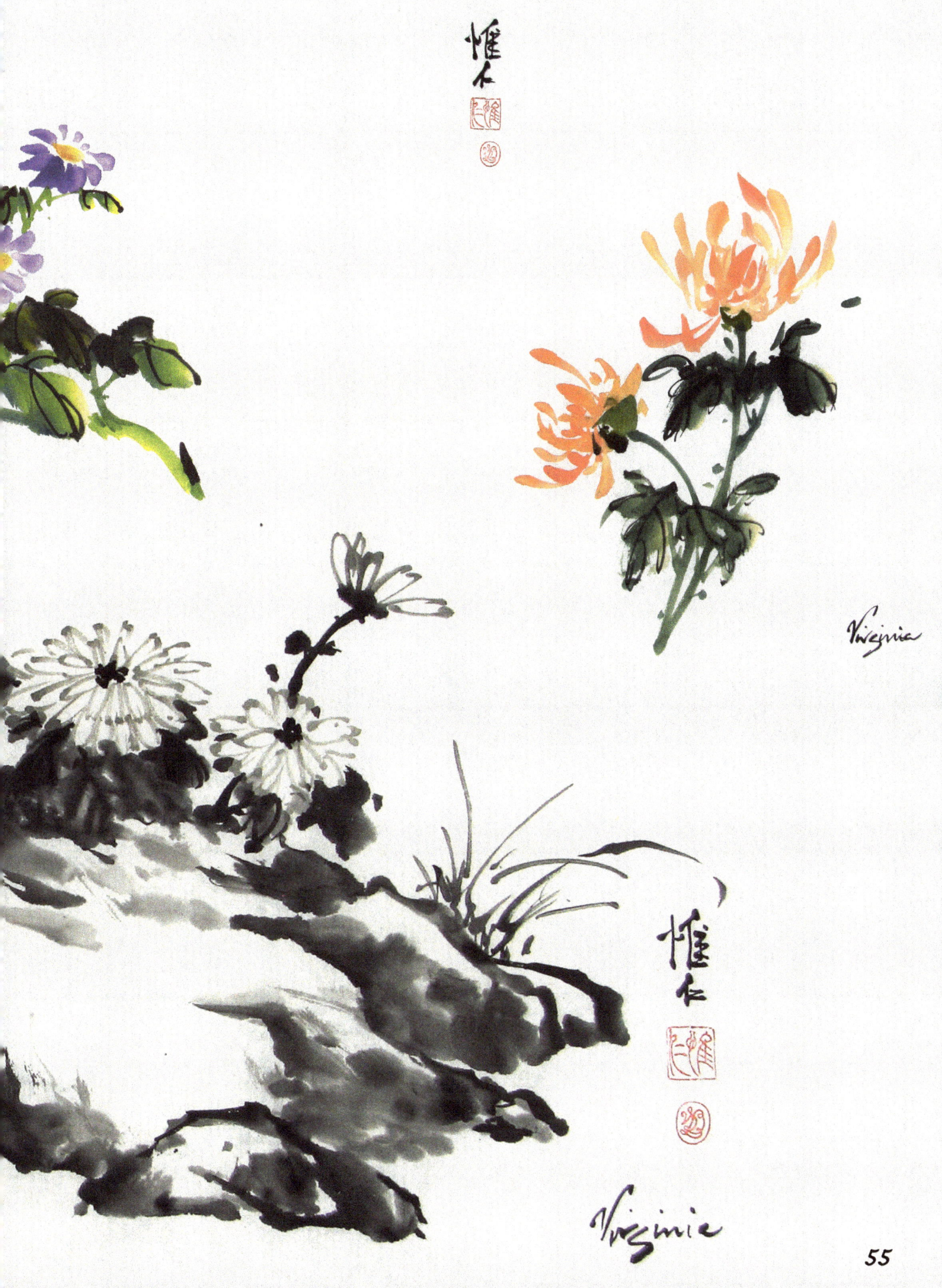

Iris

There are 200 to 300 species of iris in the world, so you may have quite a few favorites of your own! In the West, we see many varieties of bearded irises with big, showy, colorful blooms. Siberian, Japanese, and flag irises have more delicate and less top-heavy flowers. If you want to paint an elegant, understated flower, try a Siberian iris; if you prefer bold, colorful blooms and big leaves, you might try your hand at a bearded iris.

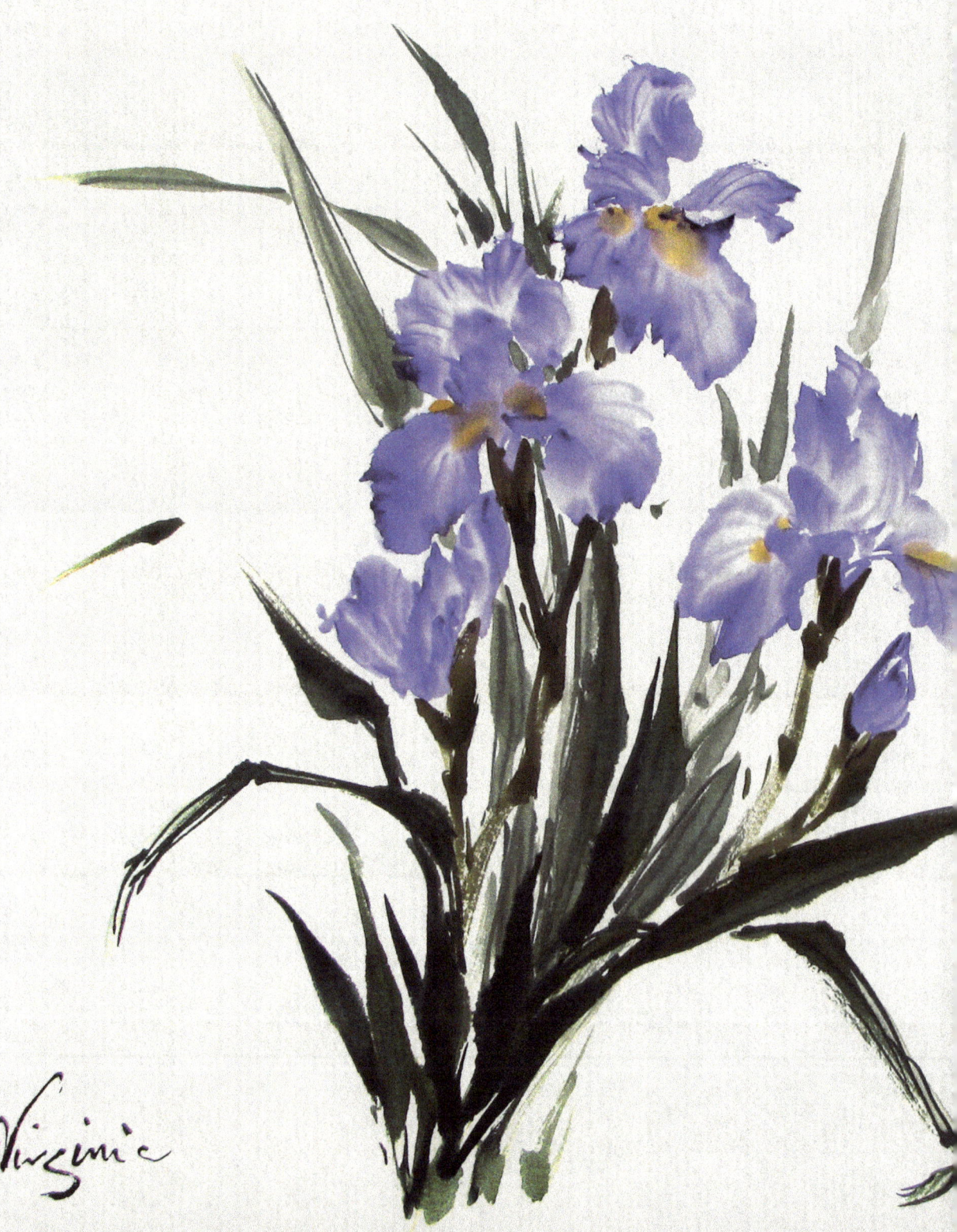

A FEW WORDS ABOUT COLOR

Some color tube sets include purple paint. If you need to mix your own purple, sky blue or cerulean blue is best, or try phthalo blue and carmine. Indigo will look duller.

Experiment with different combinations on scrap paper and choose your favorite. Remember that colors always look brighter when wet. A lighter wash color on most of your brush with a darker, more intense, and well-blended combination on the tip will give you an interesting gradation of color on the petals. Once you have created a satisfactory shade in your mixing dish, make enough for your flowers; then rinse the brush and reload it to start painting.

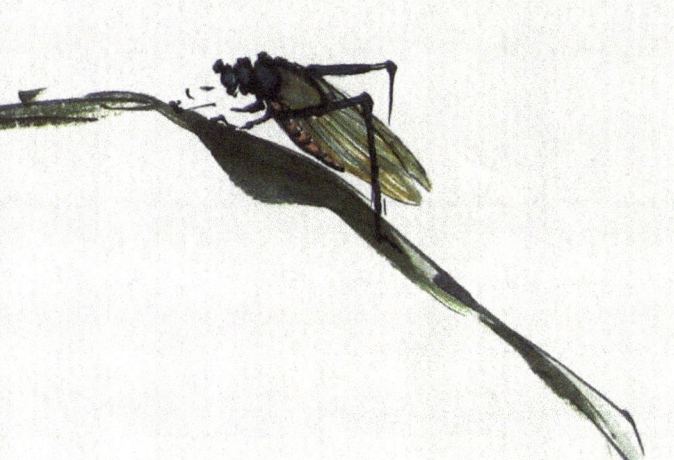

Use your small soft brush for the flowers and a bamboo/orchid brush for the leaves. For small details like the veins, use a Happy Dot brush.

Siberian Iris Flowers

With a soft brush held upright, paint the flower, starting with the short petals at the top. Make downward strokes by pressing down in the middle of the stroke and lifting. When painting the lower petals, leave space for color in the center. When the flower is damp but not yet dry, you can add the veins if you plan to include them.

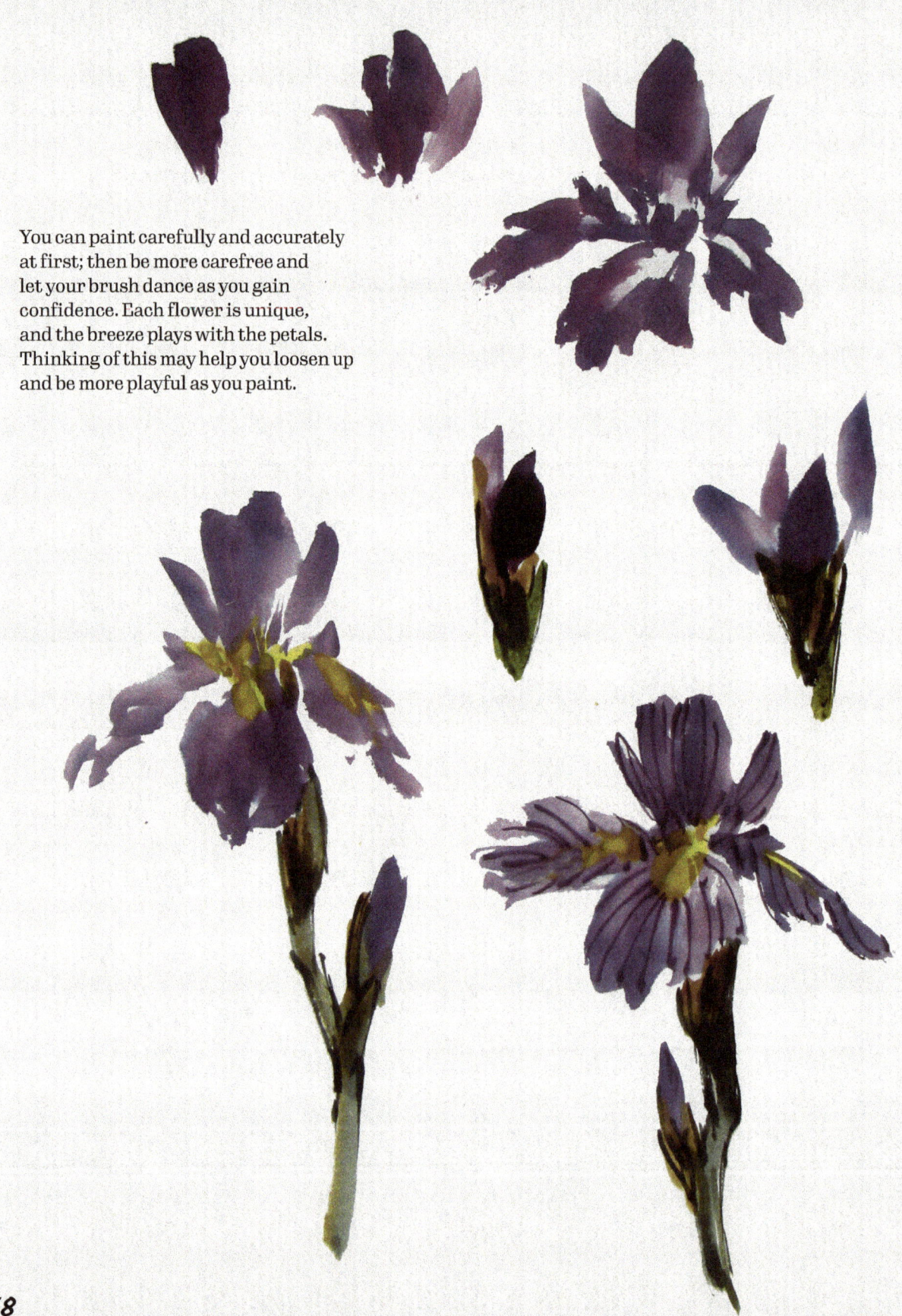

You can paint carefully and accurately at first; then be more carefree and let your brush dance as you gain confidence. Each flower is unique, and the breeze plays with the petals. Thinking of this may help you loosen up and be more playful as you paint.

Siberian Iris Leaves

These leaves grow like grasses: long, slim, and wavy. Allow them to overlap and cross to help create a sense of depth. Vary the color by adding a little black to the tip of your brush as you paint some of the leaves.

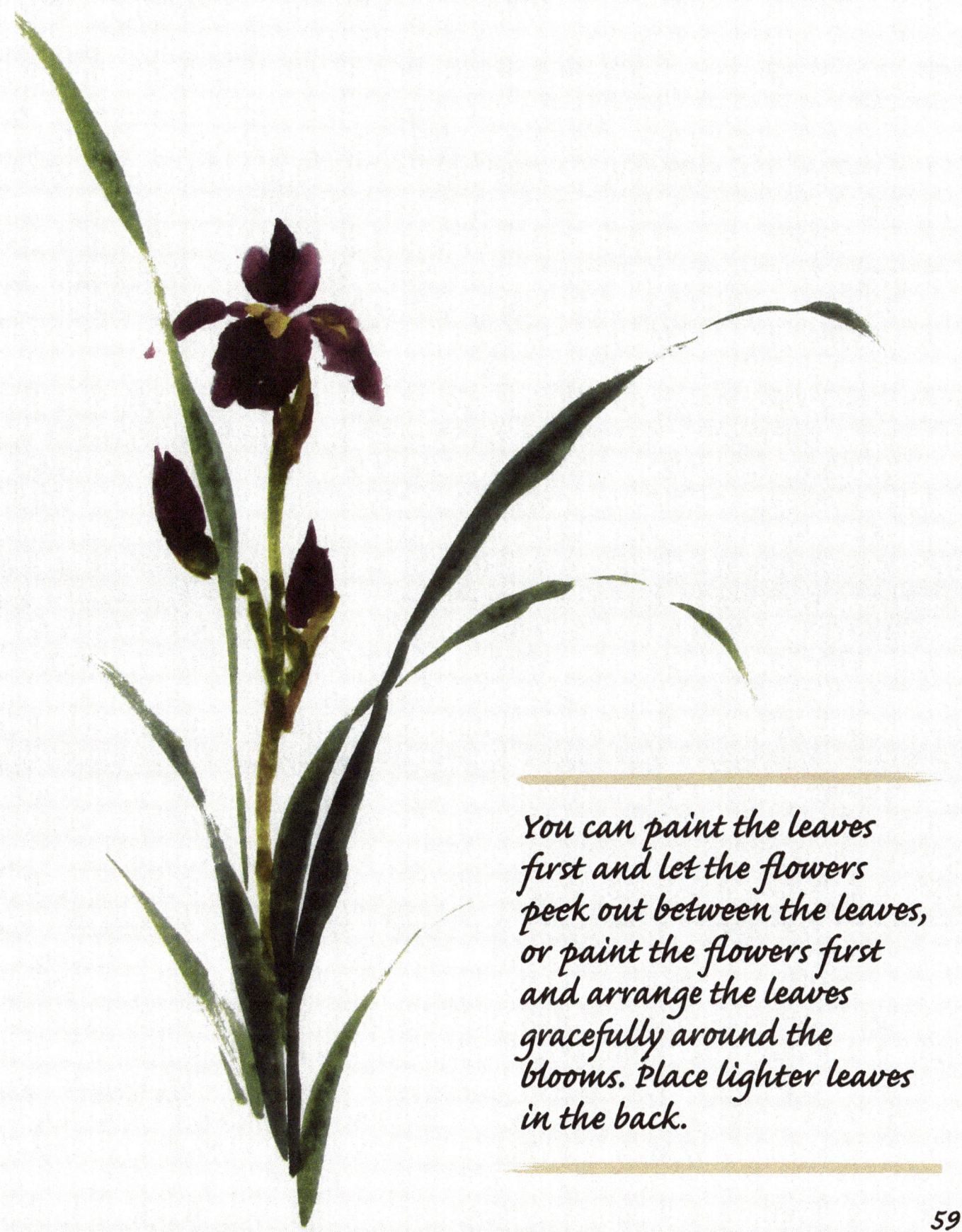

You can paint the leaves first and let the flowers peek out between the leaves, or paint the flowers first and arrange the leaves gracefully around the blooms. Place lighter leaves in the back.

Bearded Iris Flowers

1 Start with the large petal in the lower half of the flower. Load your wet brush with a light color wash halfway up; then add a darker color on the tip. Hold the brush at an angle with the tip pointing toward you, as you would for a peony flower.

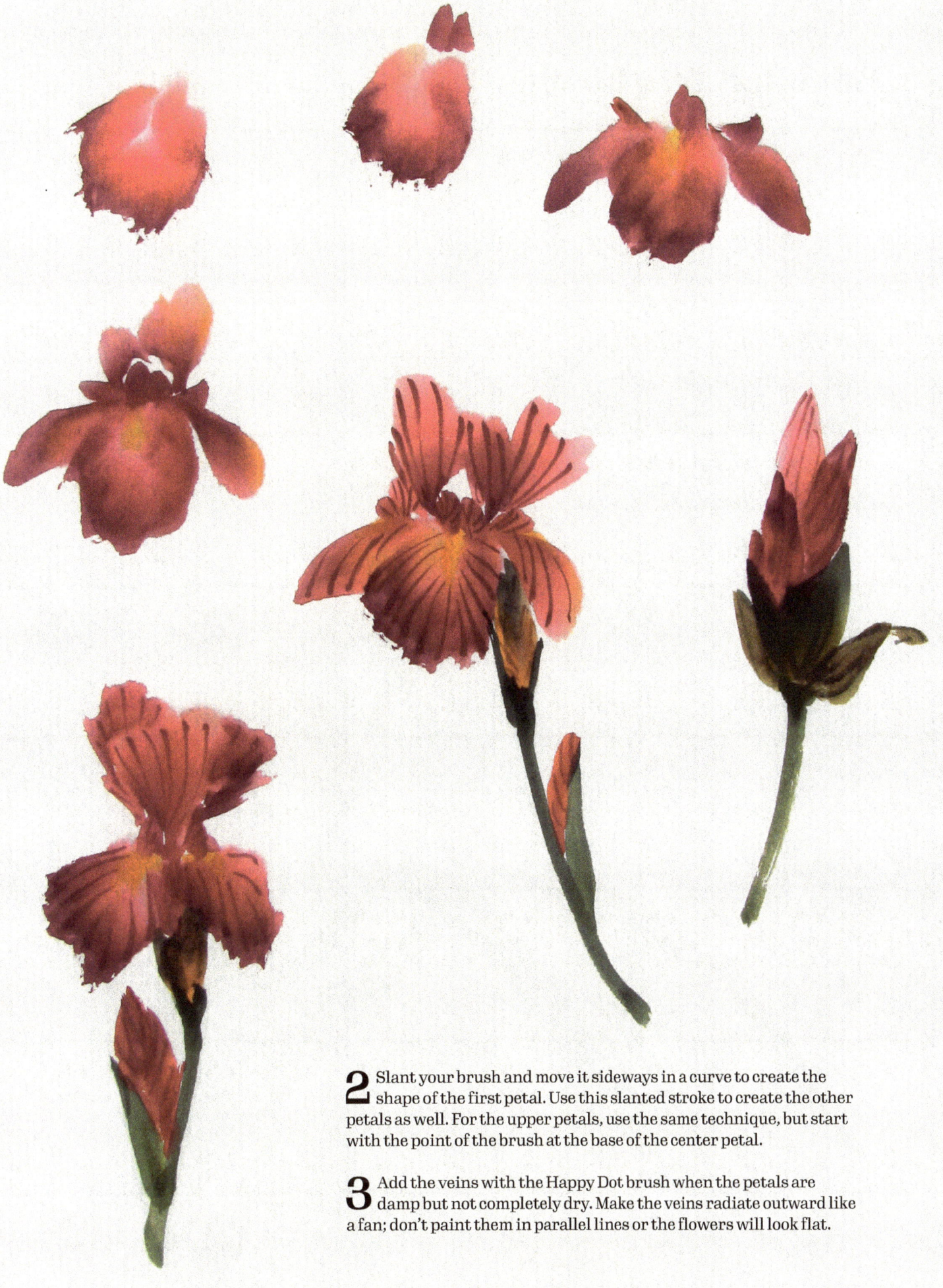

2 Slant your brush and move it sideways in a curve to create the shape of the first petal. Use this slanted stroke to create the other petals as well. For the upper petals, use the same technique, but start with the point of the brush at the base of the center petal.

3 Add the veins with the Happy Dot brush when the petals are damp but not completely dry. Make the veins radiate outward like a fan; don't paint them in parallel lines or the flowers will look flat.

Bearded Iris Leaves

Tough and leathery, iris leaves are stiff, strong, and overlap like a fan. Paint them in black and gray or black and green, with lighter leaves showing behind the flower stem to add a sense of depth. When the leaves are nearly dry, add veins in black and dark green to contrast with the pretty floating nature of the flowers.

Notice all the diagonals and triangles in this composition. Triangles emphasize the sense of three-dimensionality in a painting.

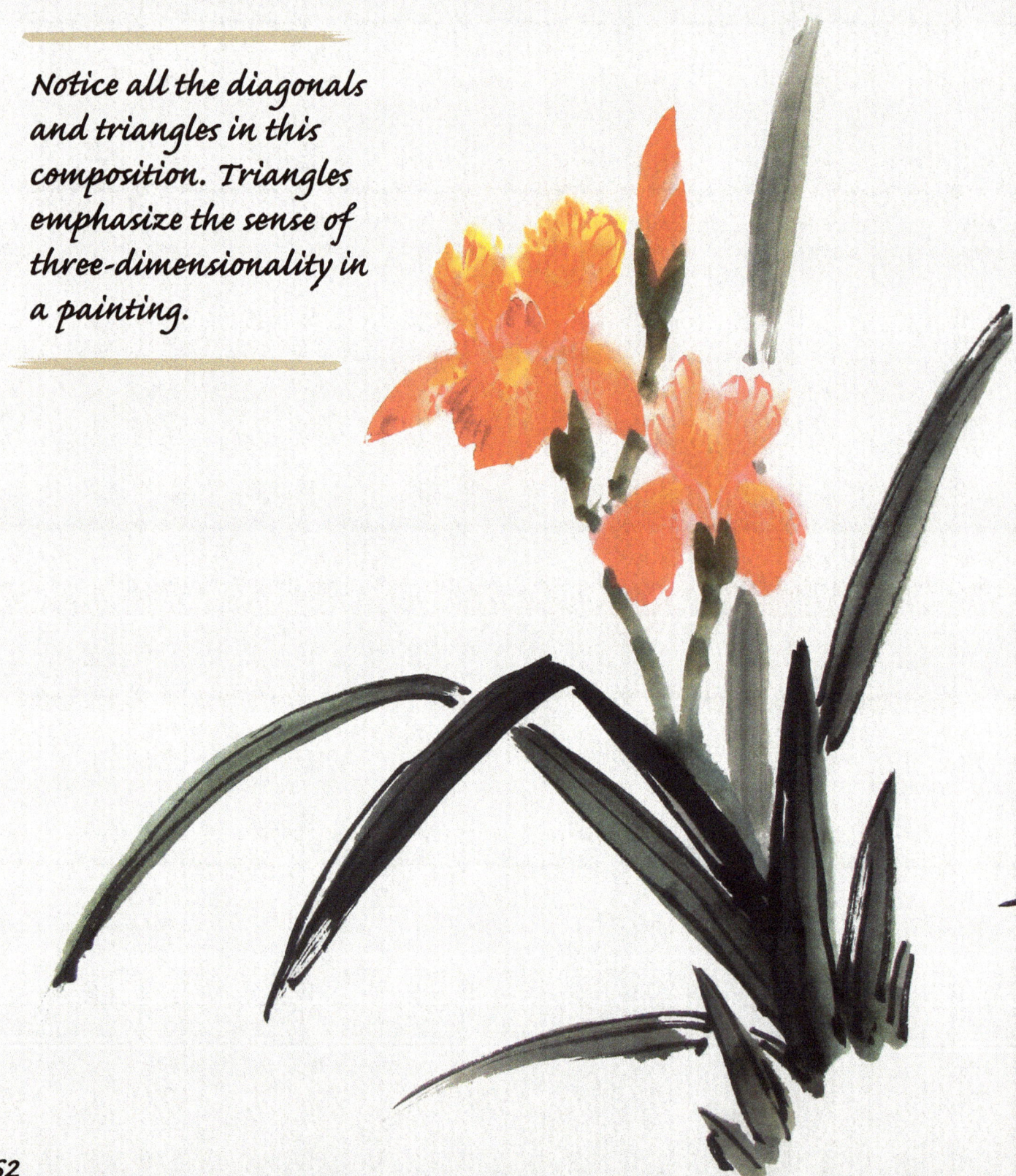

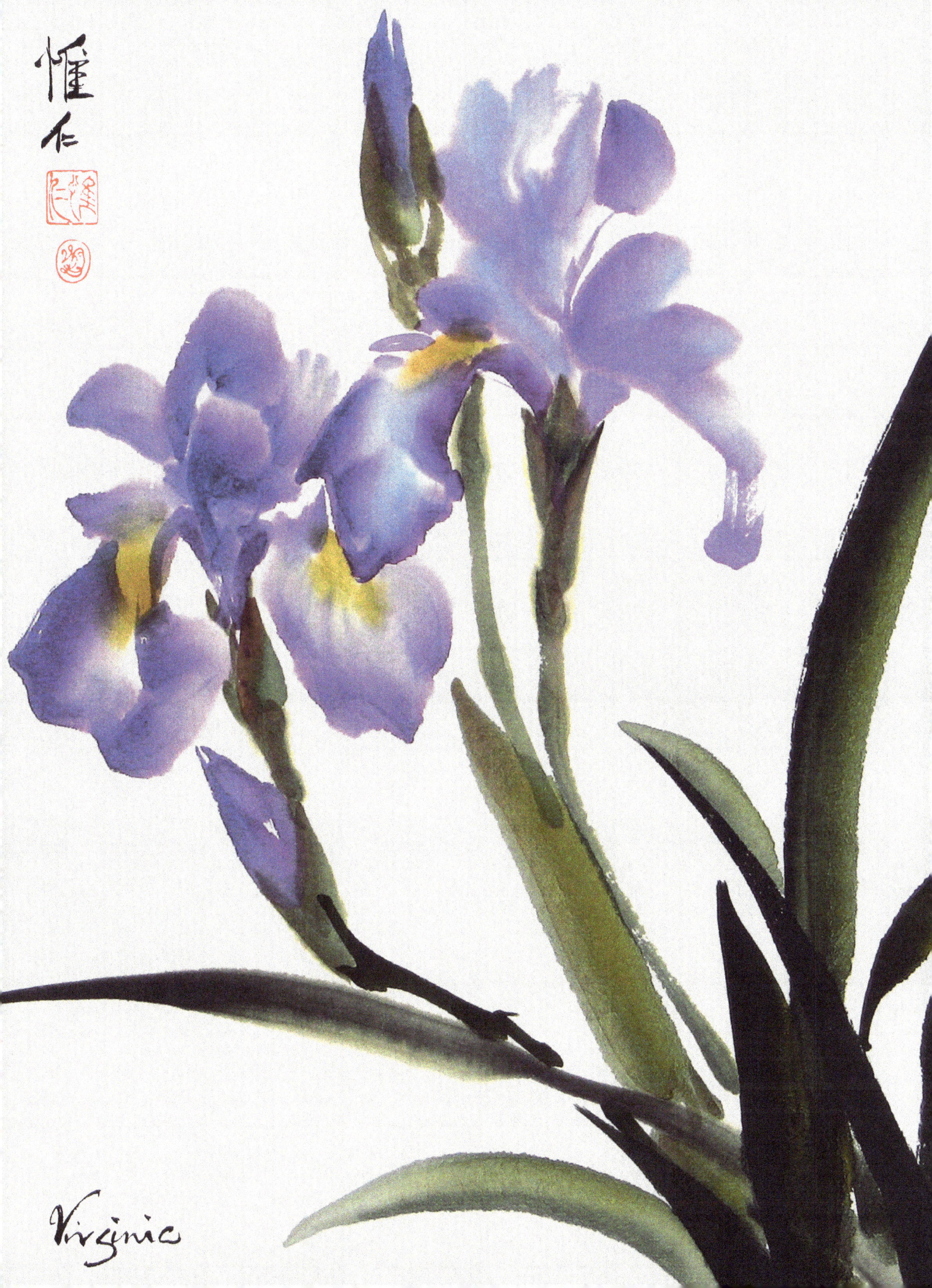

Peony

Peonies symbolize wealth and good fortune. A painting featuring a red peony and a white peony makes a lovely wedding gift.

Herbaceous peonies begin to die to the ground in the fall, only to spring back up once the frost is gone, displaying deep green leaves and red stems. Tree peonies have a woody branch structure and can grow quite tall. The leaves die back in the fall, but the branches remain.

Peonies are glorious to paint, but they are complex and require concentration. This may be a good time to remind you what Thich Nhat Hanh, the Vietnamese Zen Master and teacher writes in *The Miracle of Mindfulness*: "Always return to your awareness of the breath. If you are having difficulty in thought or action, try a deep breath and a half-smile."

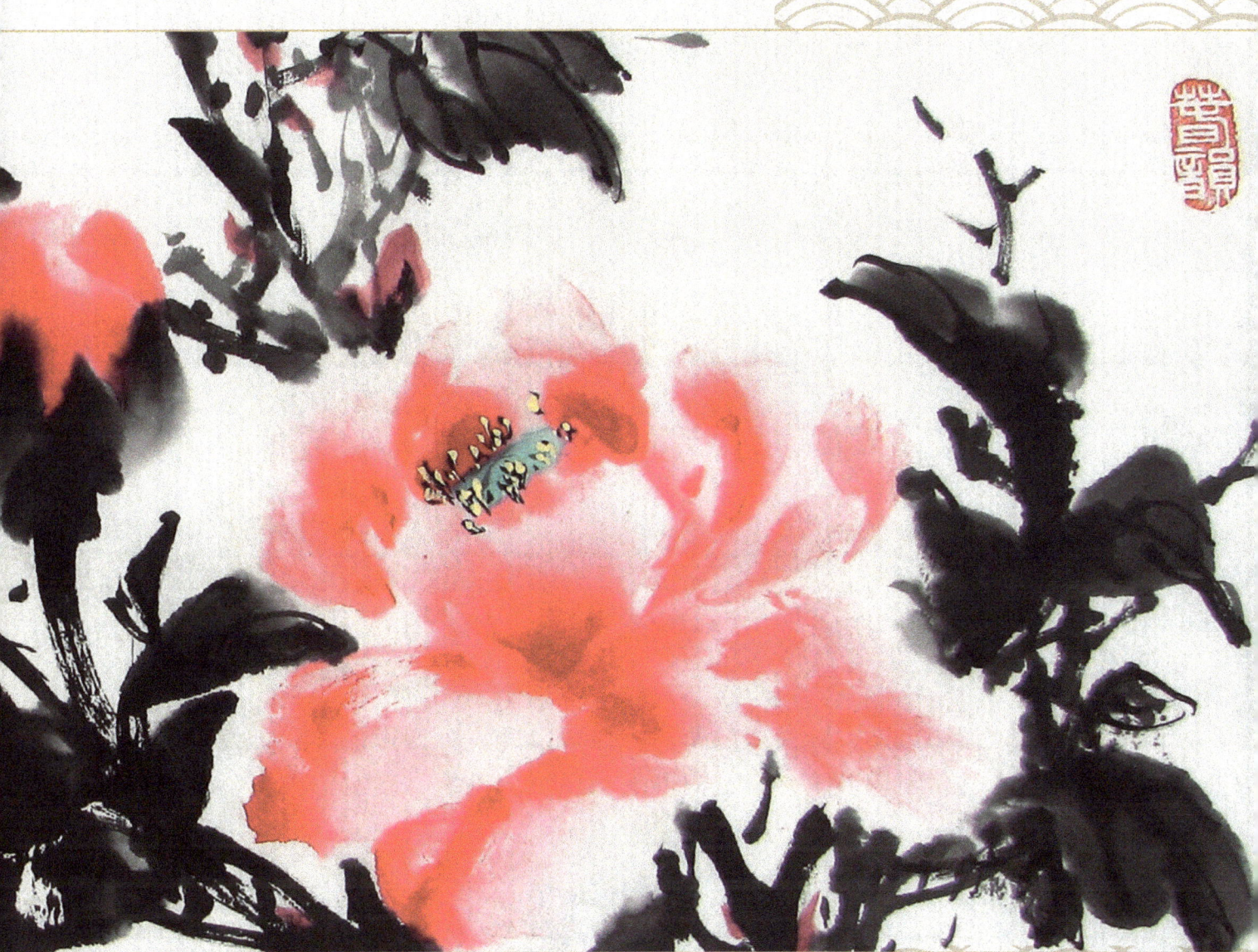

Flowers

Load a small soft brush with a dilute mixture of red one-third of the way up the wet brush, and add dark red mixed into the tip. Test your mixture by painting a side stroke on a piece of scrap paper. If you see light pink, strong red, and deep red, you're ready. If you see just one color, rinse your brush and start loading the colors again. You want to see a gradation of color in the petals.

1 To paint peonies, hold the brush at a slant while pointing the tip of the brush toward the base of the petal.

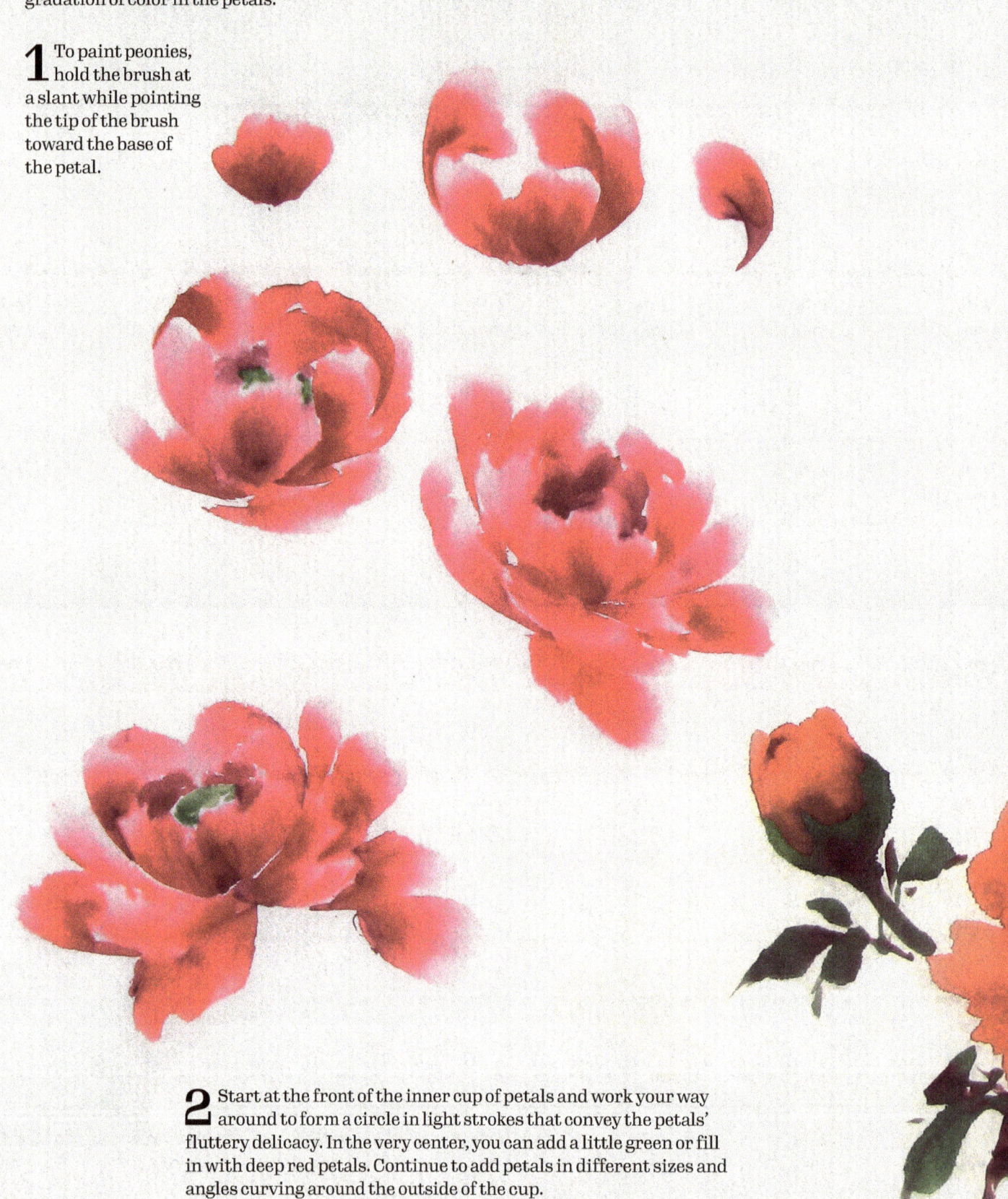

2 Start at the front of the inner cup of petals and work your way around to form a circle in light strokes that convey the petals' fluttery delicacy. In the very center, you can add a little green or fill in with deep red petals. Continue to add petals in different sizes and angles curving around the outside of the cup.

You may be tempted to keep adding petals until the flower head is massive; resist this urge and limit yourself to one or two rings of petals around the outside of the central cup. Want more color in your painting? Paint more flowers! If you paint more than one open flower, angle them differently and place one higher than the other.

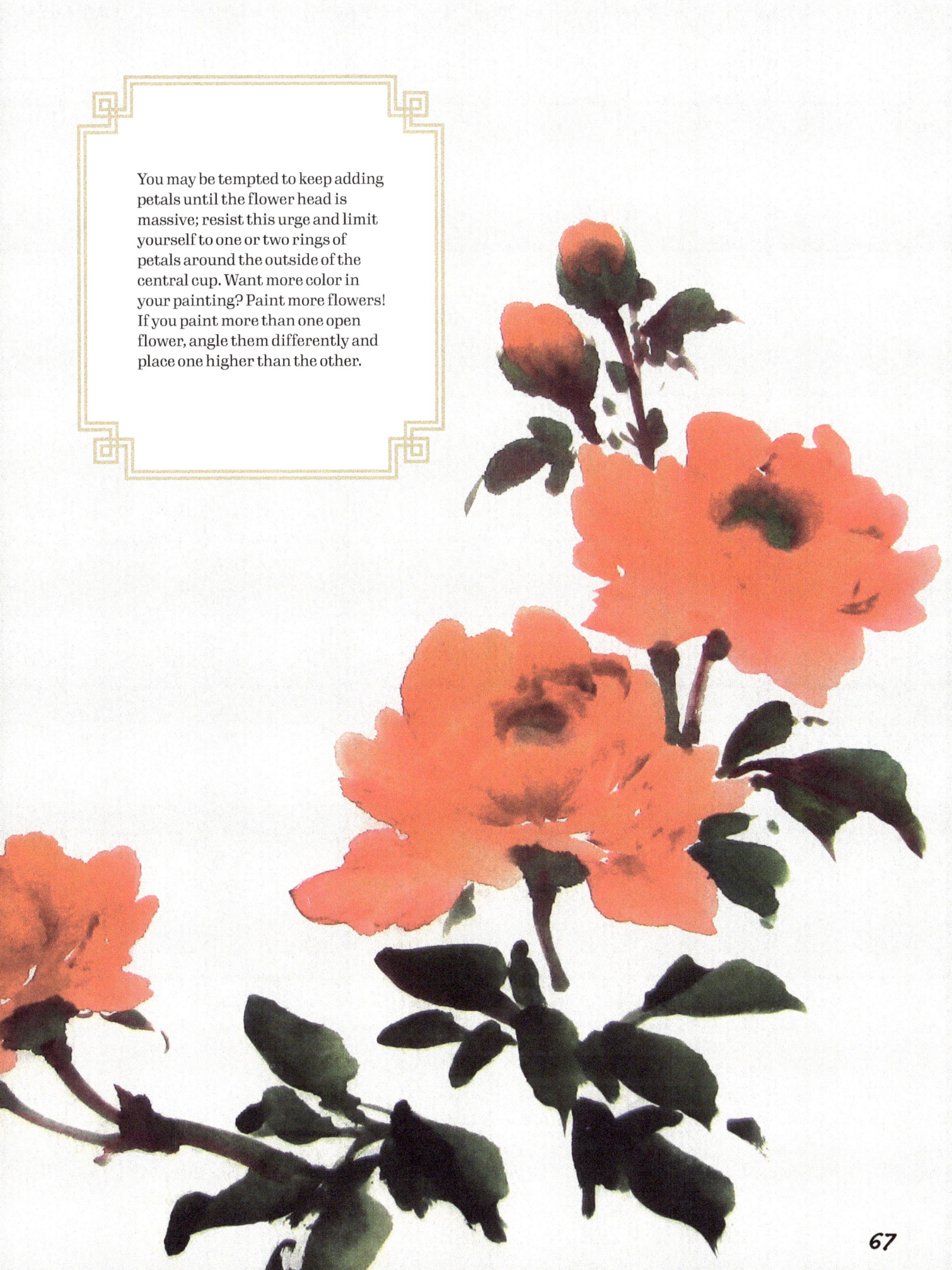

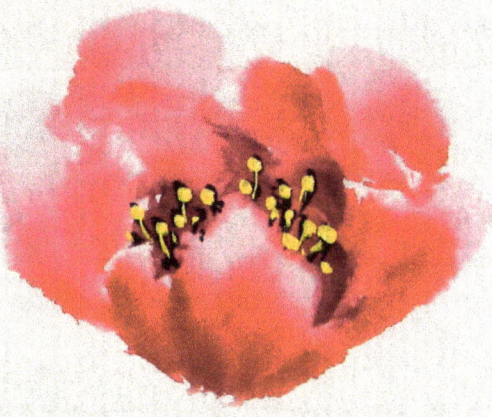

3 Buds should appear at the ends of the stems, either higher than the open flowers or on a long stem stretching to the side.

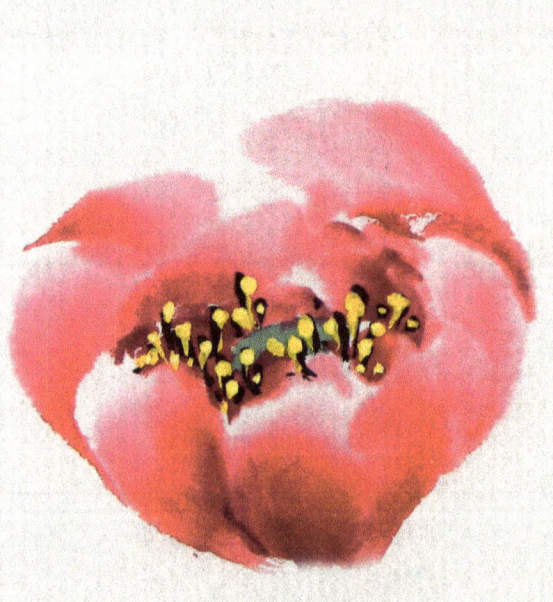

4 When the flowers are dry, add stamens using black or white mixed with yellow on top of the black.

Leaves

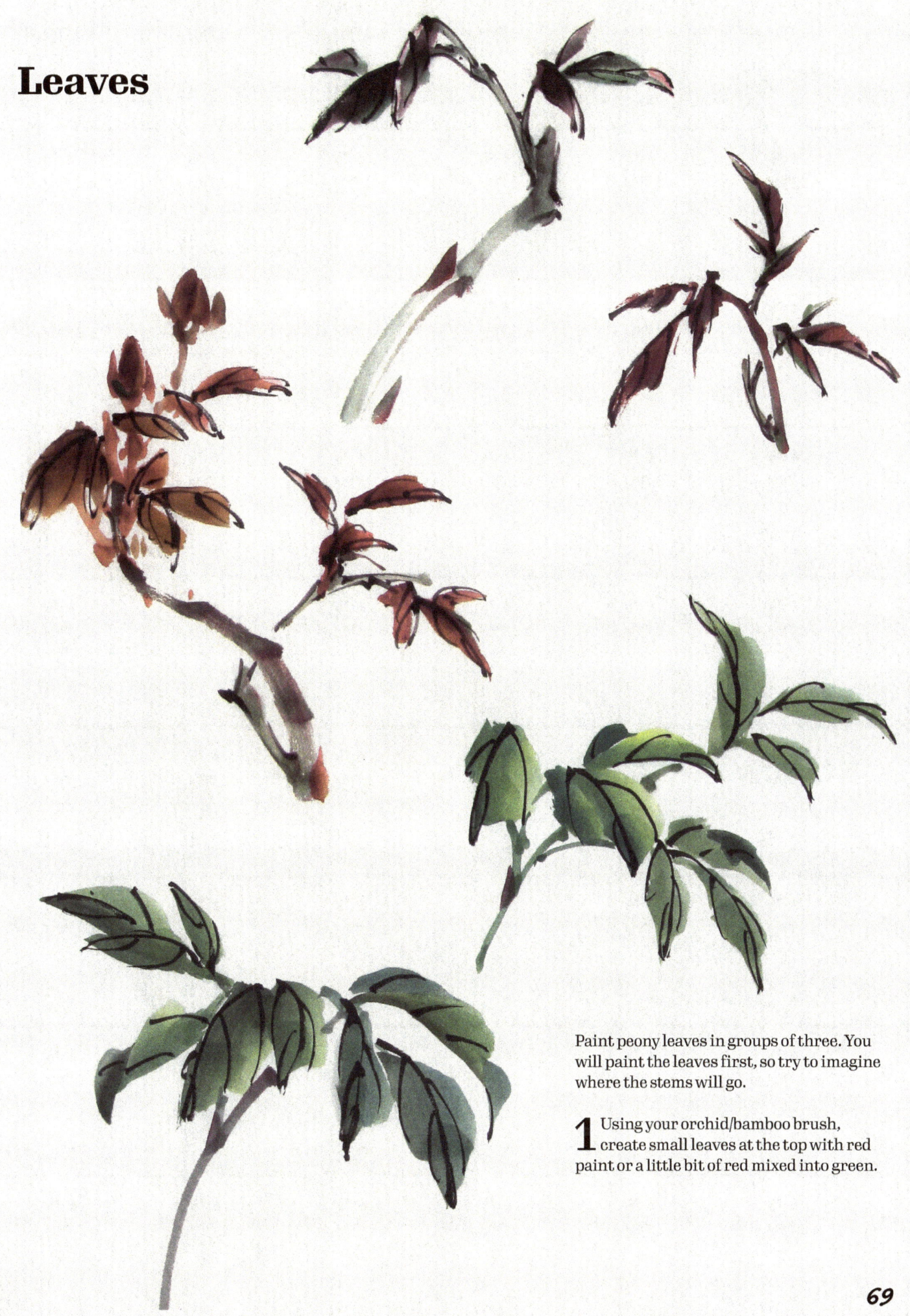

Paint peony leaves in groups of three. You will paint the leaves first, so try to imagine where the stems will go.

1 Using your orchid/bamboo brush, create small leaves at the top with red paint or a little bit of red mixed into green.

69

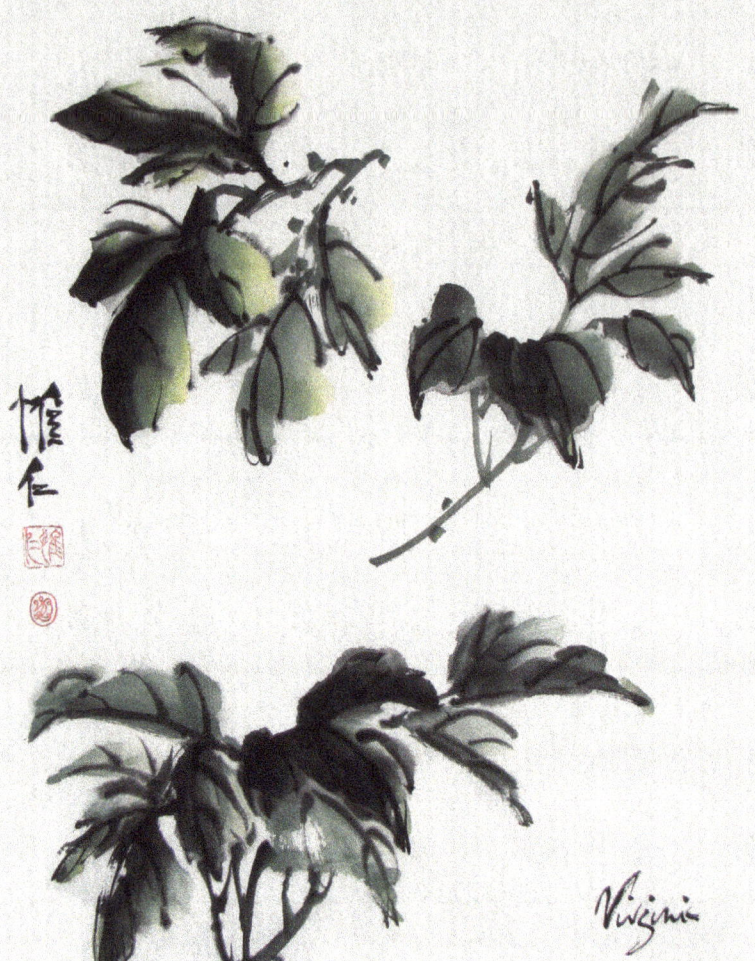

2 Older leaves in darker green with black blended at the tip create contrast in the plant. You can also add black leaves for more dramatic contrast. Let your brush dance around the page, sometimes holding it at a slant and sometimes perpendicularly. When the leaves are damp but not dry, add veins in red on the younger, lighter leaves, and use black or a mixture of red and black for the older, darker leaves.

Stems

1 For the stems leading from the buds, use red or green mixed with a little red. Holding your brush vertically, paint the leaves first and then the stems. Paint the larger stems for the open flowers in green or light brown, with woody stems at the bottom in brown or black. Start painting stems from the flower end, and paint toward the root. Add smaller stems to link the leaves to the main stems.

2 If in some areas the stems look bare or less graceful than you'd like, add a few extra leaves using light green, gray, or brown behind the stems—but don't fill up the space. Remember that your composition is made up of strokes and air, and your strokes need room to breathe too.

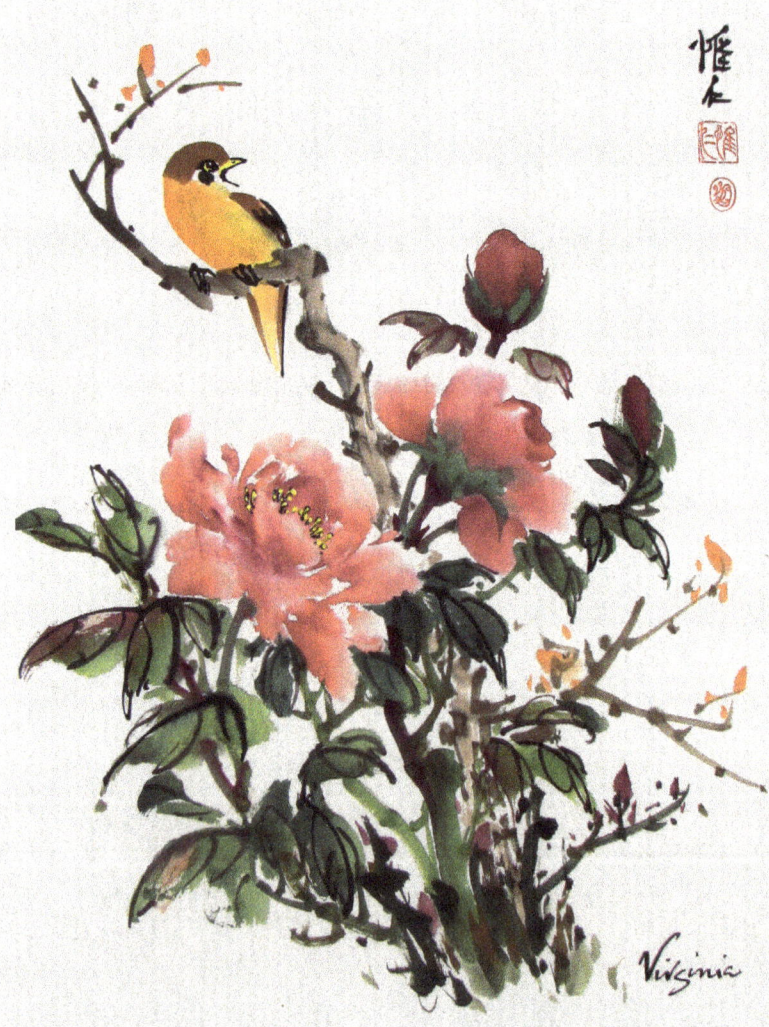

Peony Painting Progression

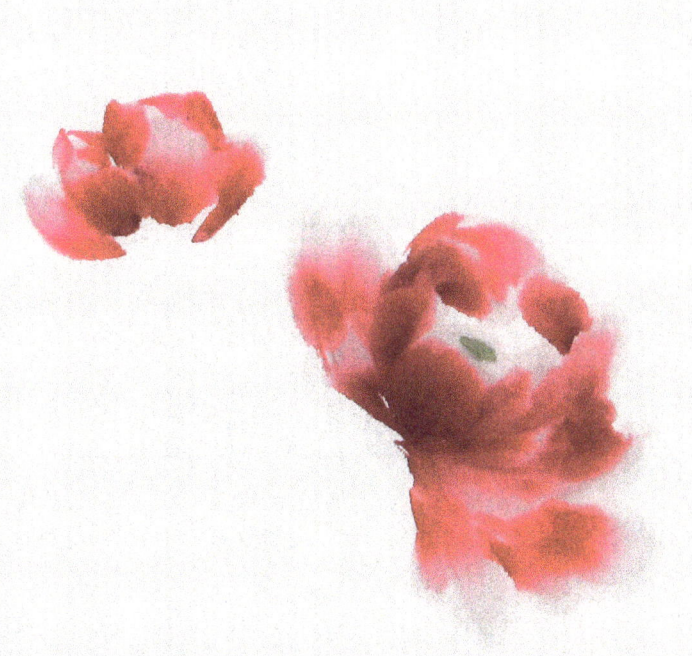

1 Start with the largest flower (the "host"); then add different-sized buds ("honored guests"). Notice how they form a triangle, with the buds on the right higher than the open flower. The colors look deep and intense because they are wet. They will soften and lighten as the painting dries, so keep this in mind when selecting the intensity of your paint colors.

2 Place groups of leaves relative to the flowers and buds.

3 Fill out the groups of leaves and add stems down from the flowers and buds to the leaves, angling toward the root area. Notice how the triangle effect is still maintained.

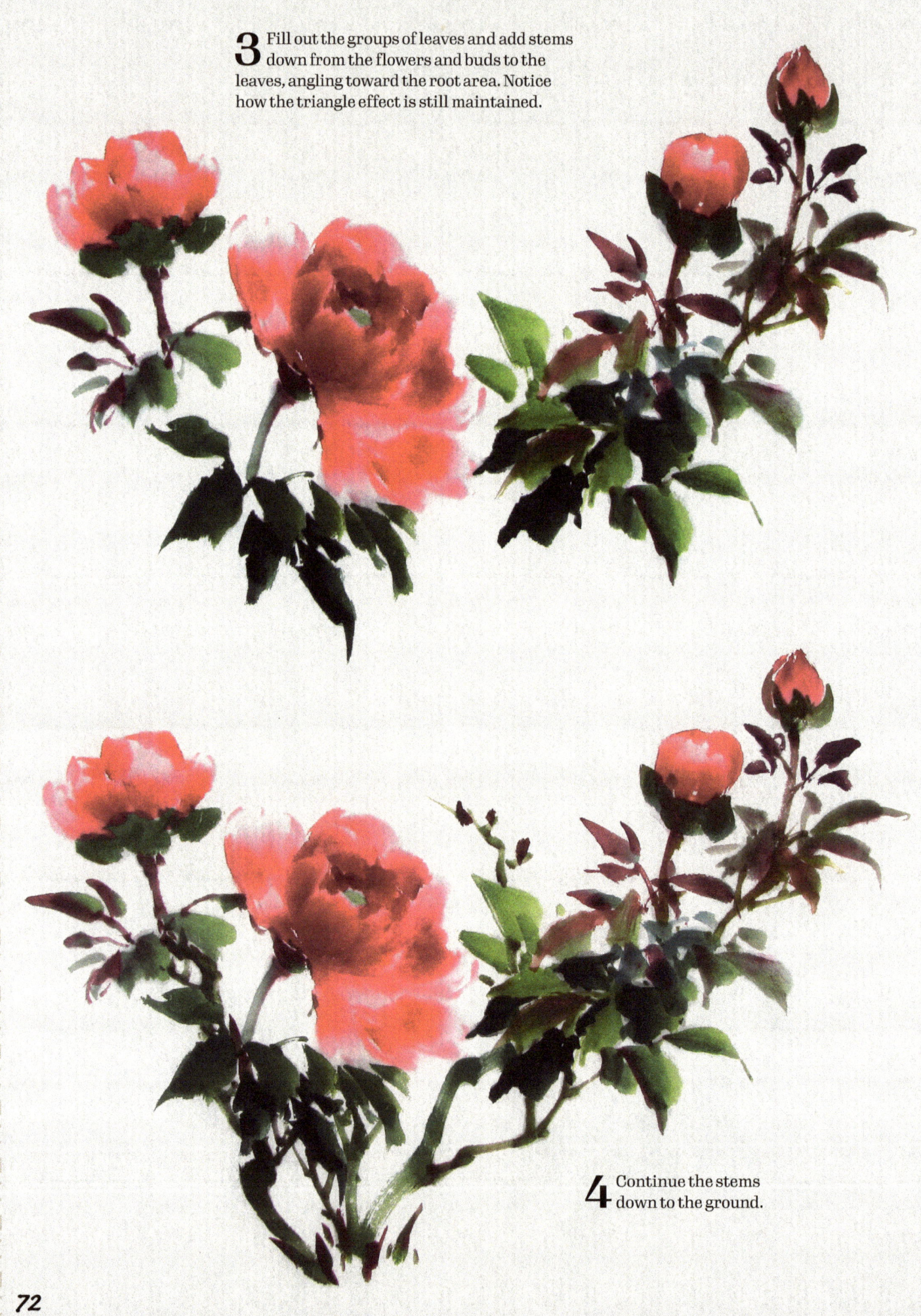

4 Continue the stems down to the ground.

5 Add veins once the leaves are damp but not dry; then paint a butterfly to continue the upward motion on the right. Notice how the butterfly forms a triangle with the buds on the right.

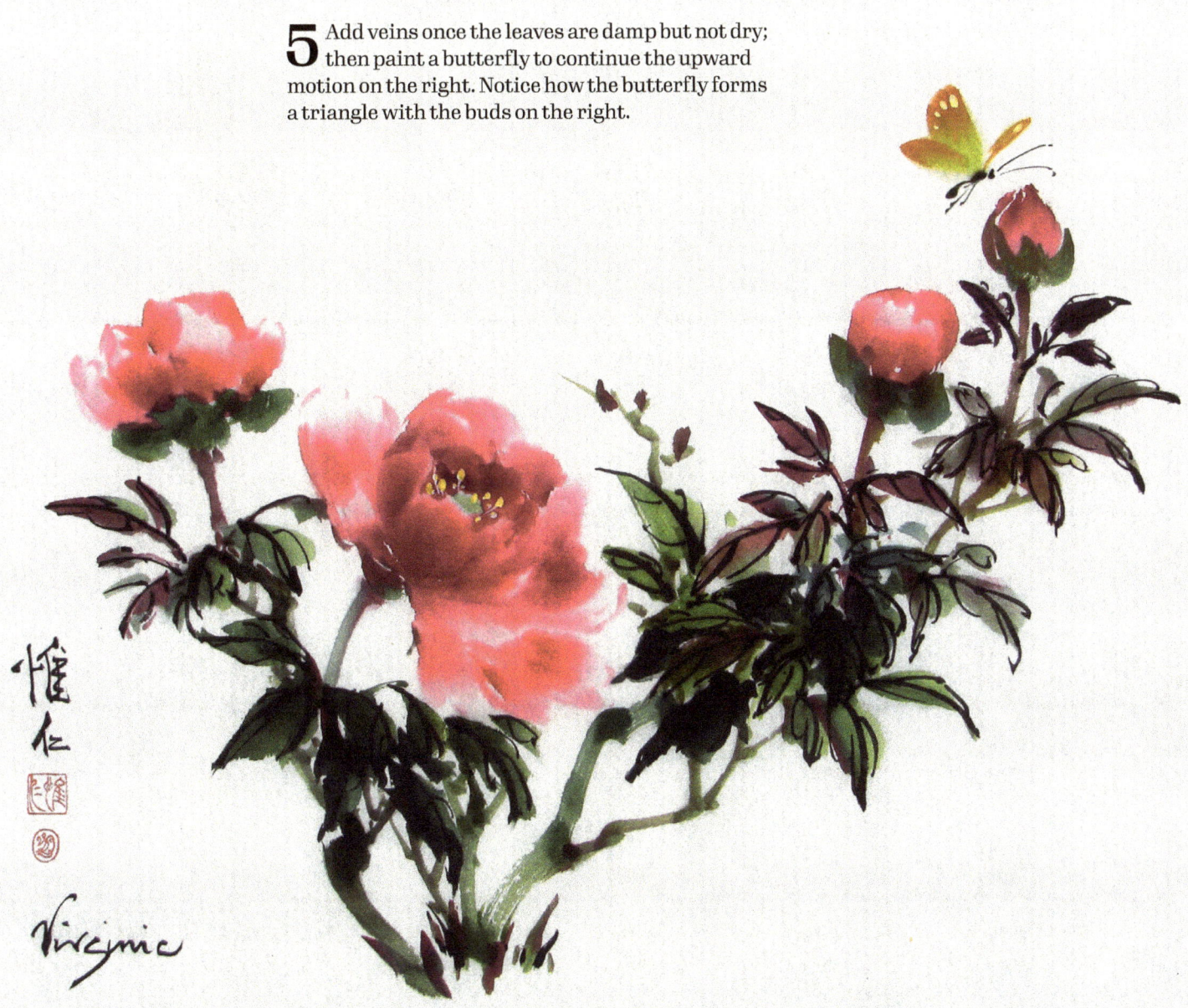

Insects

Like birds (pages 102-113), insects can add vitality and movement to a painting. You might use them to extend your composition by placing a few bugs at the tip of a flower, or you can create a focal point in an area of open space. Some schools of Asian painting create exquisitely detailed insects, while others, like sumi-e, emphasize the idea and gesture, rather than realistic accuracy. I recommend studying photos of insects so that you understand how they are formed while thinking of the dance of the brush as you paint them.

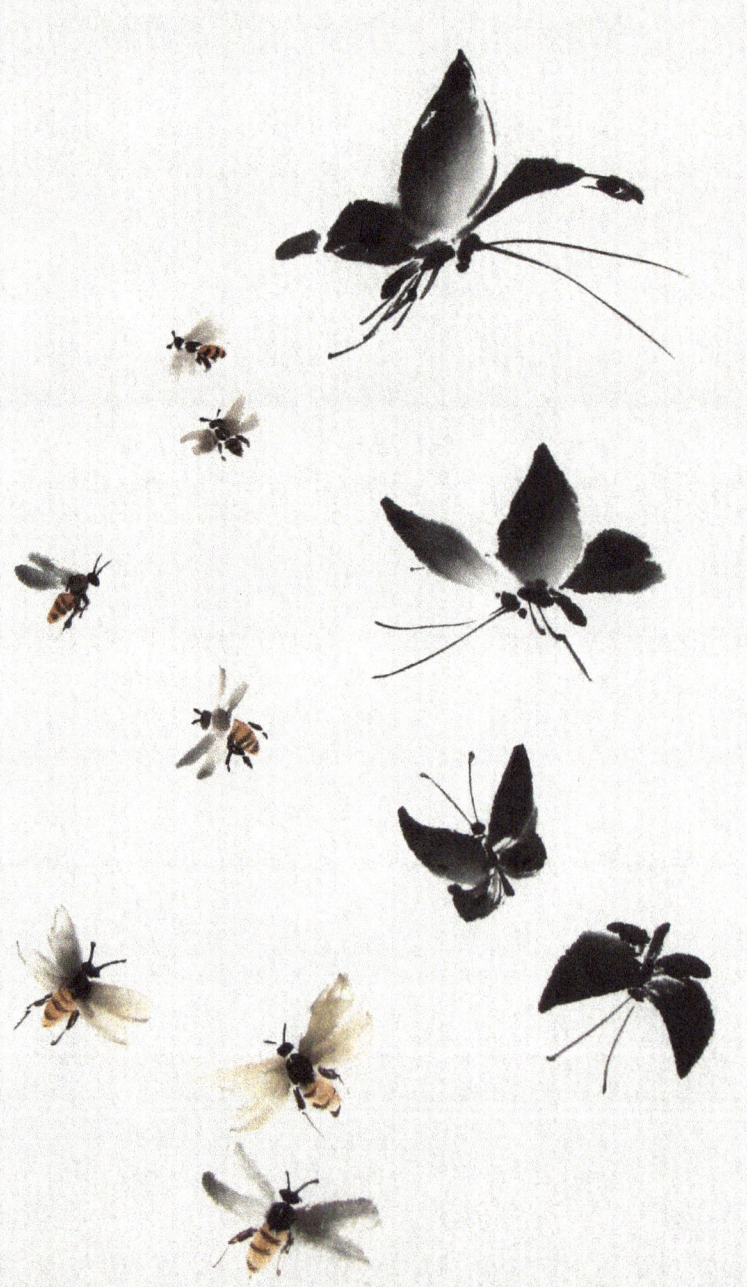

Butterflies

You can paint butterflies in two different styles: boneless quick-stroke and outline.

BONELESS STYLE

Using a small soft brush, load a light color wash halfway up, and then blend a darker color at the tip. First paint the wings in three quick strokes; then add the body. Add the antennae and legs in black with a pointed Happy Dot brush.

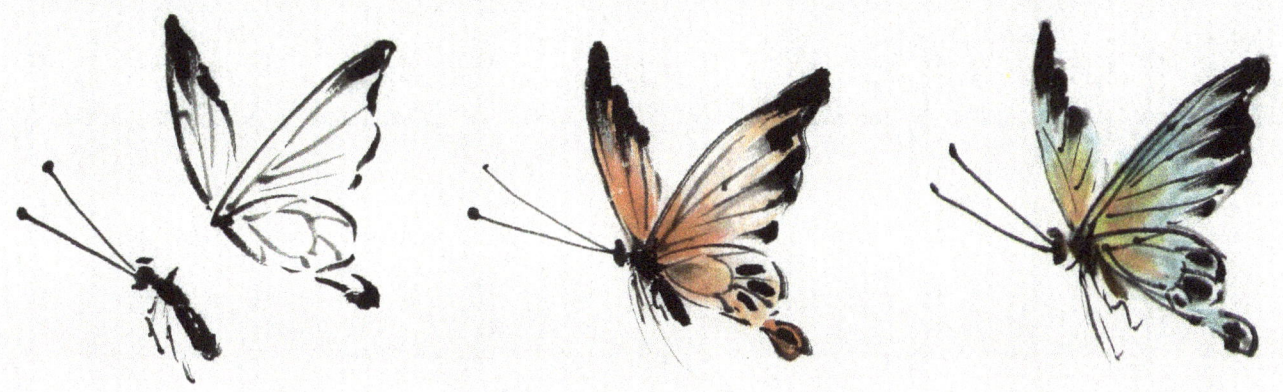

OUTLINE STYLE

Load gray onto a fairly dry Happy Dot brush; then paint the outline of the butterfly wings and add the body. Once the outline is dry, add color.

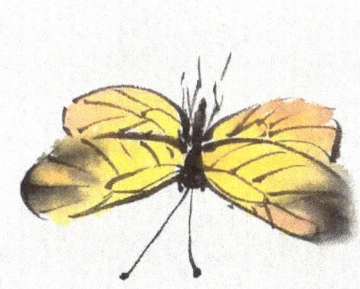

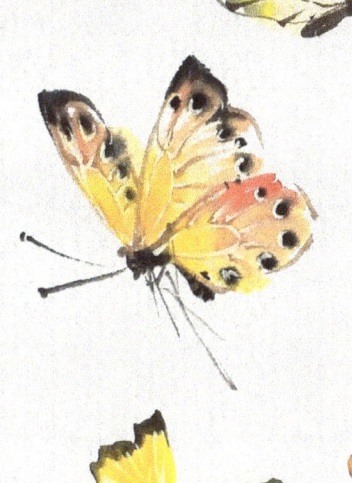

If you find it helpful, you can draw the shape of the butterfly on a sheet of paper; then trace over it onto your painting paper.

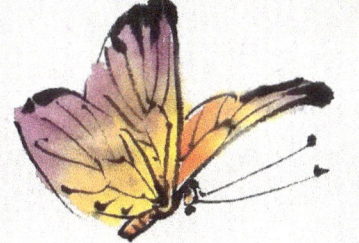

Bees & Dragonflies

First, paint the head and body; then add a light wash for the wings after testing the color on a piece of scrap paper. Finish with the antennae and legs, and add details to the wings after the wash dries.

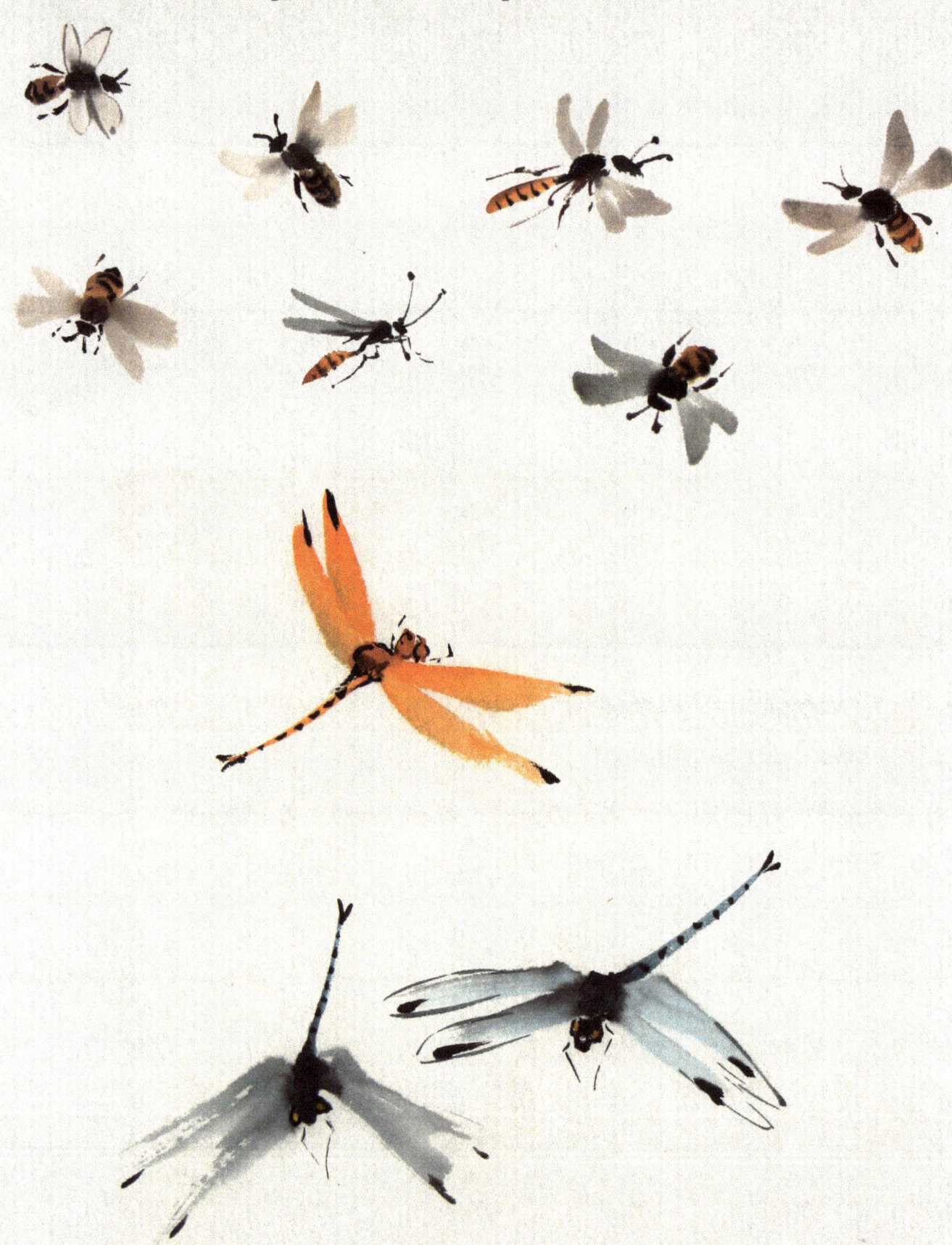

Praying Mantis & Grasshoppers

Start with the head and the body; then add the legs. The front pair angles forward; the middle pair goes to the side. The back legs tuck close to the body or stretch across to another leaf. Again, finish with the antennae.

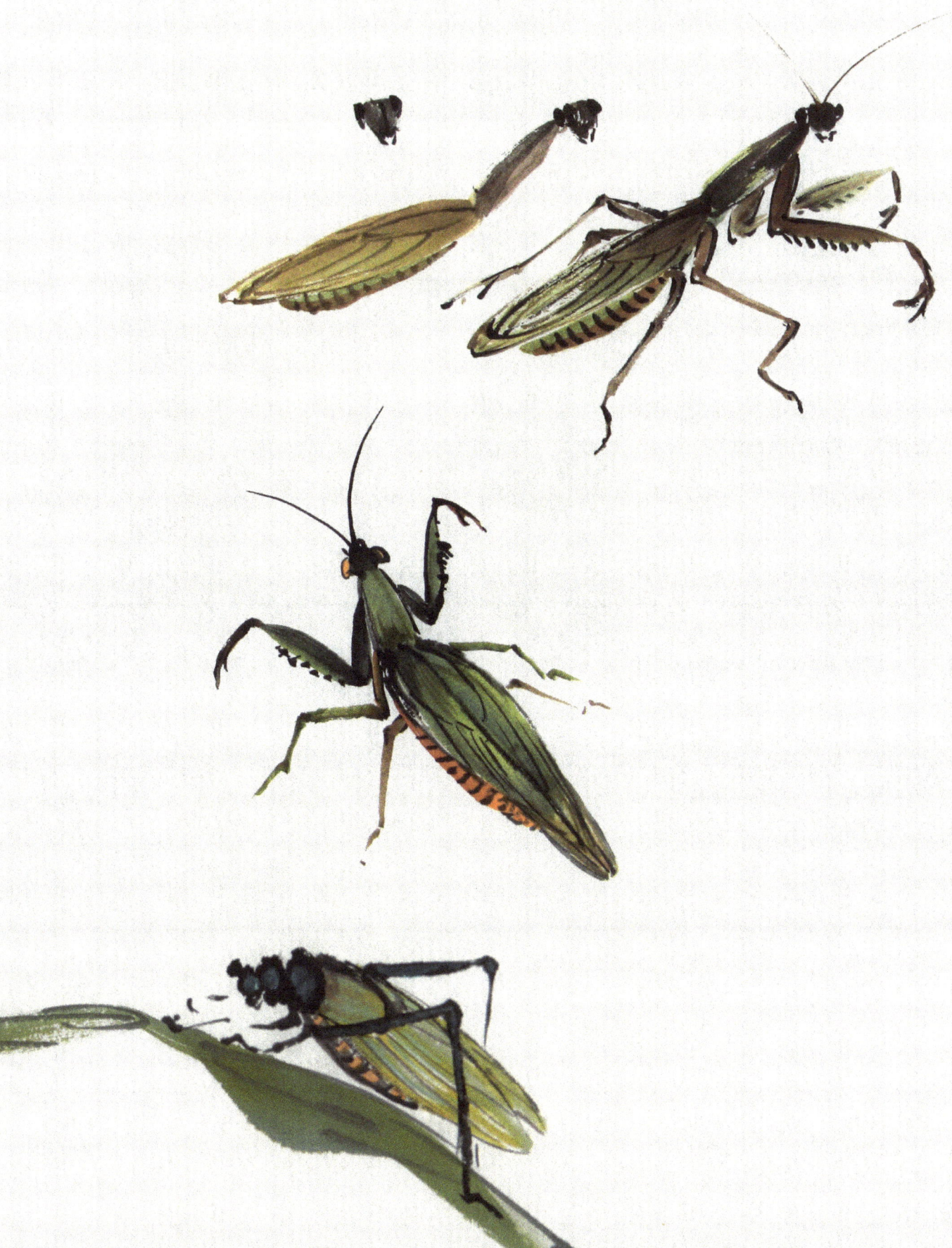

77

Wisteria

Wisteria is a vigorous climbing vine. You can find wisteria flowers in a range of colors, including lavender, white, pink, and violet. Some artists like to make their flowers quite detailed, showing the oval top petal and the lower, darker "beak," while others choose to paint in the quick-stroke impressionistic style that I've featured in this book.

Flowers

If you've already completed the iris project (pages 56-63), you may have found a purple color combination that you like. For this wisteria, I used carmine, blue, and purple. It's best to use more than one color and mix on your dish so that you feature a variety of hues in your flowers.

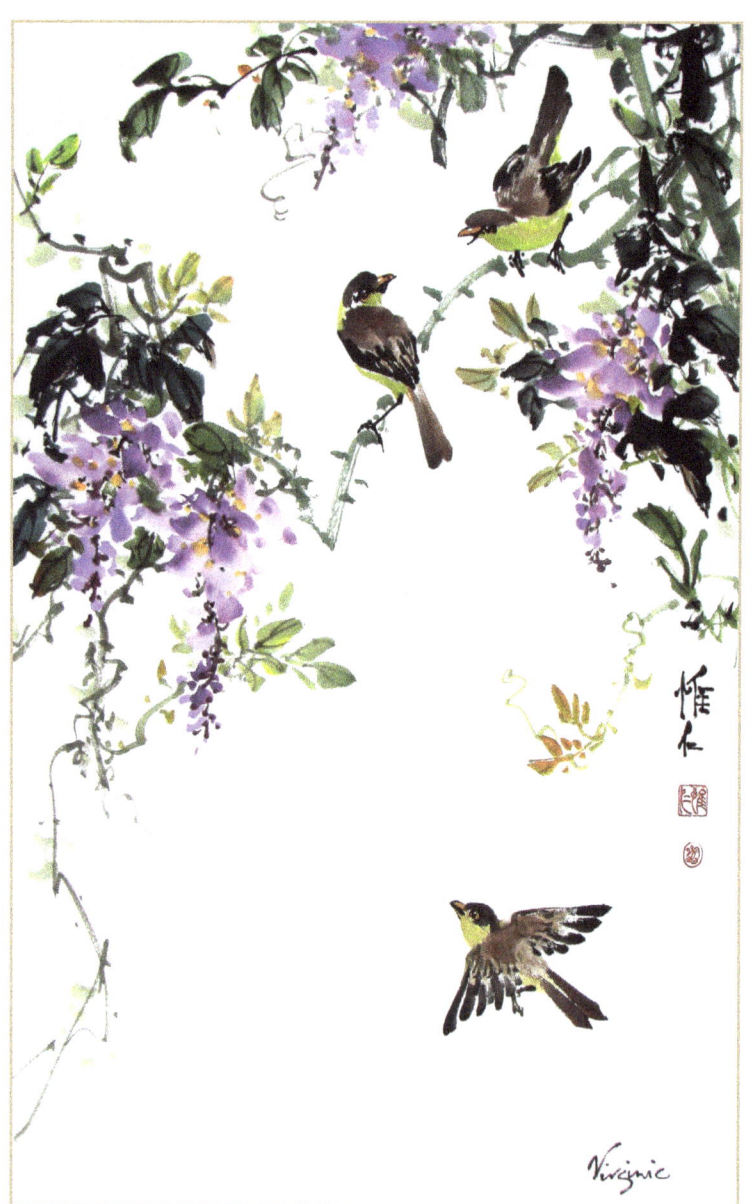

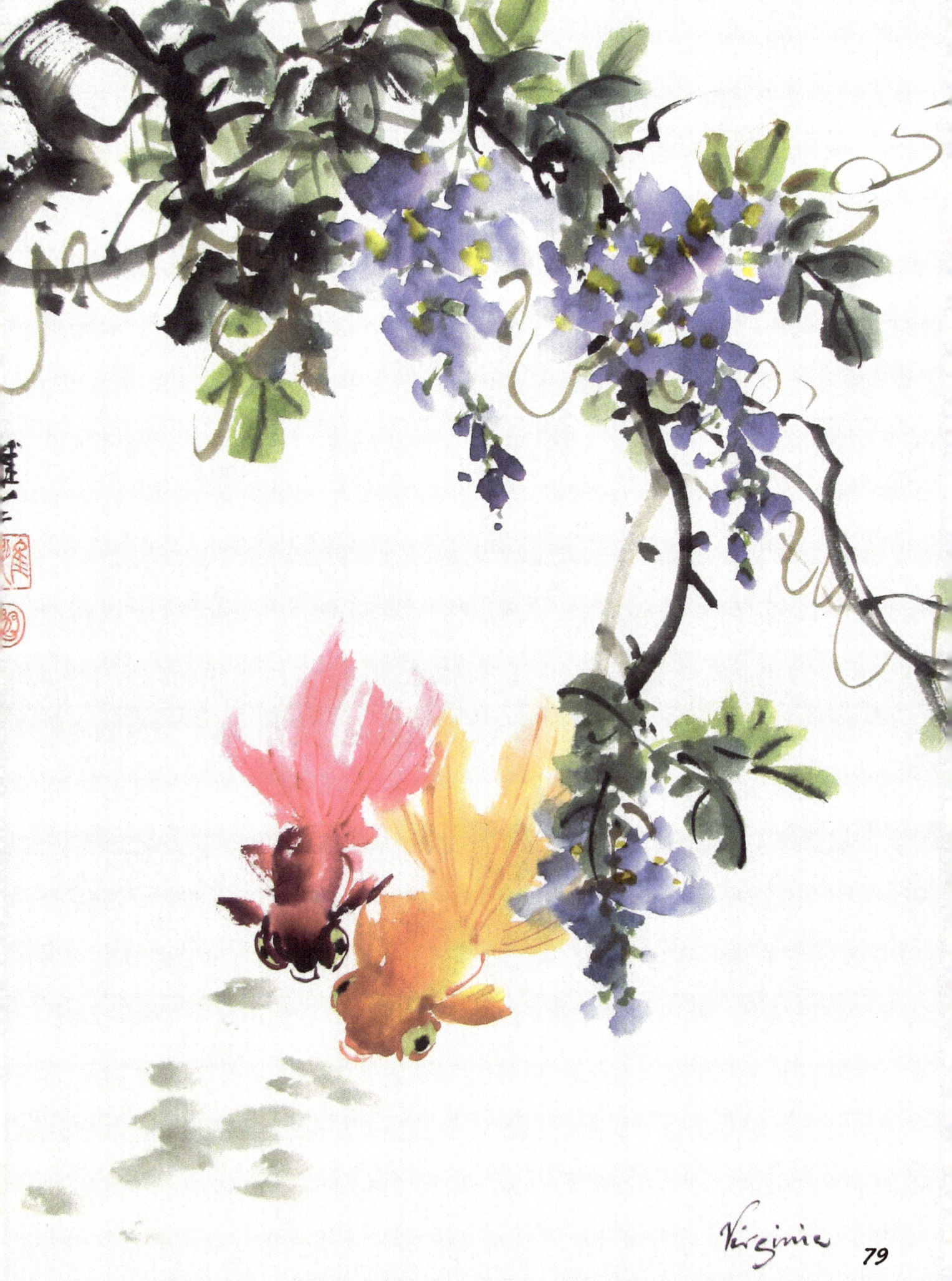

1 Wet a small soft brush, add a light shade of purple halfway up; then blend a darker color at the tip. Start at the top of the flower cluster and work your way down using a flicking check mark stroke, varying the size, lightness, darkness, and direction of each flower. When you reach the small, dark buds at the bottom of the cluster, leave some spaces down the middle for the stems.

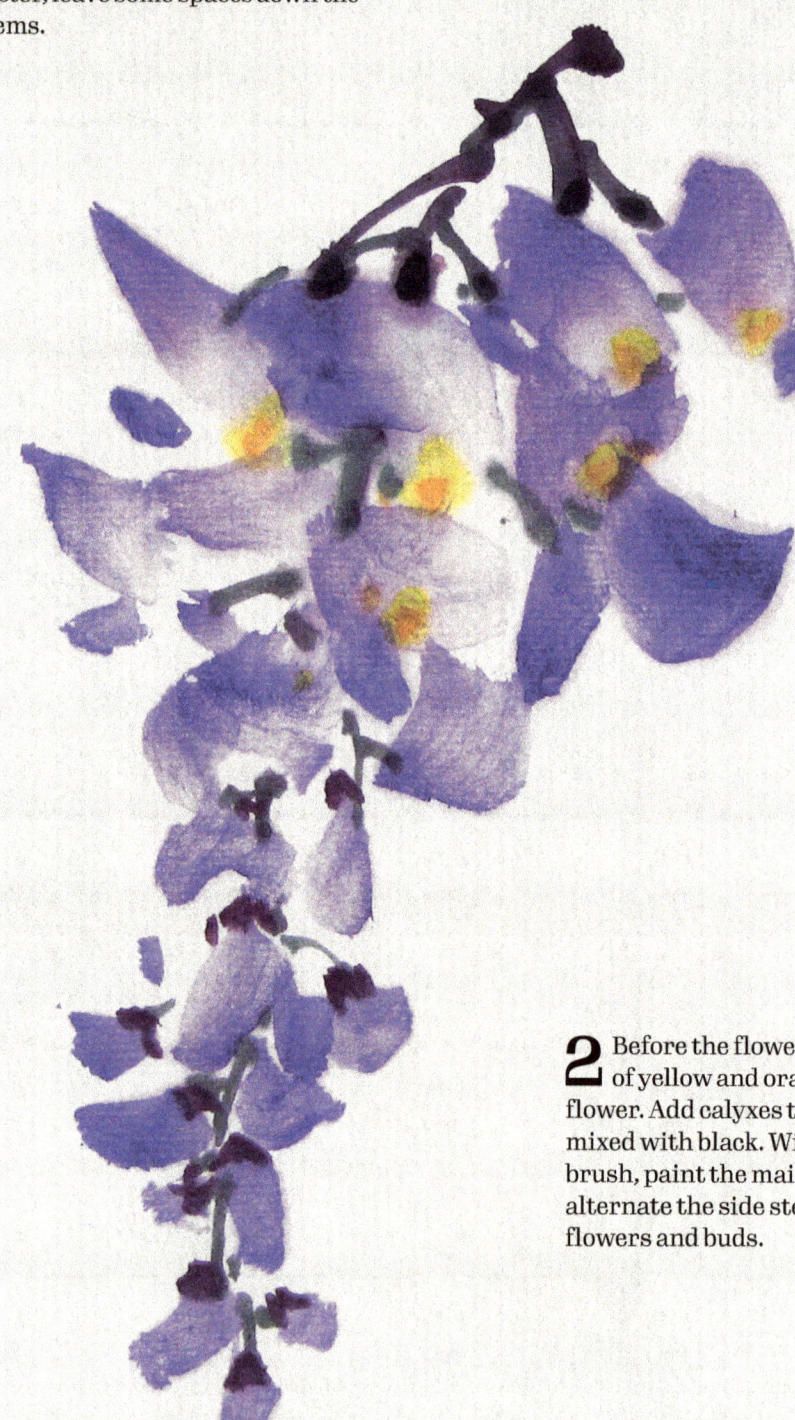

2 Before the flowers dry, add a dilute touch of yellow and orange at the center of each flower. Add calyxes to the buds using rouge mixed with black. With green on a Happy Dot brush, paint the main stem from the top and alternate the side stems, angling toward the flowers and buds.

Leaves

You may find it helpful to paint some center stems first in light green, arching and crossing like orchid leaves (pages 32-33). Using the orchid/bamboo brush loaded with a mixture of yellow, blue, and a tip of black, add the leaves, starting with the leaf at the tip. Fill in the group with extra leaves in lighter green or black. Paint the young leaves with light green and a little orange, and make sure to paint the leaves in groups rather than randomly scattered throughout.

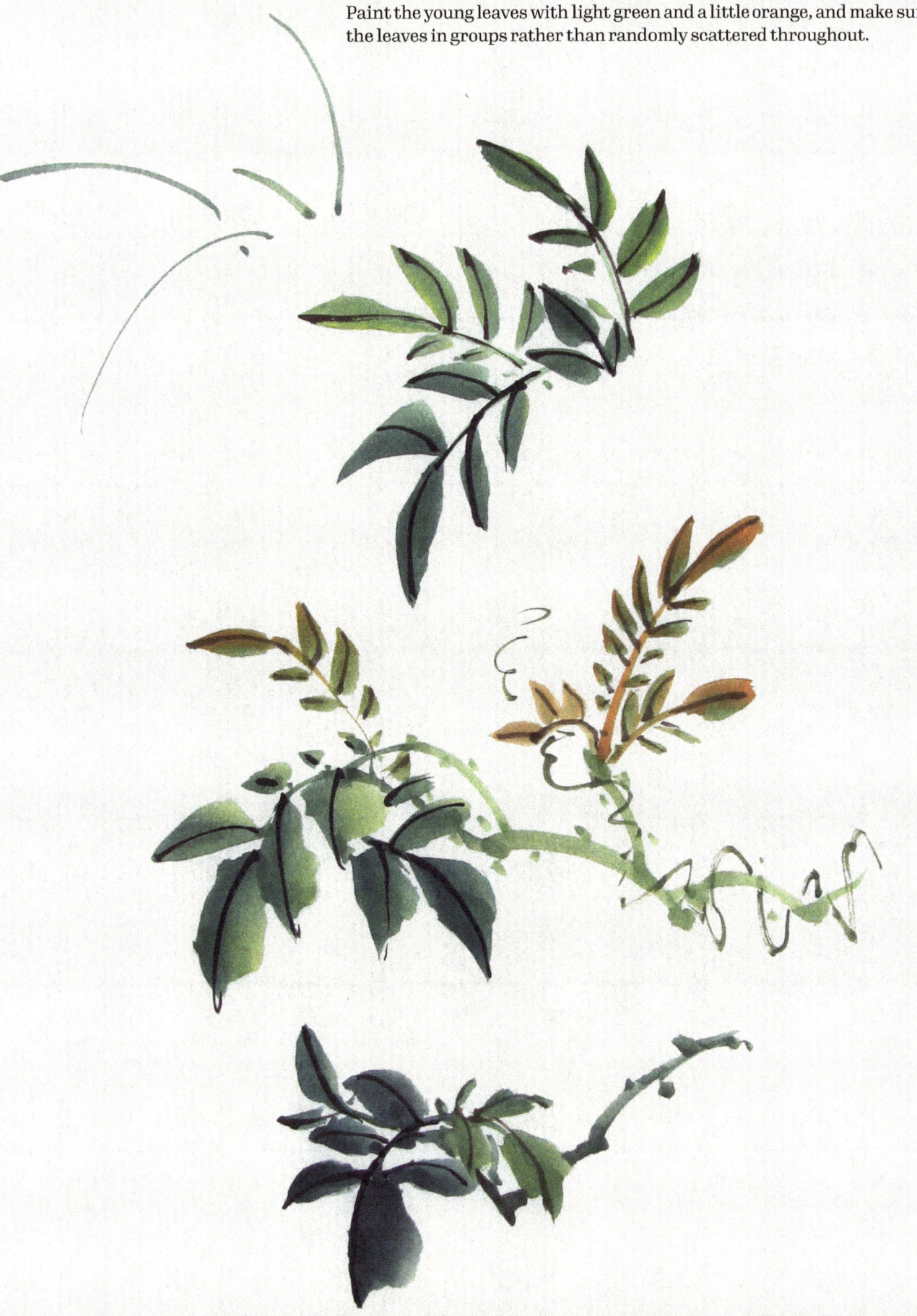

Vines

Holding your orchid/bamboo brush vertically, paint the branches and vines in brown and green. Let them twist and cross over, and don't forget a few tendrils in black or green wrapping around the vines and reaching out into space.

Tendrils are a great way to extend your composition without adding excessive volume.

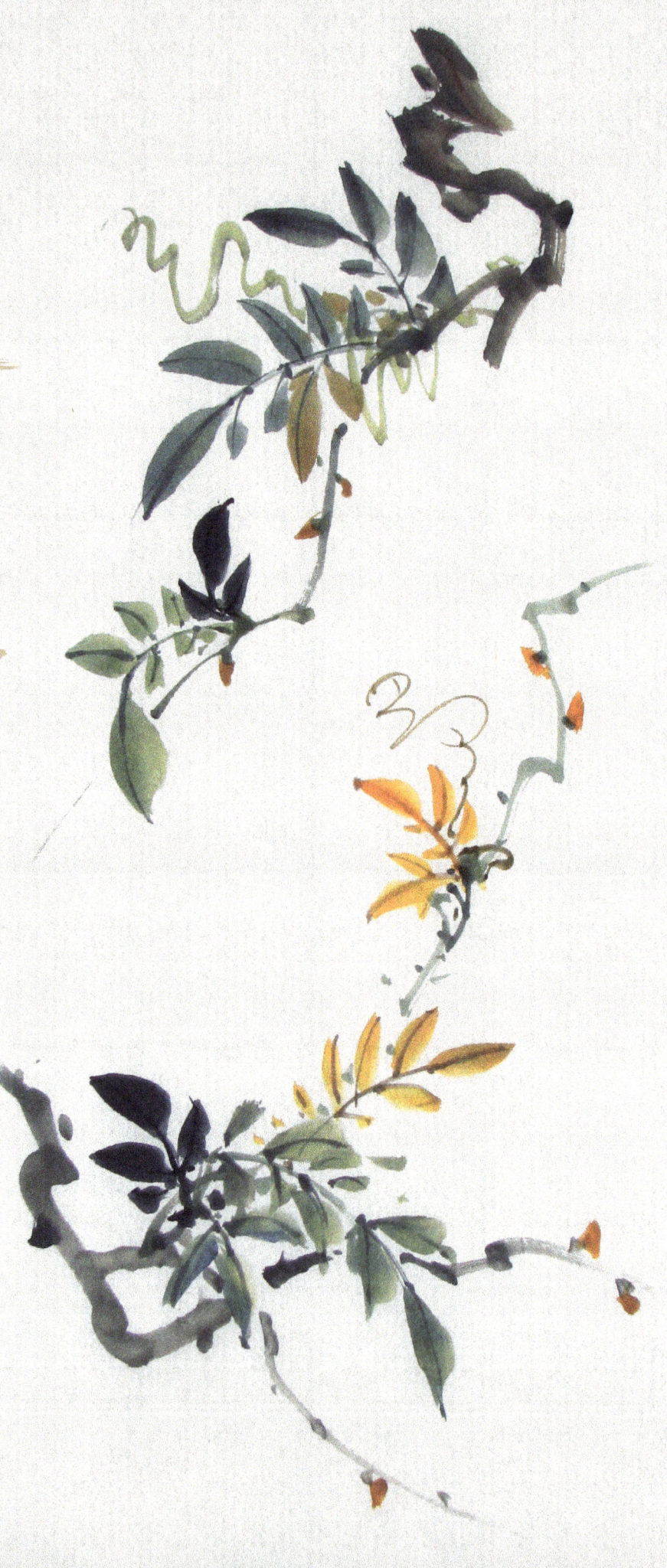

Wisteria Painting Progression

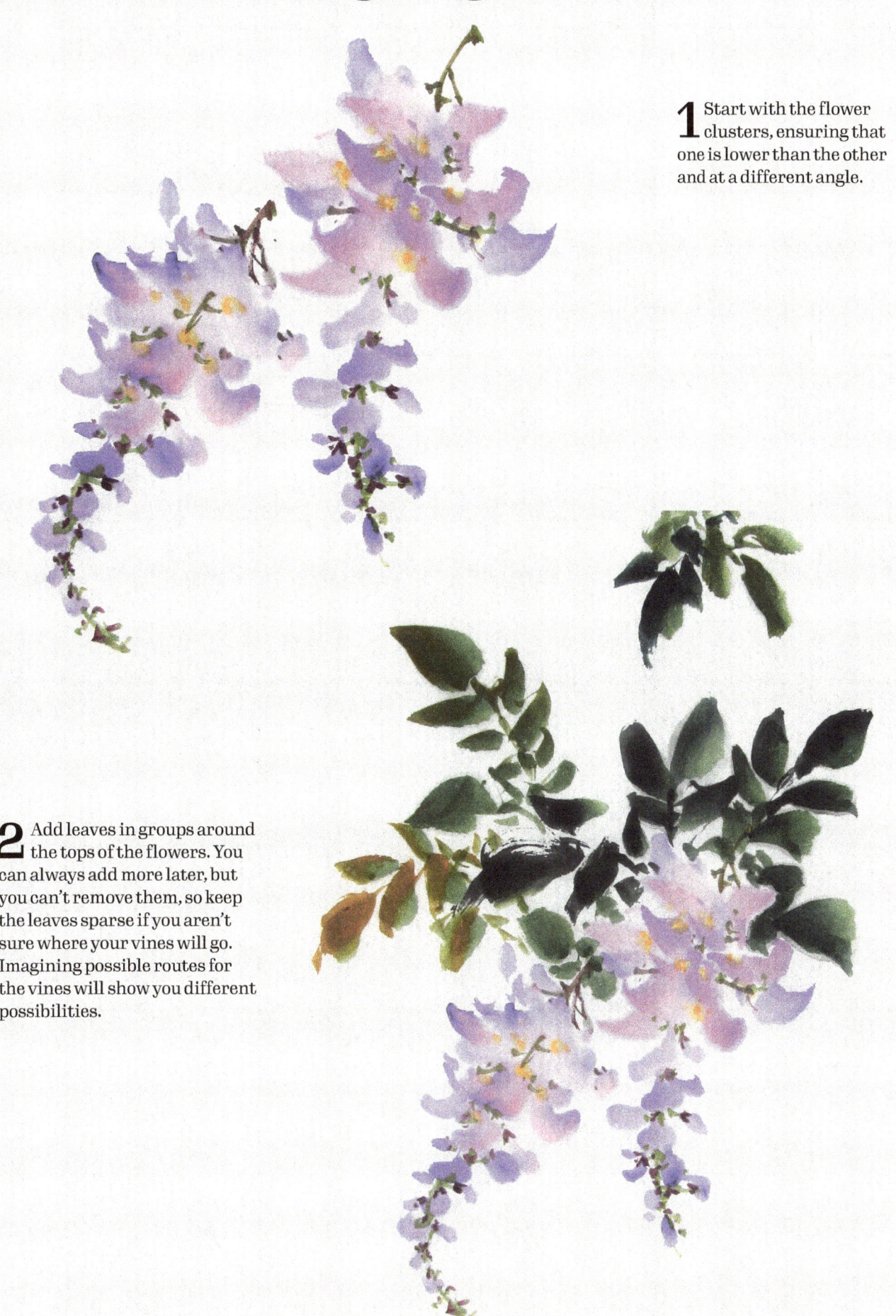

1 Start with the flower clusters, ensuring that one is lower than the other and at a different angle.

2 Add leaves in groups around the tops of the flowers. You can always add more later, but you can't remove them, so keep the leaves sparse if you aren't sure where your vines will go. Imagining possible routes for the vines will show you different possibilities.

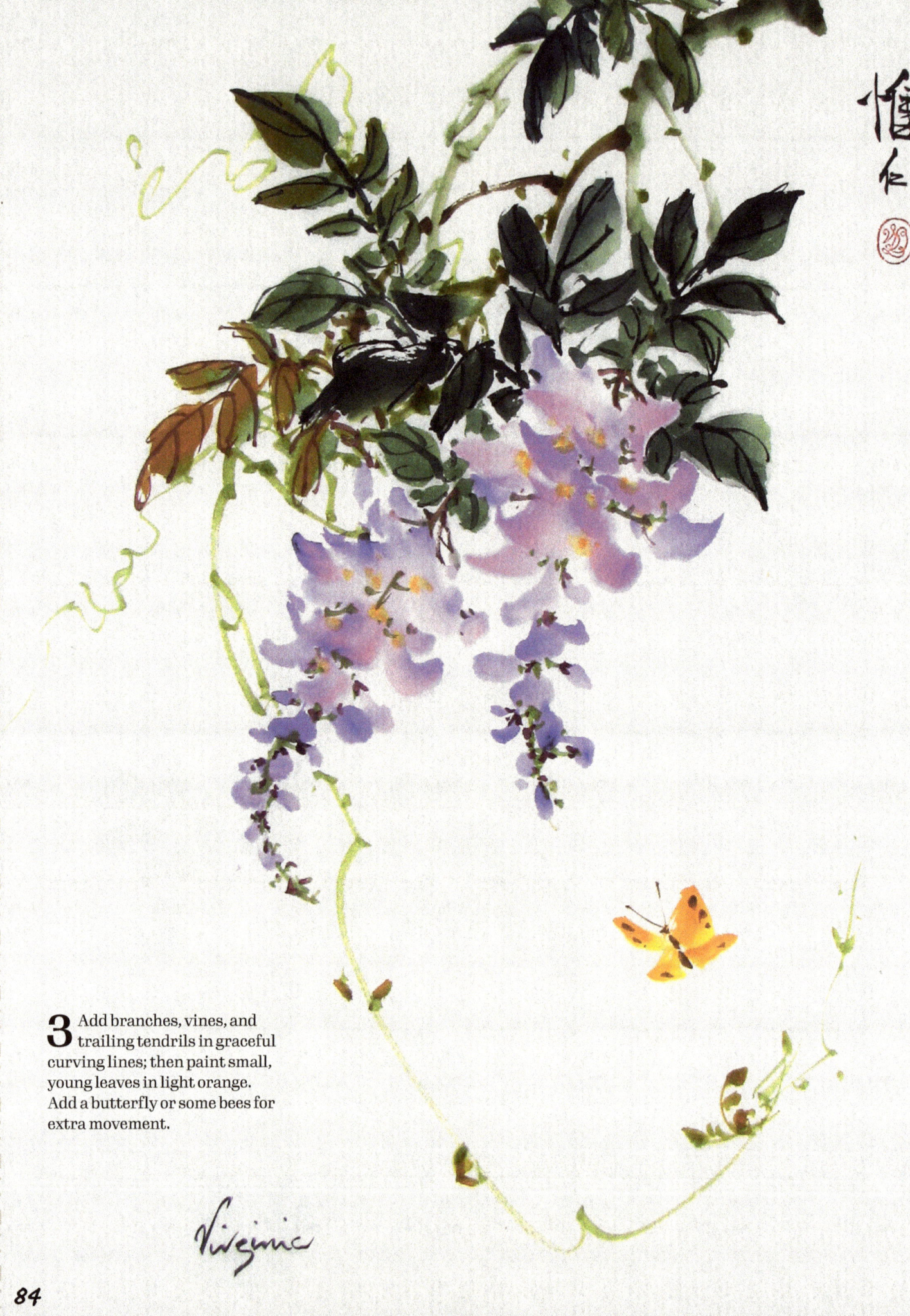

3 Add branches, vines, and trailing tendrils in graceful curving lines; then paint small, young leaves in light orange. Add a butterfly or some bees for extra movement.

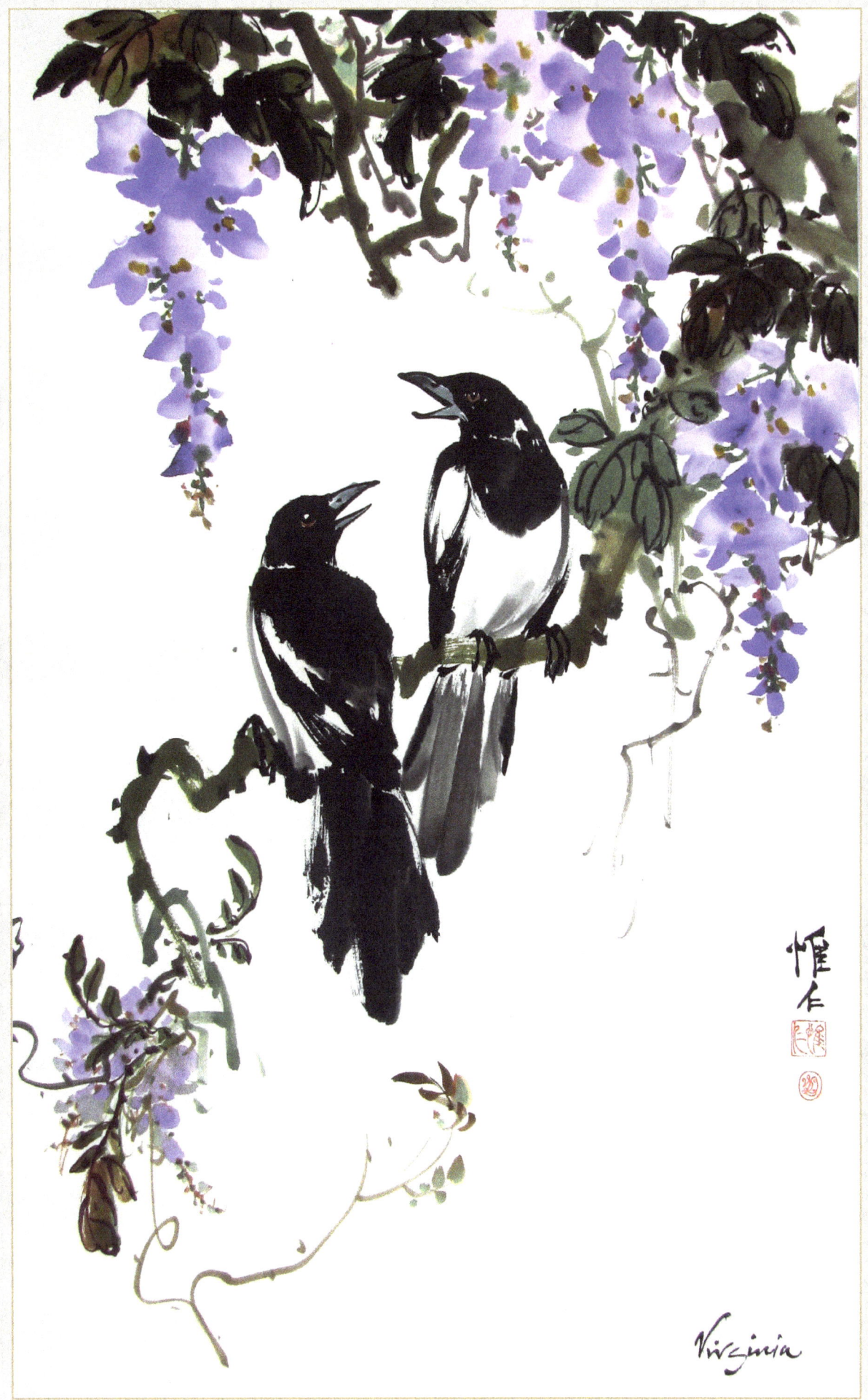

Grapes

Some Asian painting techniques make the grapes look so real, you almost feel as though you could pluck them right off the paper and eat them. Sumi-e style grapes appear more relaxed and dynamic.

Leaves

1 On the vine, the leaves shelter the grapes, so start by painting the leaves, placing most of them higher than the clusters of fruit. You can create gray and black leaves or use any combination of indigo, gamboge, burnt sienna, and black. Vary the shading on the leaves, placing the darker ones in front and lighter ones in the back. The undersides of the leaves are lighter.

2 Use a large hard bristle brush to paint big leaves. Different grape varieties have different leaf shapes, but the main veins always come from a central spot and fan out.

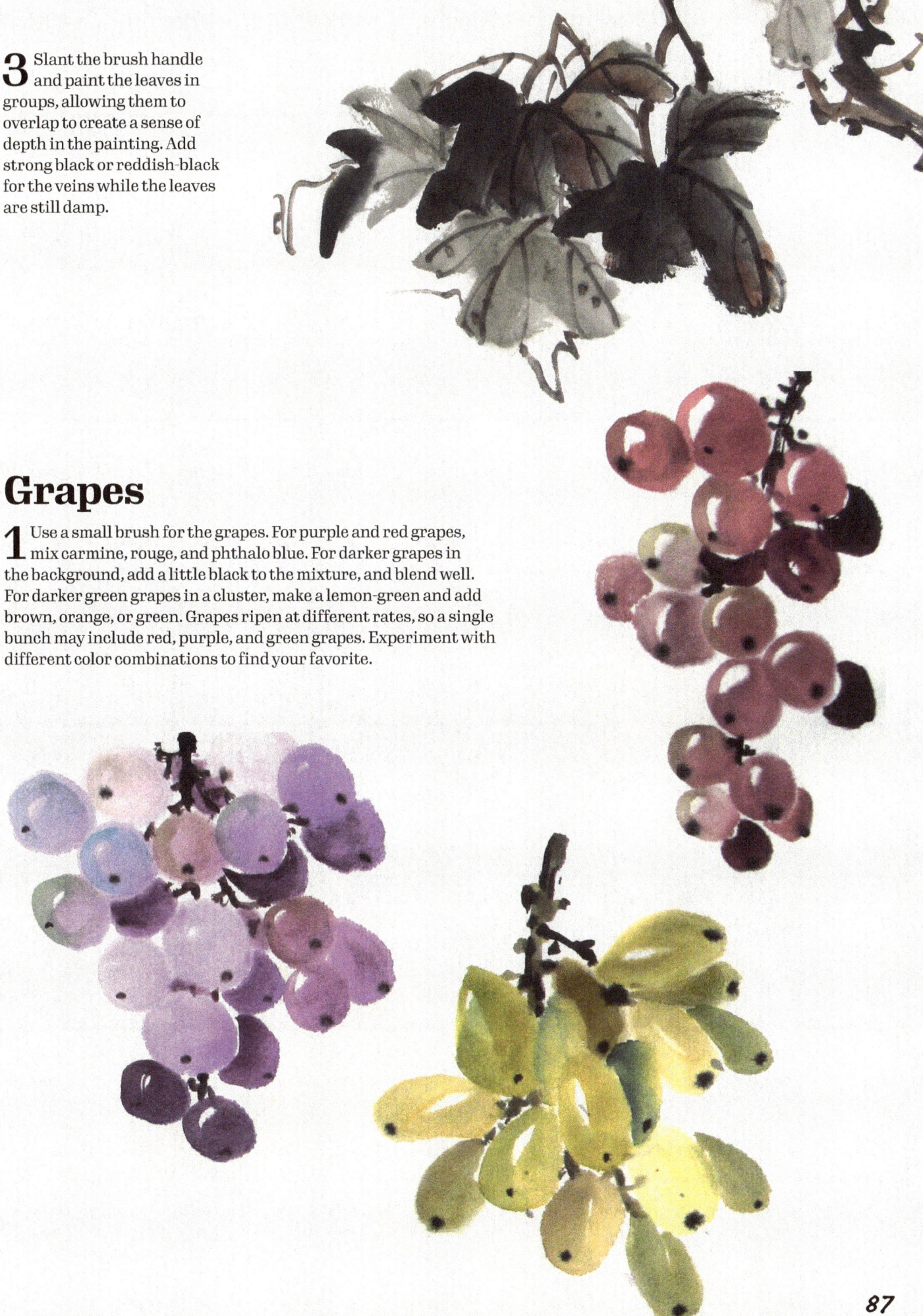

3 Slant the brush handle and paint the leaves in groups, allowing them to overlap to create a sense of depth in the painting. Add strong black or reddish-black for the veins while the leaves are still damp.

Grapes

1 Use a small brush for the grapes. For purple and red grapes, mix carmine, rouge, and phthalo blue. For darker grapes in the background, add a little black to the mixture, and blend well. For darker green grapes in a cluster, make a lemon-green and add brown, orange, or green. Grapes ripen at different rates, so a single bunch may include red, purple, and green grapes. Experiment with different color combinations to find your favorite.

2 With the tip of the brush, start by painting a "C," and then complete the circle of the grape using a side stroke and filling in all but a highlight spot in the upper left. If you are left-handed, you may find it easier to paint a backwards "C."

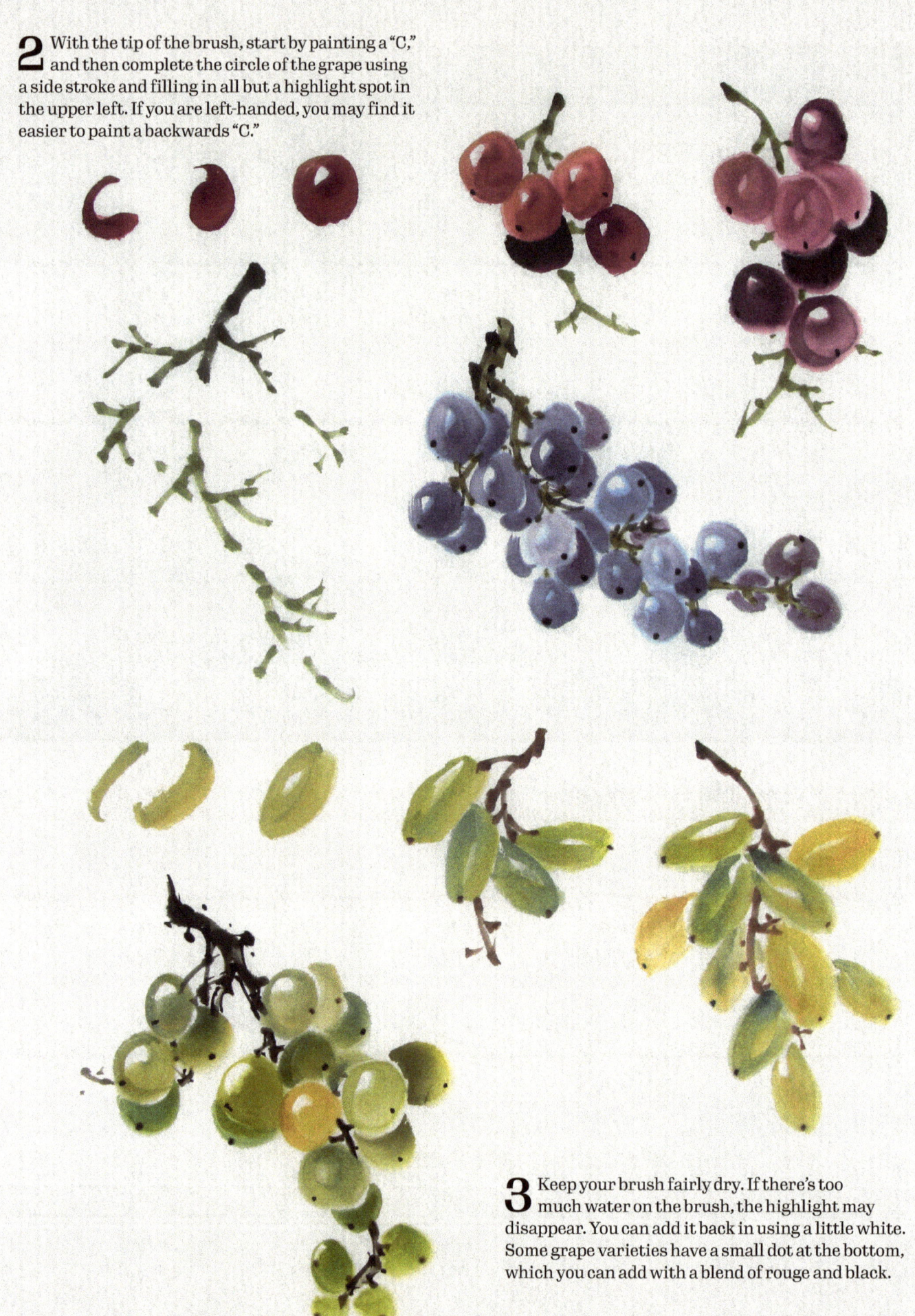

3 Keep your brush fairly dry. If there's too much water on the brush, the highlight may disappear. You can add it back in using a little white. Some grape varieties have a small dot at the bottom, which you can add with a blend of rouge and black.

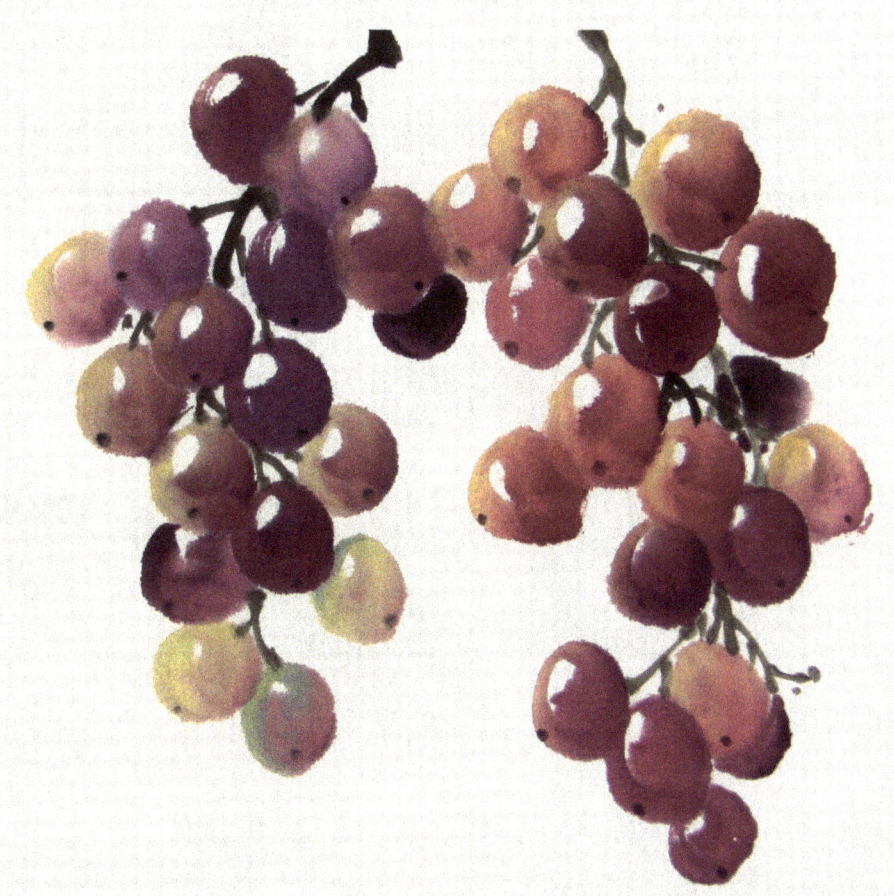

4 Place darker grapes half hidden behind the lighter ones to add volume to each bunch. Place the clusters in your painting at various heights and make them different sizes. Each bunch should be rounded at the bottom, rather than forming a sharp triangle. Add the stems after the grapes in a contrasting color.

Vines, Branches & Tendrils

Have fun! Hold your orchid/bamboo brush vertical to the paper and let it dance! Load your brush with reddish-brown, green, or gray to harmonize with the leaf colors; then blend black at the tip. Let the vines twist and twirl over the paper, joining the leaves and grapes. Leave open spaces for bugs or birds, or paint them in first.

Grape Painting Progression

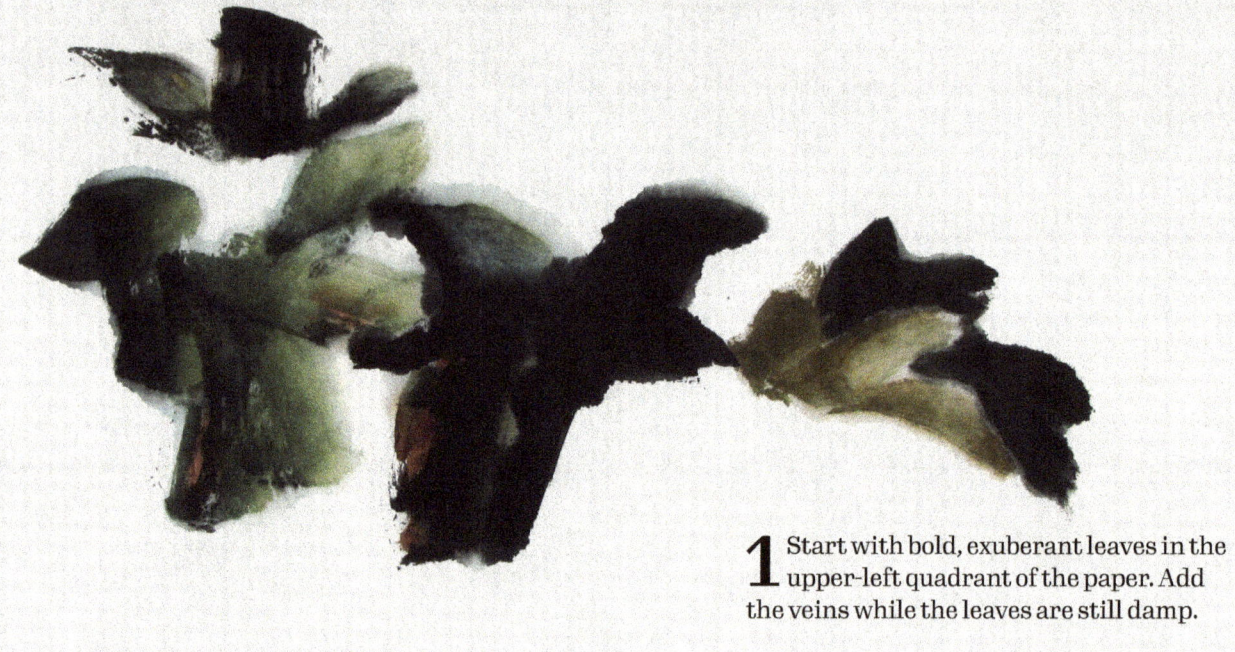

1 Start with bold, exuberant leaves in the upper-left quadrant of the paper. Add the veins while the leaves are still damp.

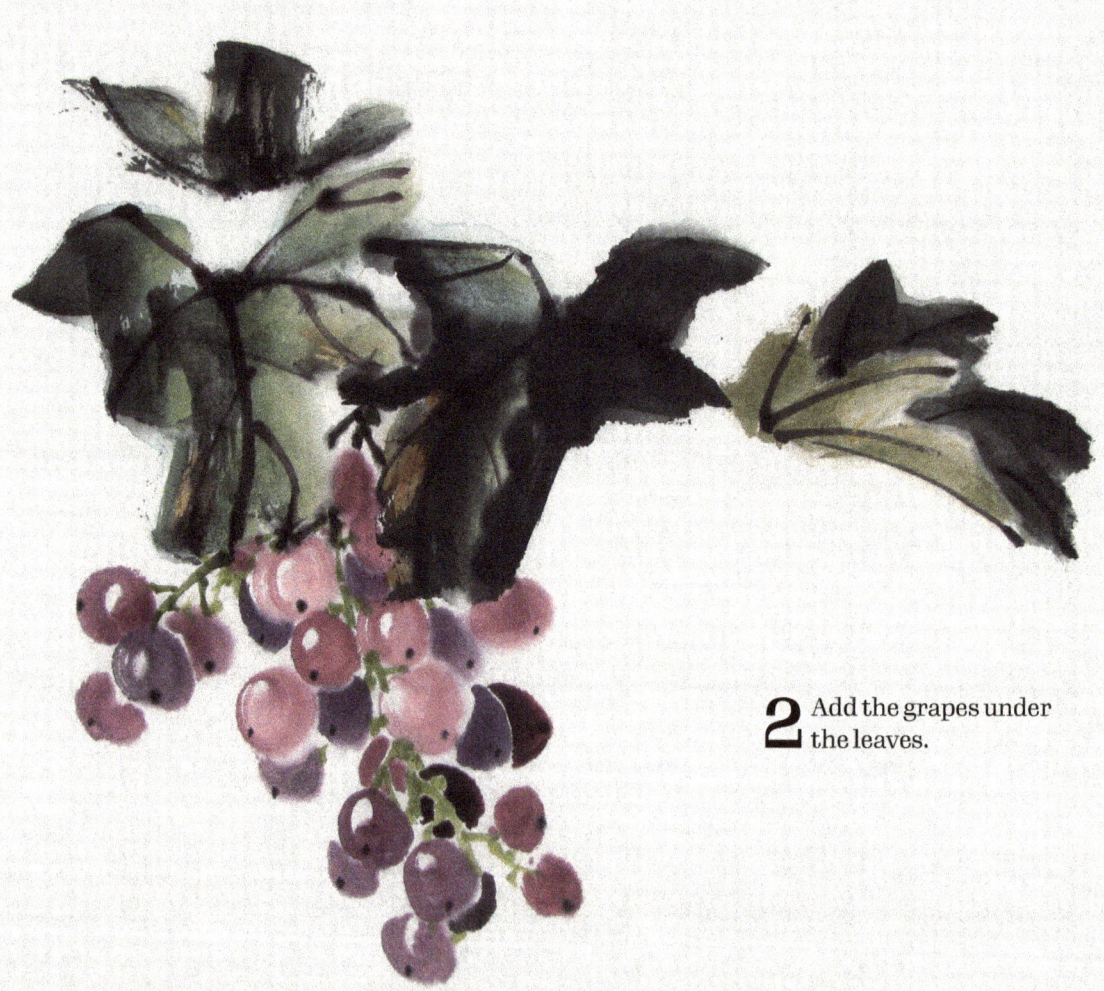

2 Add the grapes under the leaves.

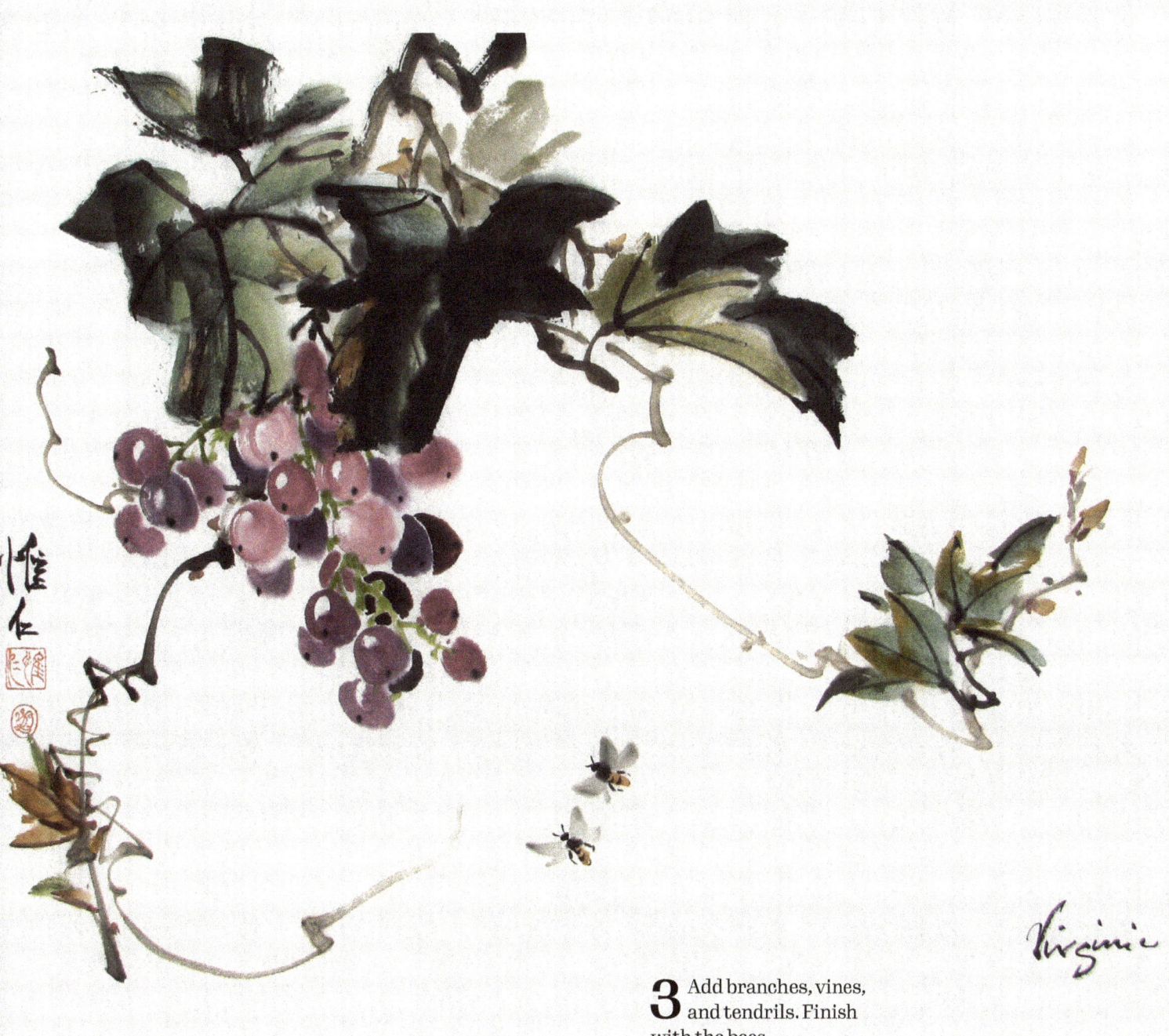

3 Add branches, vines, and tendrils. Finish with the bees.

Lotus & Kingfisher

The lotus, a semi-aquatic plant that plants its roots in the mud, symbolizes purity, nobility, and spirituality in many Eastern religions. The seed pods start off a light yellowish-green color inside the flower, and then swell and turn brown when the petals fall.

Leaves

You may paint lotus leaves in color or using shades of black and gray. The leaf stems can grow taller than a person, so the artist's viewpoint is usually from the side rather than looking down from above.

Young leaves roll up. Paint the first with one stroke and the second with two strokes. For the opening leaves, start with dark gray or green and black for the inside, and add a light gray or light green outline to indicate the outside. Add little bumps like soft thorns to all the stems.

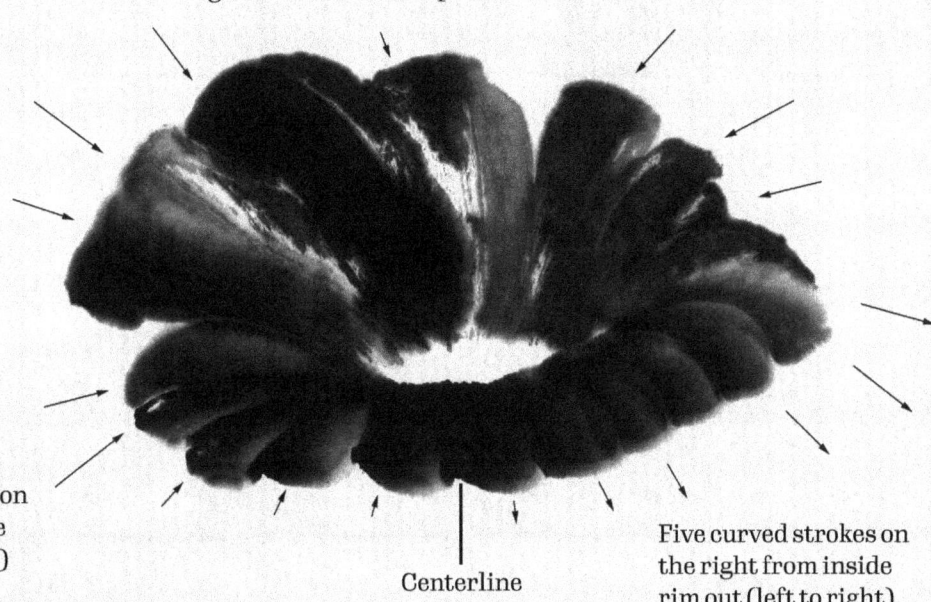

Big strokes from the top down toward the center

Fully open leaves follow a stroke pattern; studying this pattern will help you understand how to paint a leaf. As you become more confident, you may loosen up and splash on the ink more freely.

Five curved strokes on the left from outside edge in (left to right)

Centerline

Five curved strokes on the right from inside rim out (left to right)

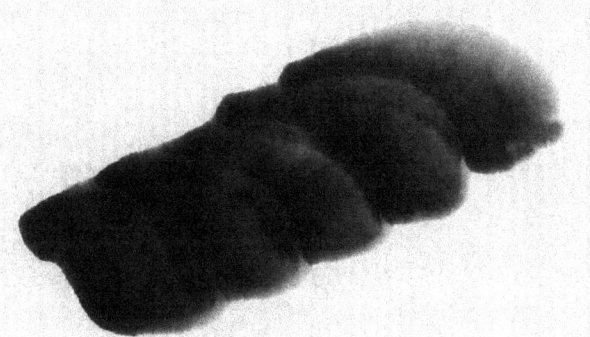

1 Load a large brush with dark gray and lots of black. Keeping the handle slanted down, make five strokes in a diagonal curve toward the right to form the first quarter of the leaf.

2 Reload your brush and make five strokes on the left side. The two segments join at the center of the leaf edge; ensure that the two sides are the same length. If you're right-handed, paint the strokes from left to right, reversing the direction if you're left-handed.

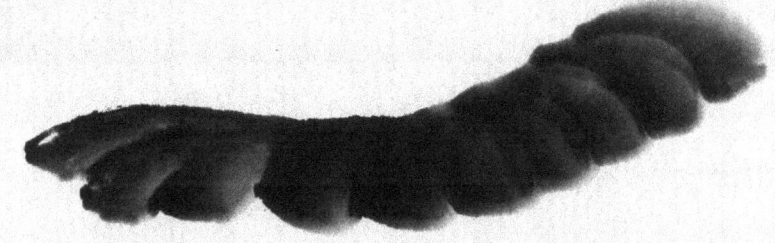

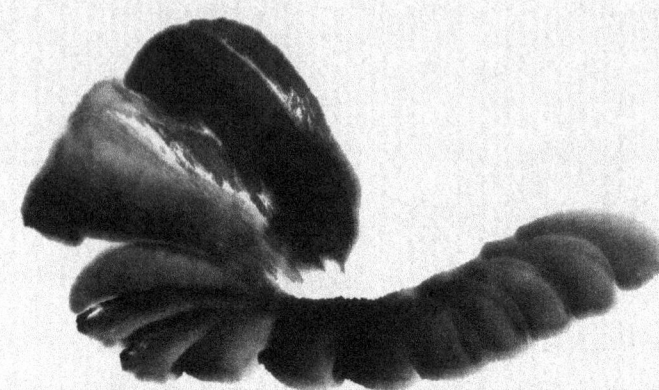

3 Reload the brush with dark gray and a little less black this time. Starting at the top-left edge, paint three to four large segments toward the center of the leaf. Leave some space untouched near the center. This part can be left white, showing highlights, or you can add a little light gray later.

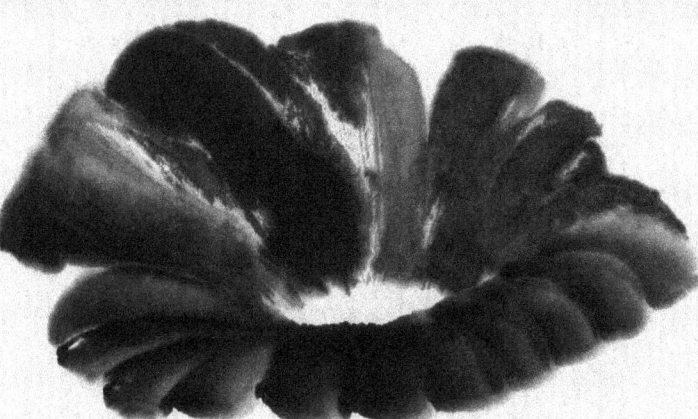

4 Reload the brush with dark gray and finish the oval of the leaf.

5 While the leaf is still damp, add veins with a pointed brush, alternating between single and Y-shaped lines. Take care to curve the veins down toward the center, following your original strokes.

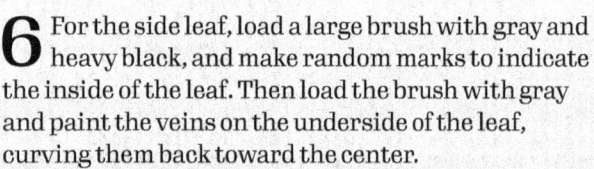

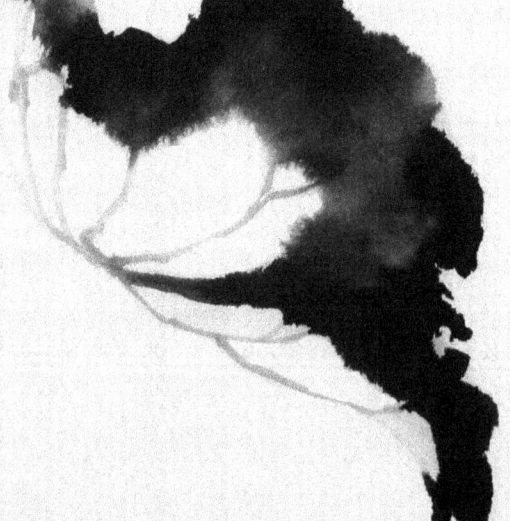

6 For the side leaf, load a large brush with gray and heavy black, and make random marks to indicate the inside of the leaf. Then load the brush with gray and paint the veins on the underside of the leaf, curving them back toward the center.

Flowers

There are two ways to paint lotus flowers: outline and boneless.

OUTLINE FLOWERS

Load a small brush with dark gray. Start with the petal closest to you, and with your brush upright, begin at the tip of the petal and pause before painting one side. Pause again at the top and paint the other side of the petal. Then build the inner ring of petals in the form of a cup. Make sure your petals always angle back to the center where the stem joins the flower, and add more petals in an outer ring.

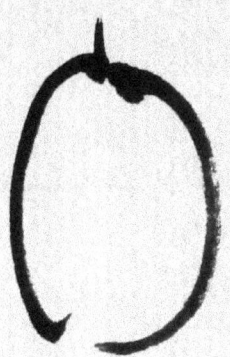

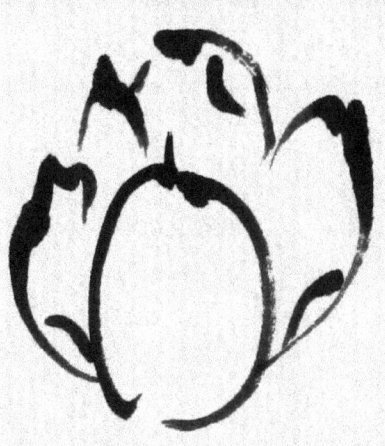

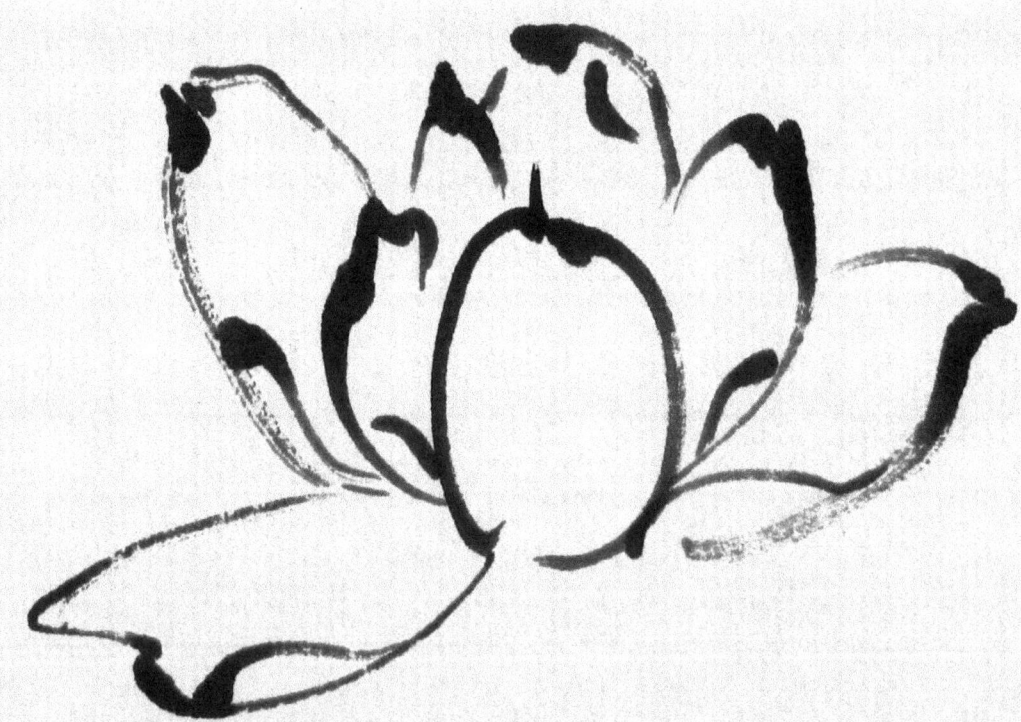

BONELESS FLOWERS

Charge a soft brush with a light carmine wash and add stronger carmine to the tip. Hold your brush slanted and paint the front petal in two strokes, starting at the top and with the tip pointing toward the outside edge. Complete the inner ring of petals. Finish with a few petals to form an outer ring and add stamens and the stem, ensuring that the stem points to the center of the flower.

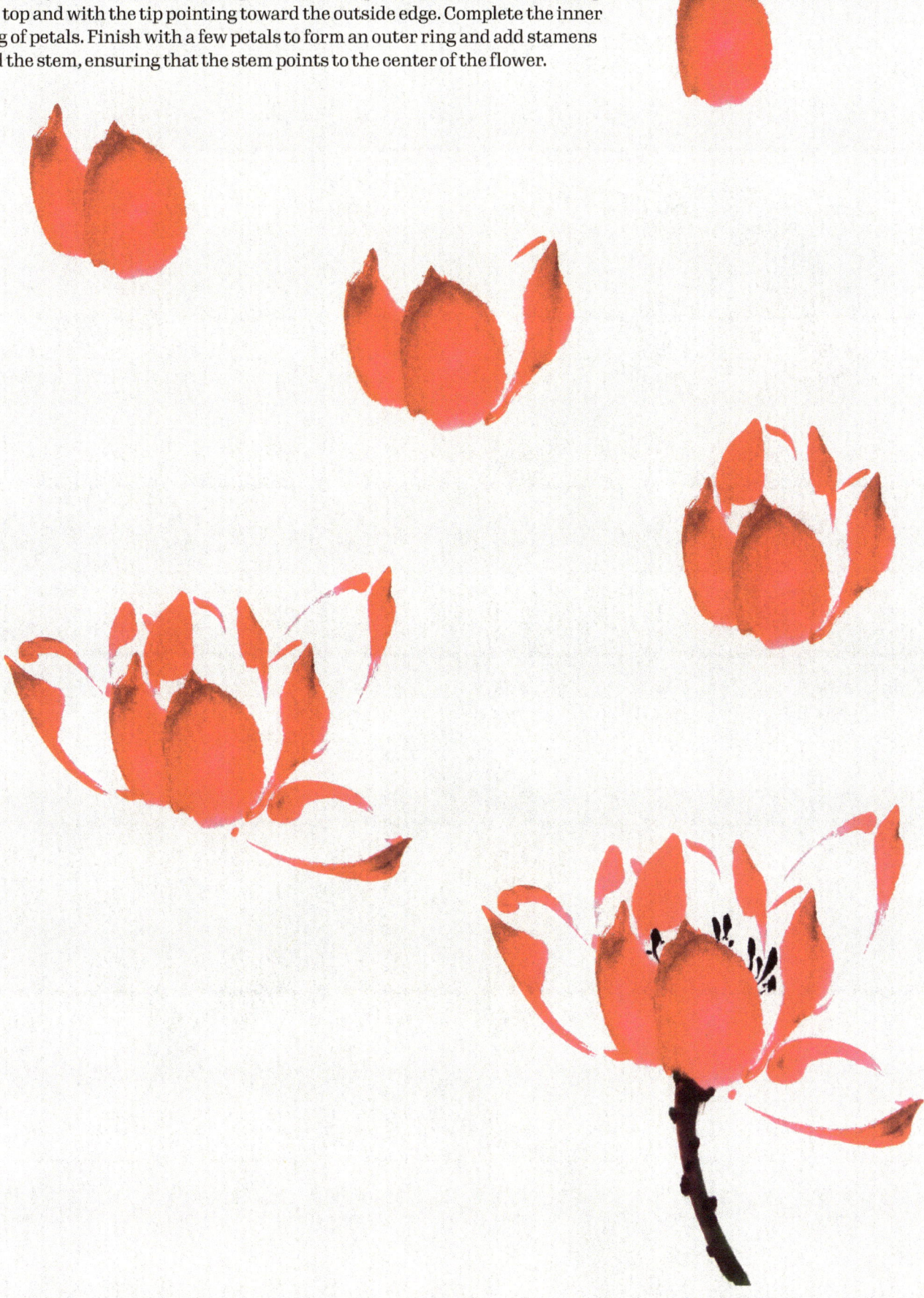

Kingfishers

Kingfishers in blue, green, or gray and black add liveliness to a painting. For this one, I used phthalo blue for the head and wings and red mixed with orange for the breast and beak. Once the bird was dry, I added highlight dots in phthalo blue mixed with white to the head and wings. You can also include frogs, fish, and dragonflies in your pond.

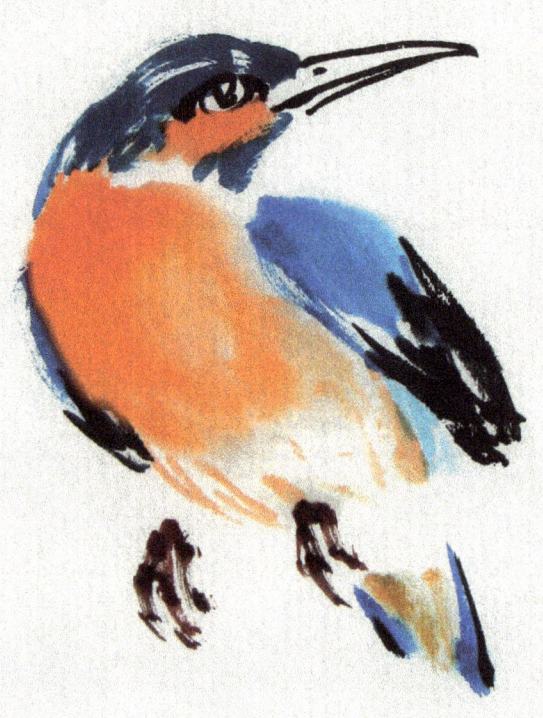

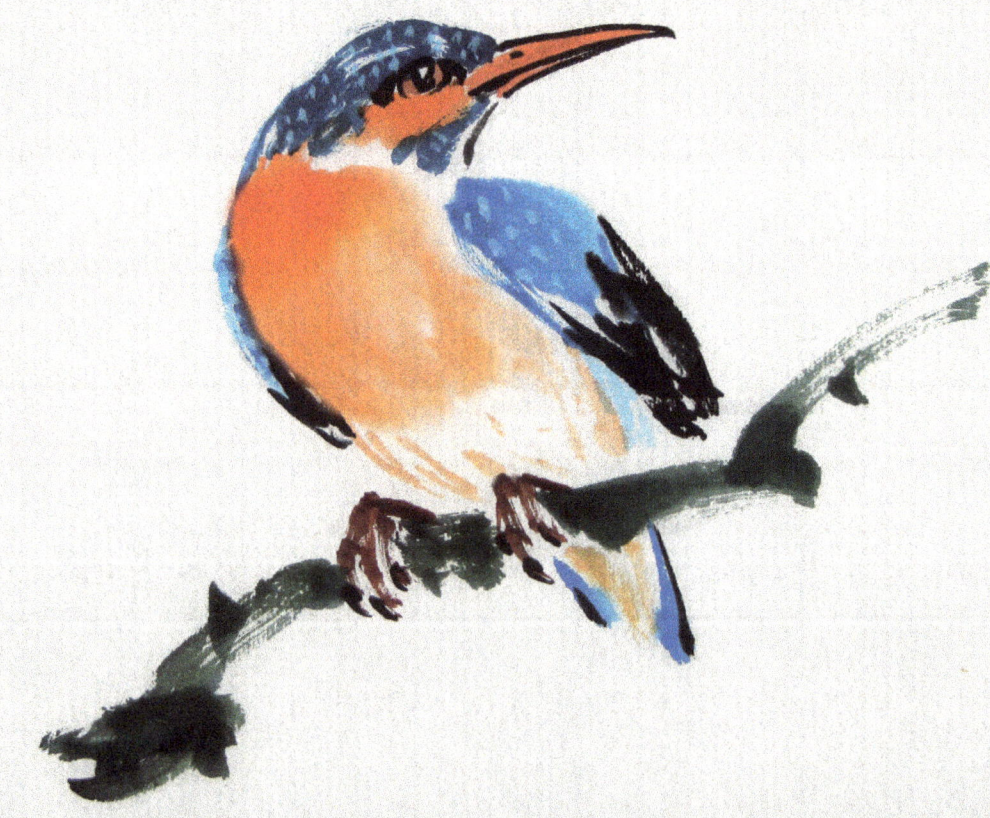

Here are a few other poses to try. Add mineral green or mineral blue over gray for a different effect.

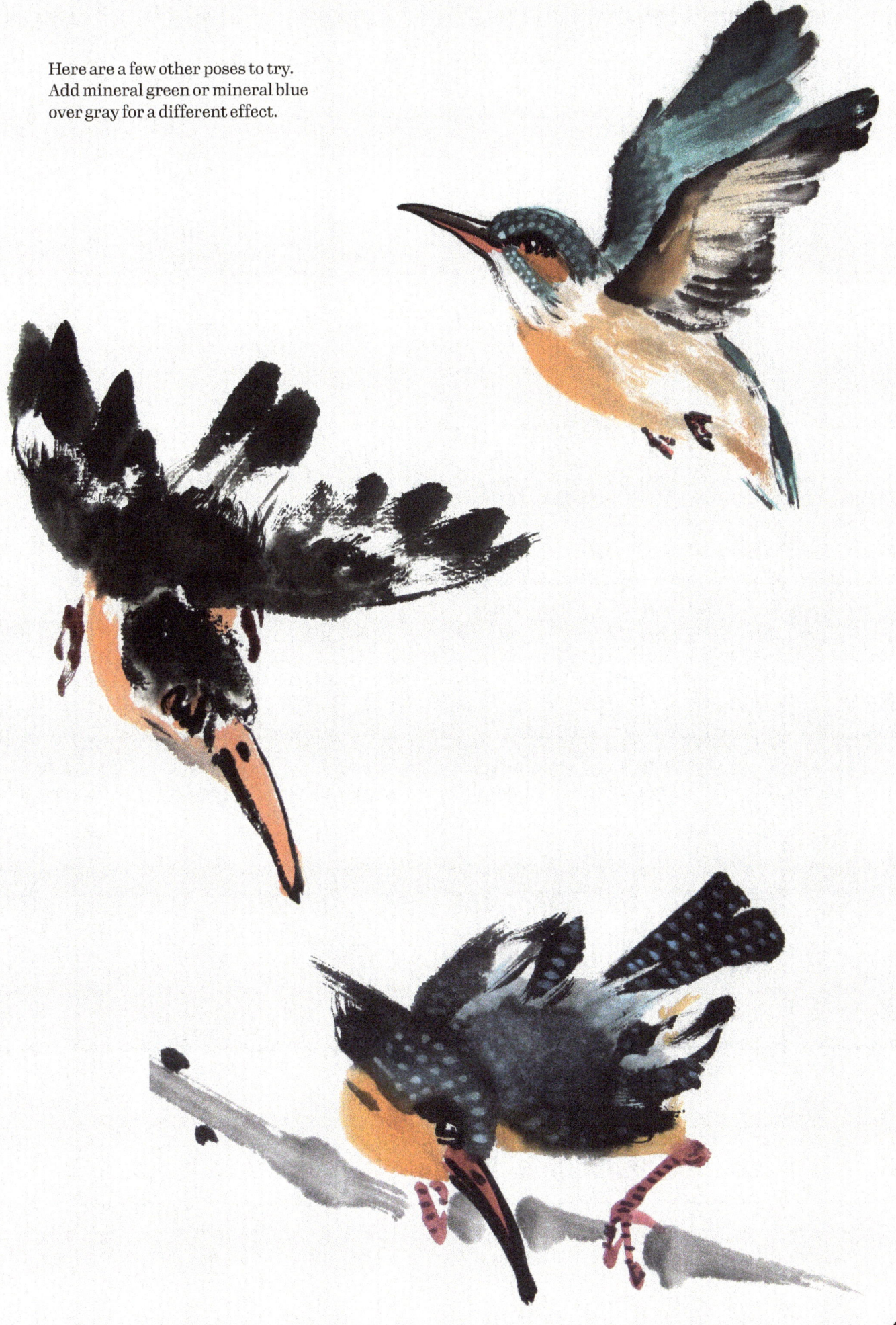

Lotus & Kingfisher Painting Progression

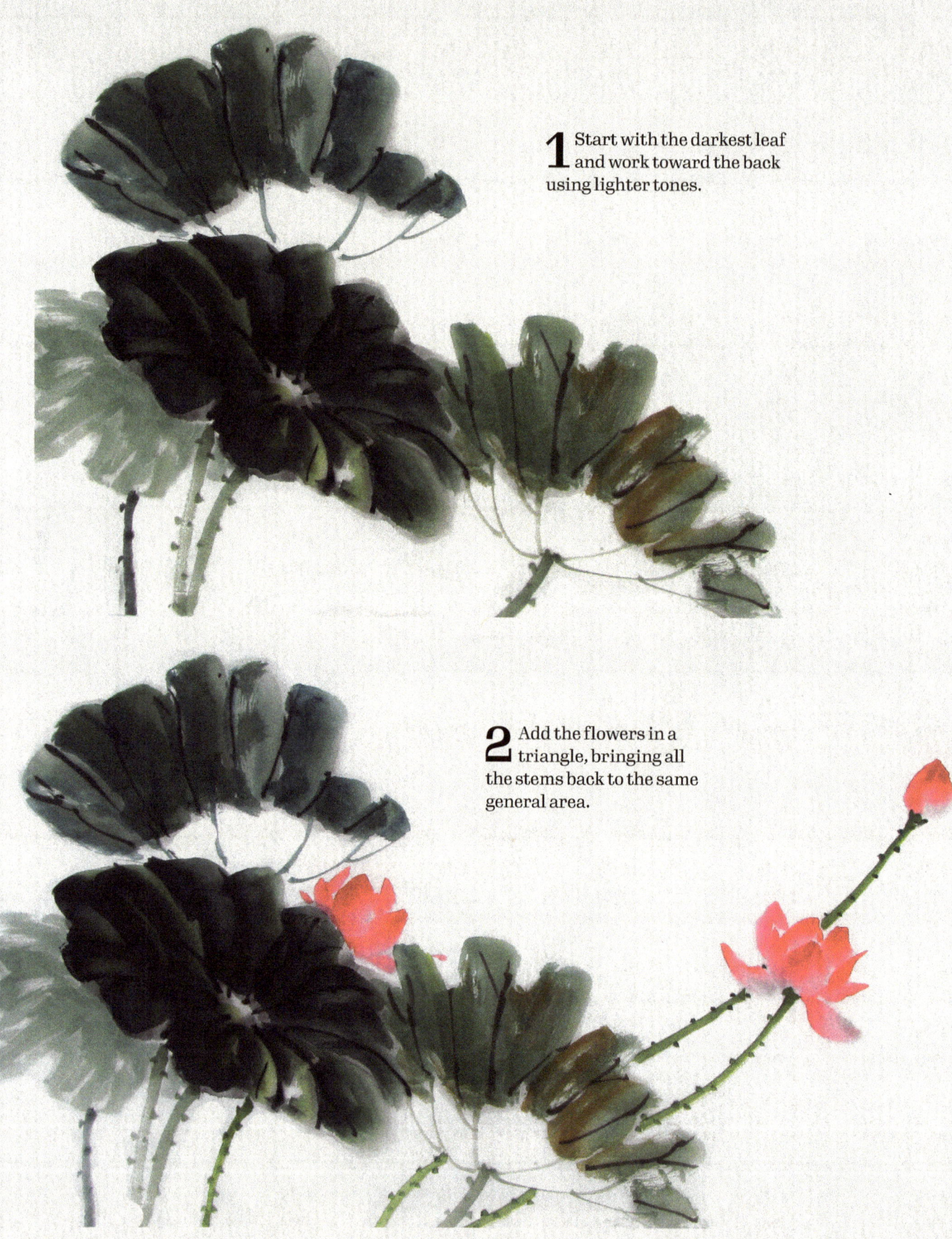

1 Start with the darkest leaf and work toward the back using lighter tones.

2 Add the flowers in a triangle, bringing all the stems back to the same general area.

3 Point the bird toward the center of the painting, and finish with extra stems and water weeds.

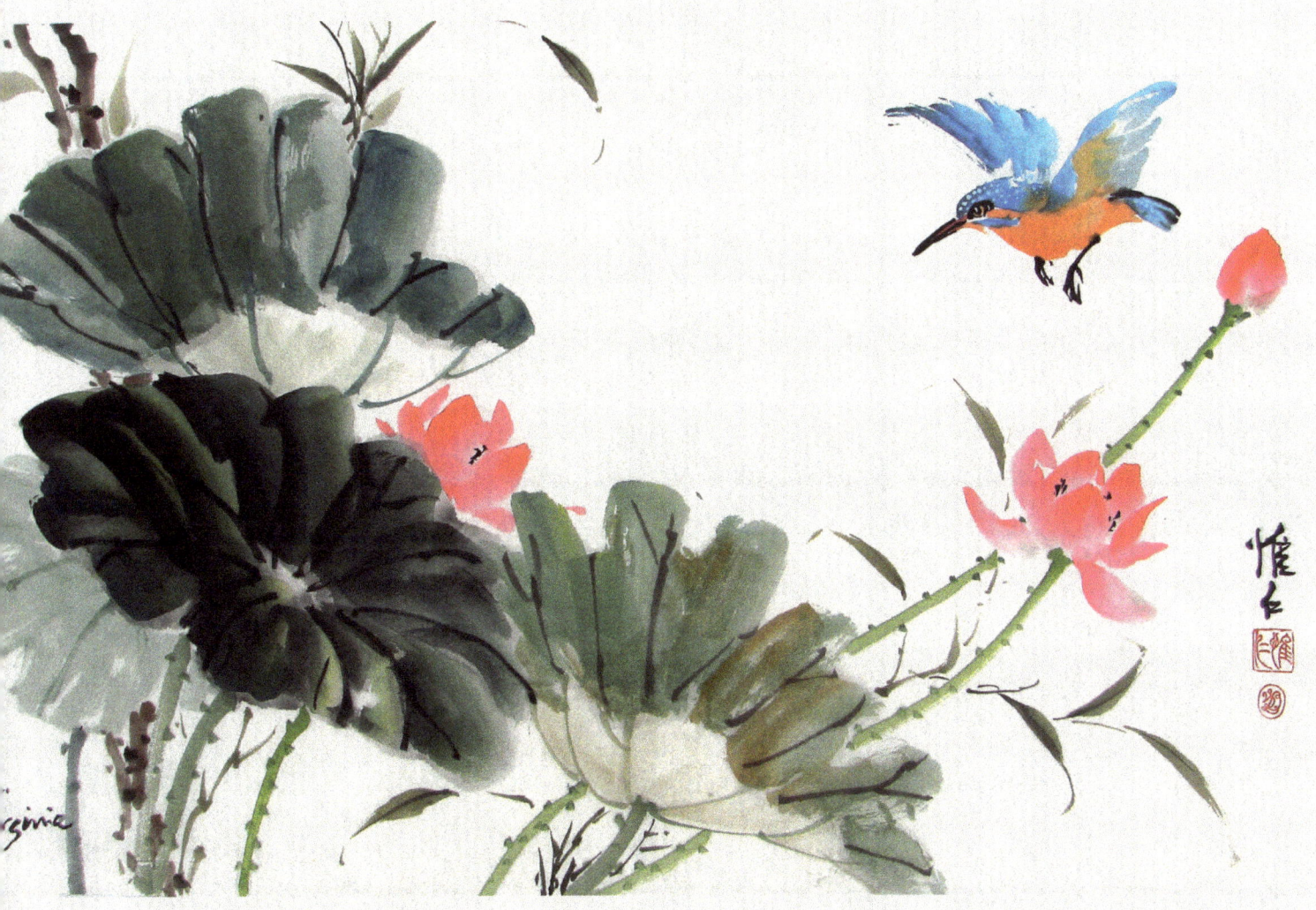

Bird Basics

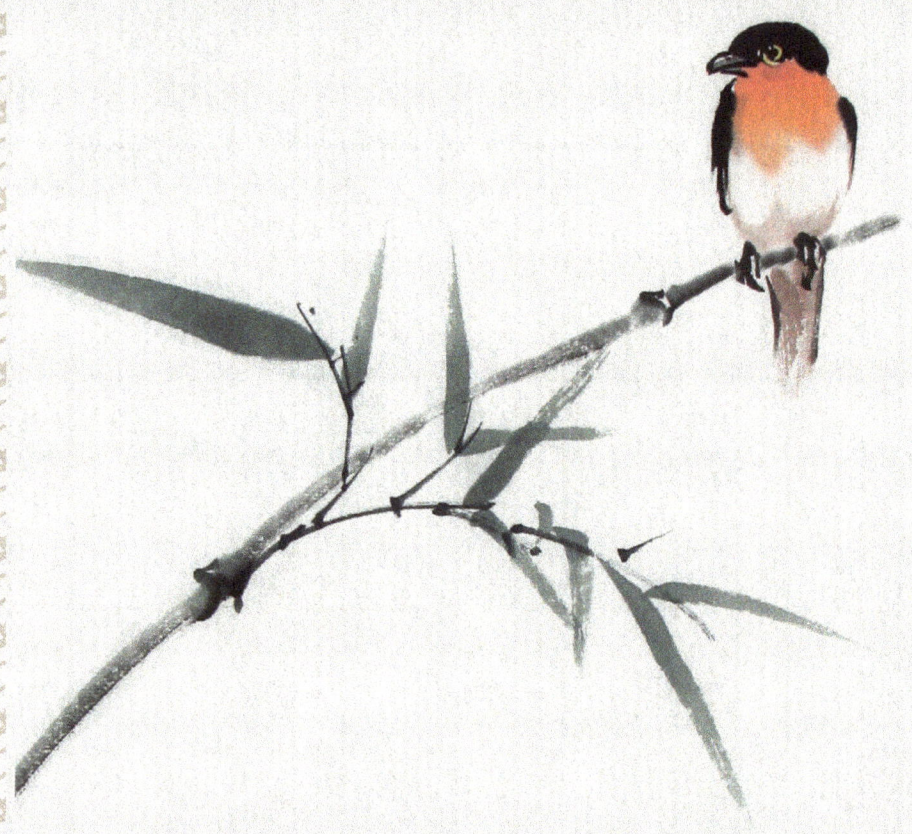

Sumi-e birds add movement and liveliness to a painting. You don't need a wide variety of poses in your bird-painting repertoire. Instead, follow the classical poses that have been handed down through the centuries.

If you master two birds sitting...

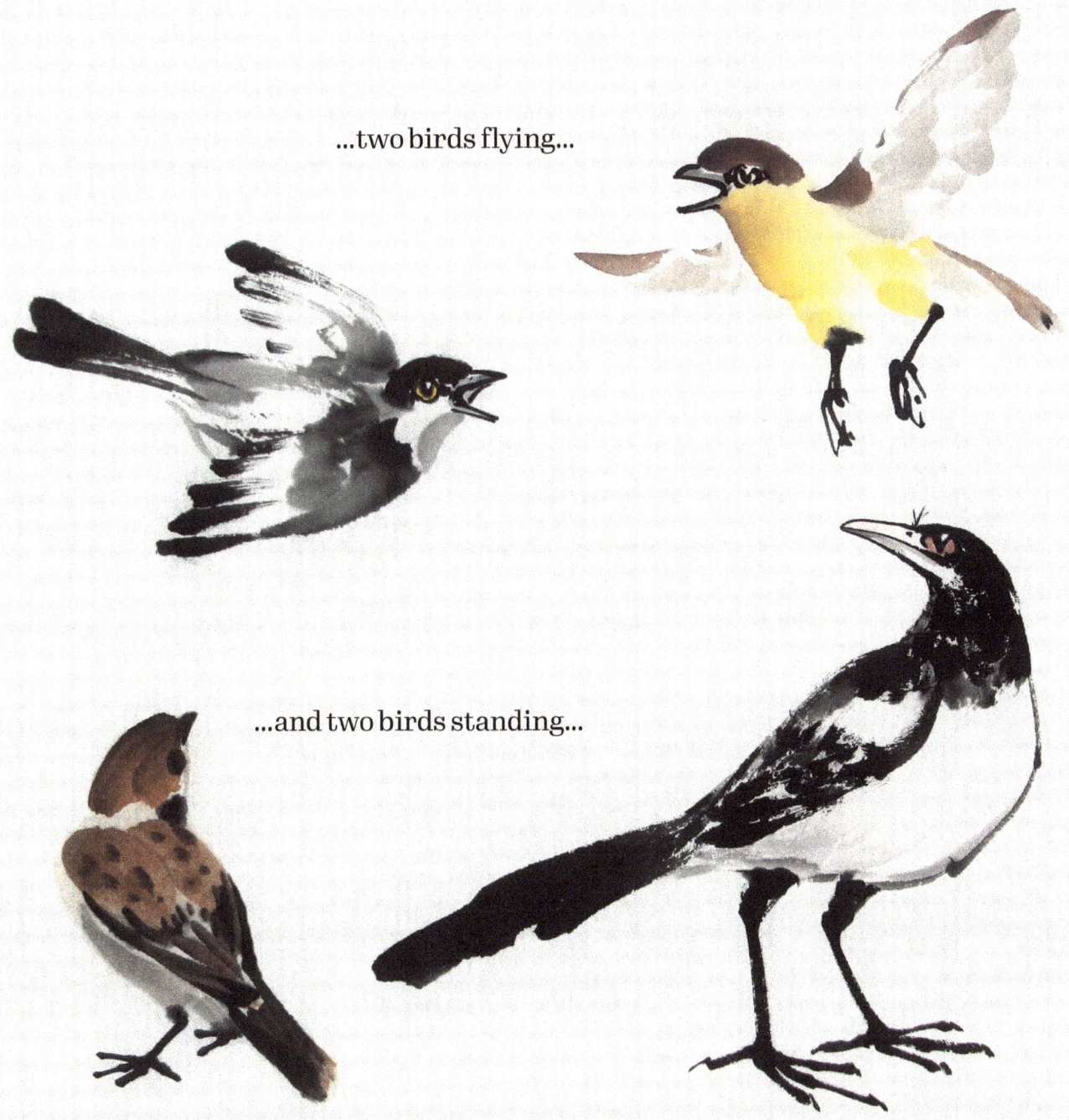

...two birds flying...

...and two birds standing...

...then you will have 12 poses since you can reverse each one to create its mirror image.

TIPS FOR CREATING BIRDS

- Study bird photos, but don't get stuck on photorealism. Sumi-e artists exaggerate the eyes, beak, and feet to bring out the character in a bird. There's also no need to paint every feather; detail overloads the gesture. Let your brush dance with your breath and create your own reality.
- I don't sketch birds in advance, but I still practice different poses. When starting out with sumi-e, you may want to place your sketches under your sumi-e paper to make sure you get the proportions right.

Beaks & Eyes

The bird's expression tells a story, so start there. Practice creating hundreds of beaks and eyes to improve your skills through repetition. When these strokes are confident, the rest will follow.

Keep in mind that the beak is not the bird's nose. It is the equivalent of our jaws and it hinges at the side of the bird's head, below the eyes.

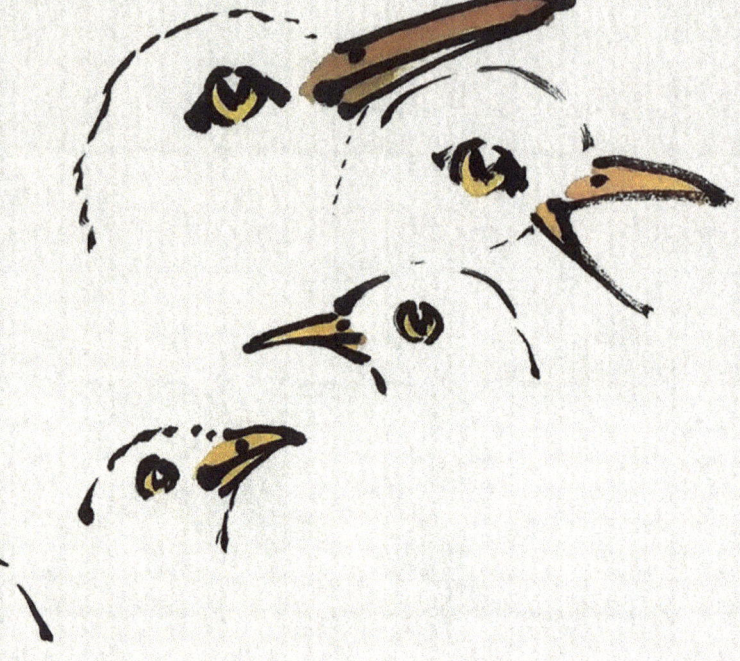

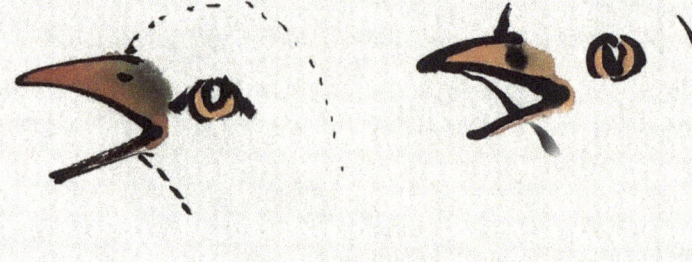

Dip the tip of an orchid/bamboo brush, a Happy Dot brush, or any well-pointed hard-bristle brush in black ink. Paint a closed beak in three strokes, starting with the long centerline. Paint an open beak with three or four strokes and add a pause at the jaw hinge.

Paint the eye as a circle within a larger oval, leaving a highlight in the middle. If the highlight gets lost, add it back in with white. Make sure the eye sits on or above an imaginary line extending back from the centerline of the beak.

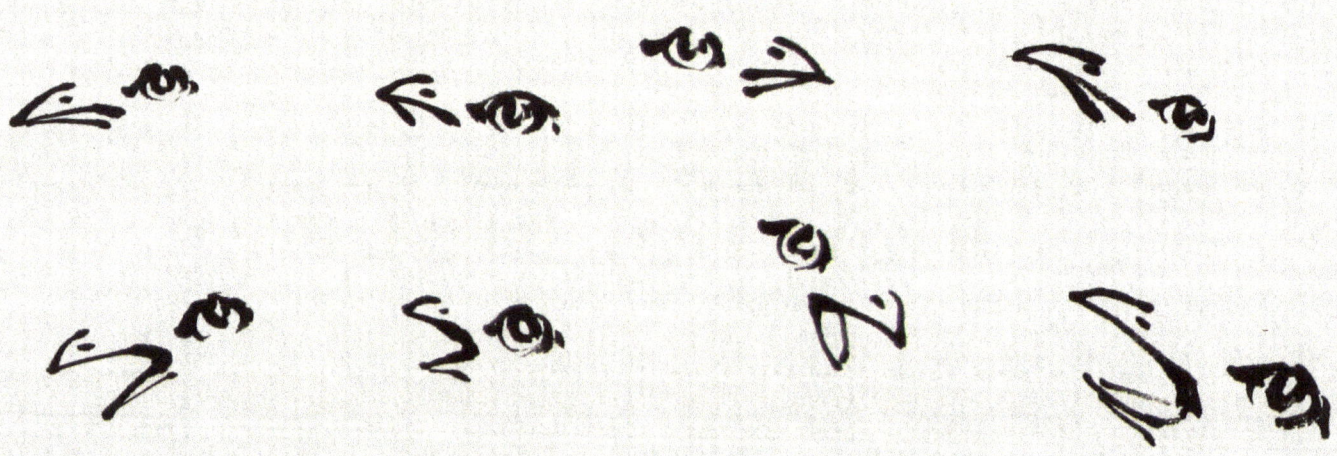

Legs & Feet

In songbirds, you mostly see the leg from the ankle joint down. In wading birds like cranes and egrets, more of the shank above the ankle is visible, and you never see the knee. If it's helpful to remember which way to bend the leg, imagine it as the forearm and the hinge as the elbow.

Keep your brush relatively dry and paint the legs without hesitation. If you want them outlined, start with a lighter color first; then add an outline after drying.

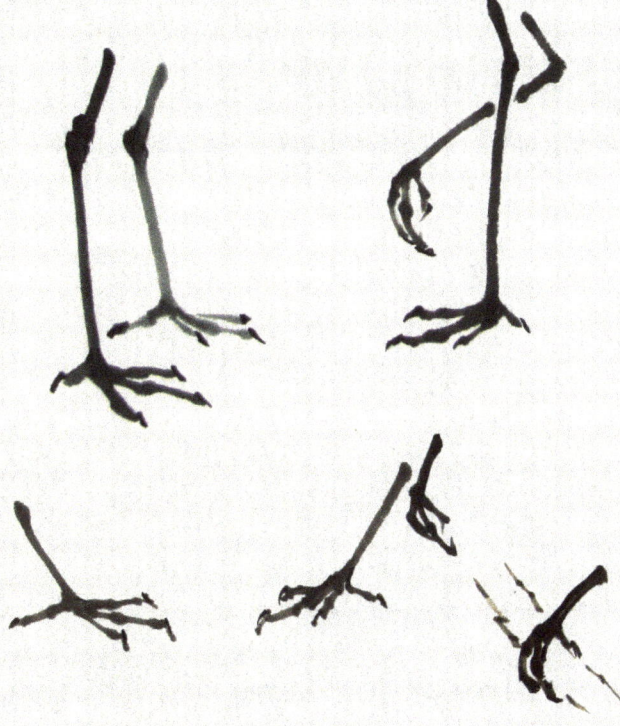

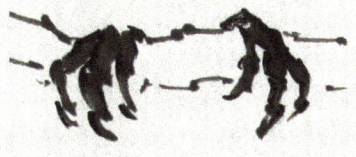

Wings

Wings can be tucked up on the back or droop below the tail.

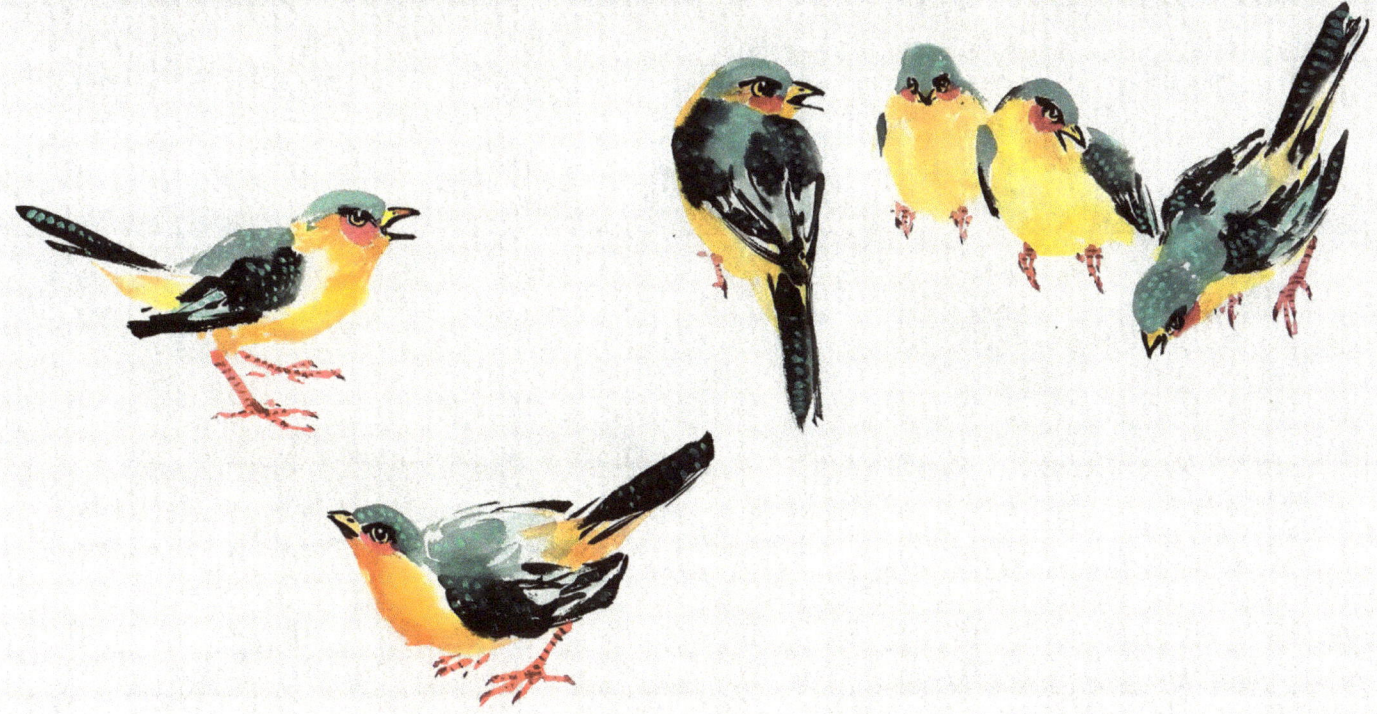

105

Sitting Bird

The easiest pose is the sitting bird with its head turned sideways. Use a side stroke for the head, back, and belly, and a perpendicular stroke for the rest. A small soft brush is best for the belly, but make sure the color is light and not too watery or it will spread too far.

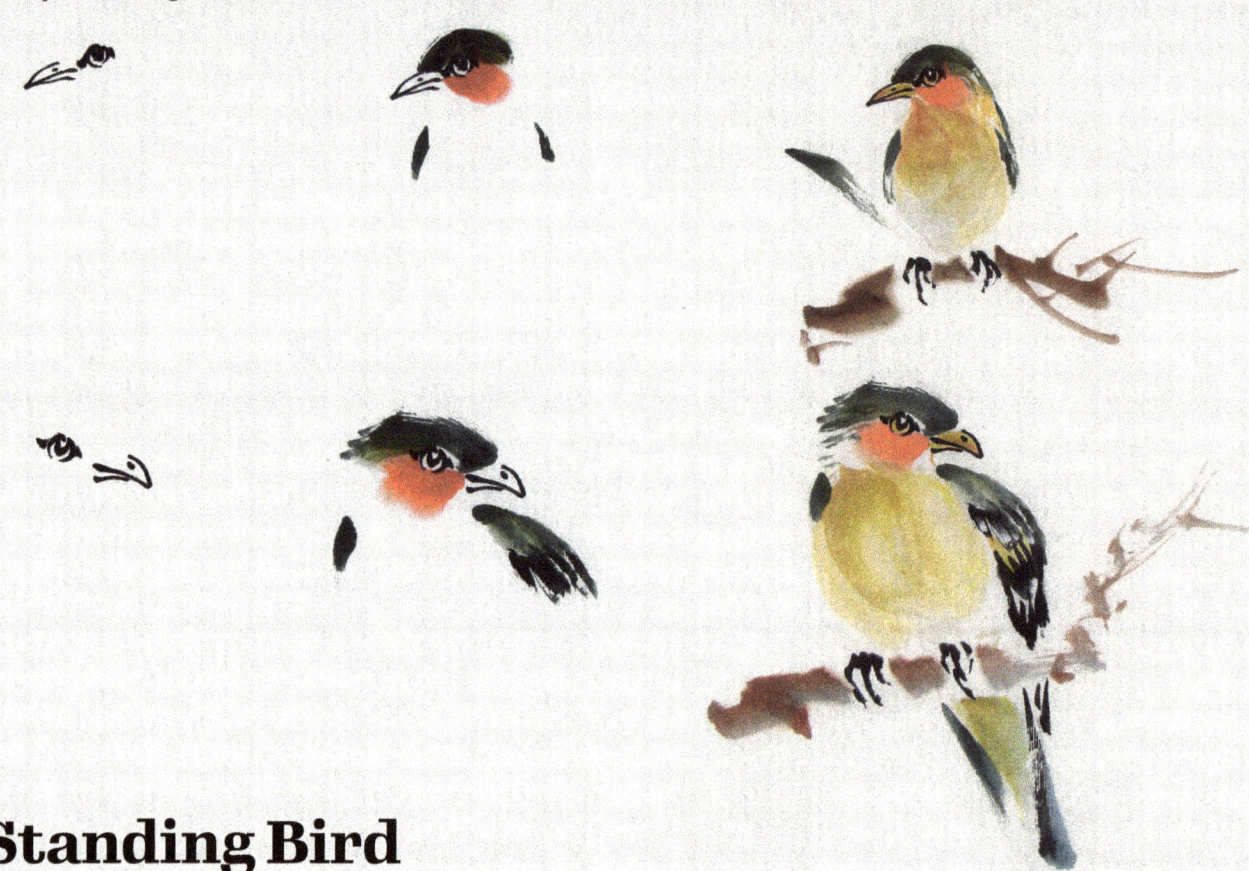

Standing Bird

When viewed from the side, the bird's back slopes down a little and is balanced by the angle of the tail. Make sure the feet are under the heaviest part of the bird, not in front of the chest.

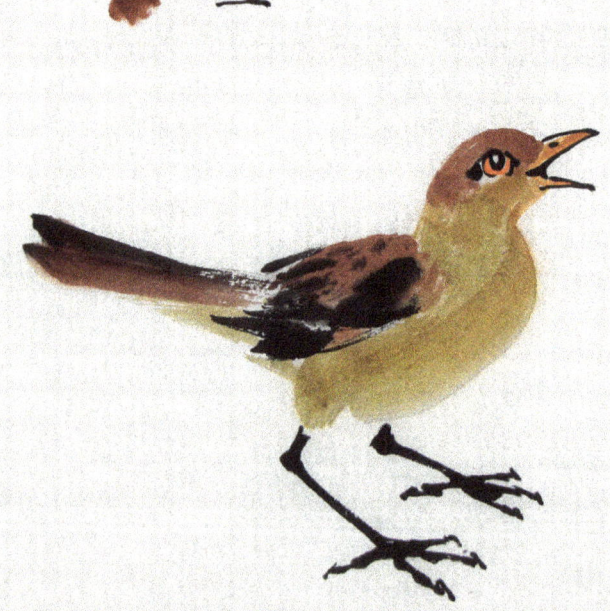

When open, wings and tails unfurl like a fan and are lighter underneath.

Flying Bird

When viewed from below, you will not see the back. Imagine the oval shape of the bird's body to create the correct curve for the belly, and keep the feet back from the front of the bird.

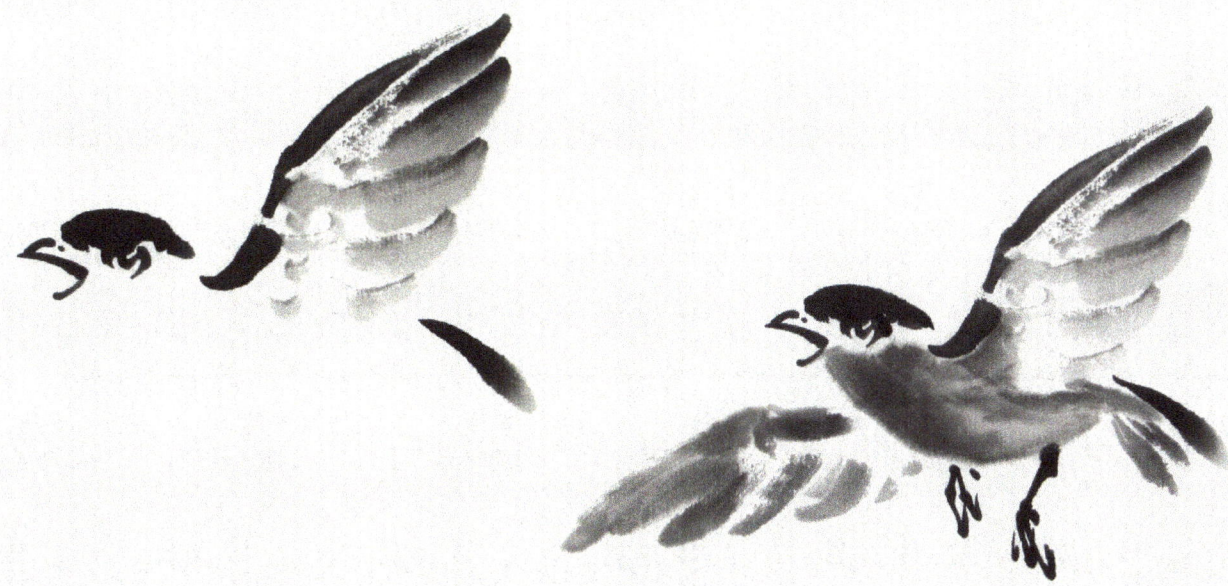

Perching Bird

Everything angles down toward the front. Show the soft feathers under the tail in the same color as the belly. Spread the feet so the bird looks balanced, ensuring that neither foot extends past the shoulder.

Bird Adventures

After working your way through "Bird Basics" (pages 102-107), your strokes will become more confident. Although sumi-e artists seek to get their birds somewhat anatomically correct, exaggeration can often make these pieces successful and will help convey an attitude. Everything in life is related, and the painter, the painting, and the viewer form a triangular relationship, sharing ideas and energy back and forth.

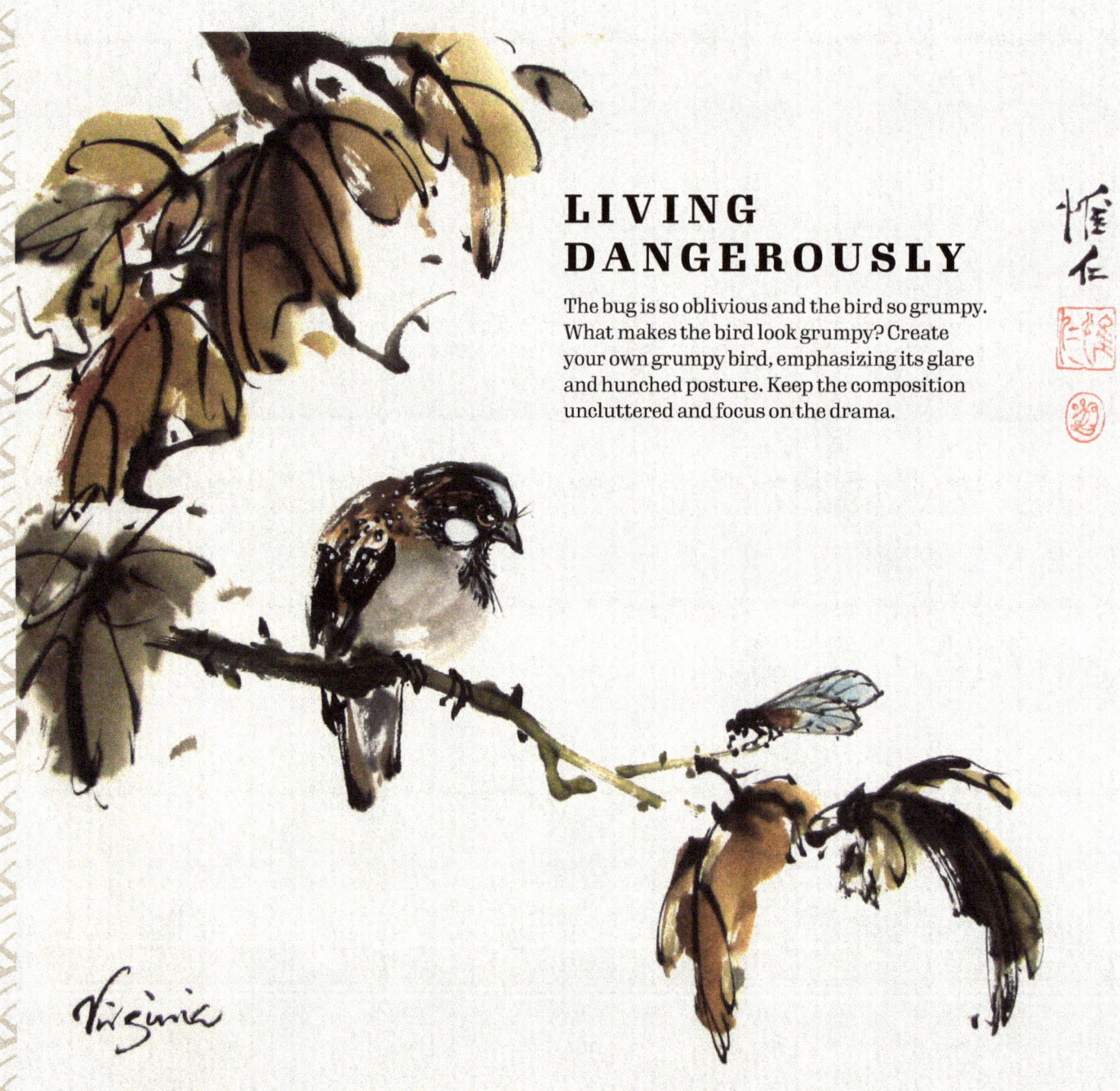

LIVING DANGEROUSLY

The bug is so oblivious and the bird so grumpy. What makes the bird look grumpy? Create your own grumpy bird, emphasizing its glare and hunched posture. Keep the composition uncluttered and focus on the drama.

YOUNG LOVE

I didn't plan the yearning glance, but that's what emerged. Is it the way the bird on the left leans over? The tilt of its head? How is the look emphasized by the bird on the right with its dubious, alarmed look?

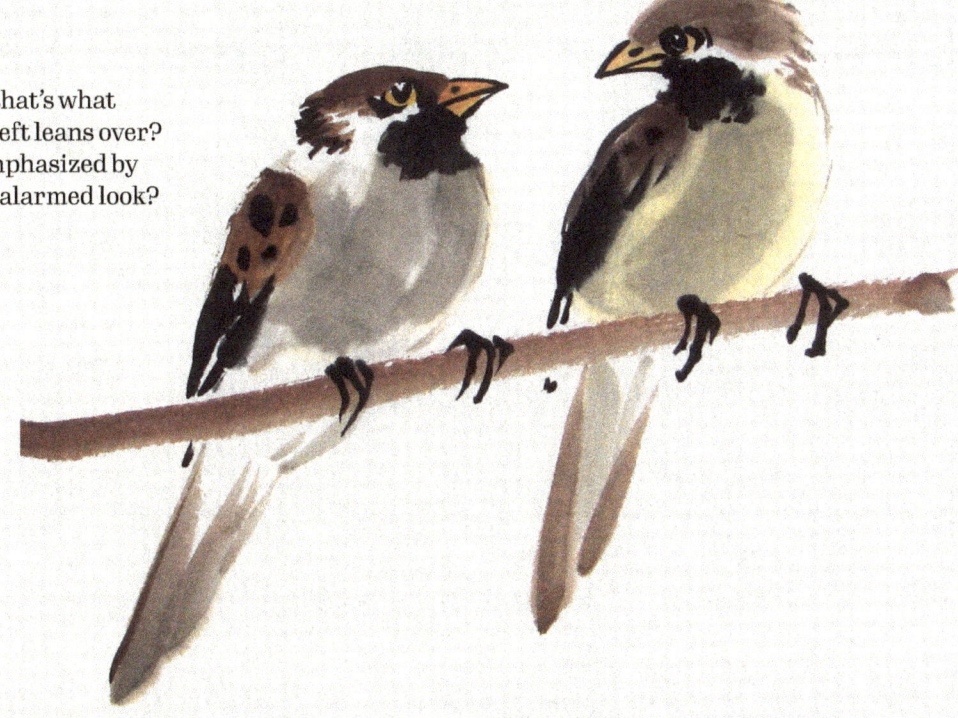

OLD LOVE

Alternatively, you may feel more drawn to this cozy older couple, snuggled up and clearly comfortable with each other. You don't need to finish the bird in the back; hiding the rest of it creates a sense of closeness and depth in the composition.

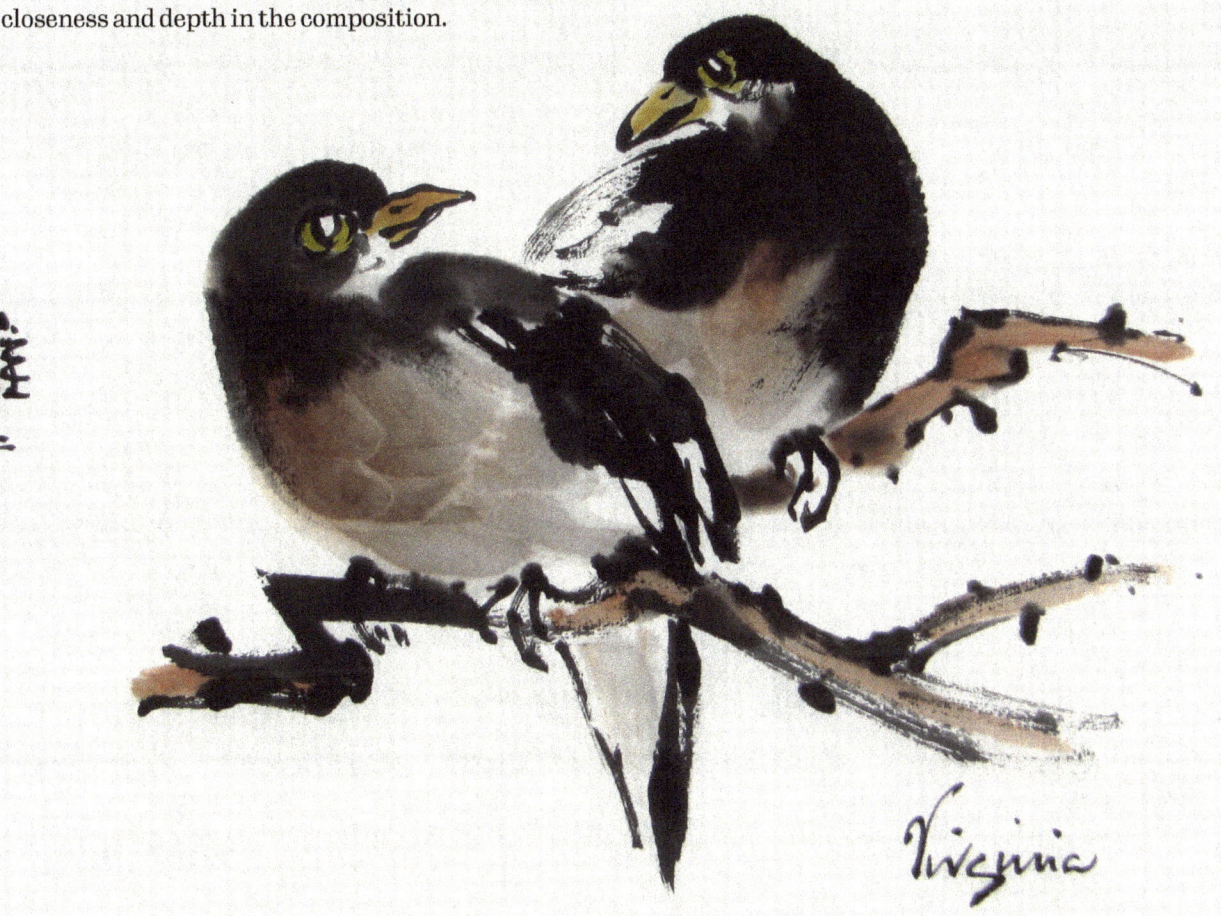

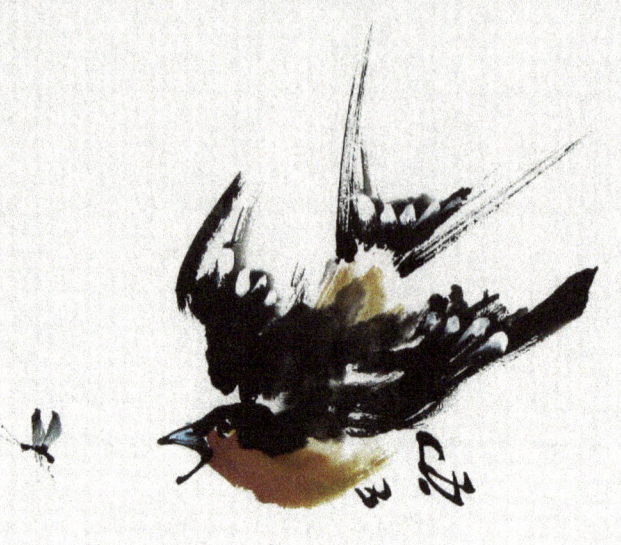

LUNCH!

This swallow will make short work of the bug. The exaggerated angle of the tail to the body echoes a swallow's aerial gymnastics, and the wind-blown willow leaves on the right add to the movement in the painting. See how loose you can get your brushstrokes.

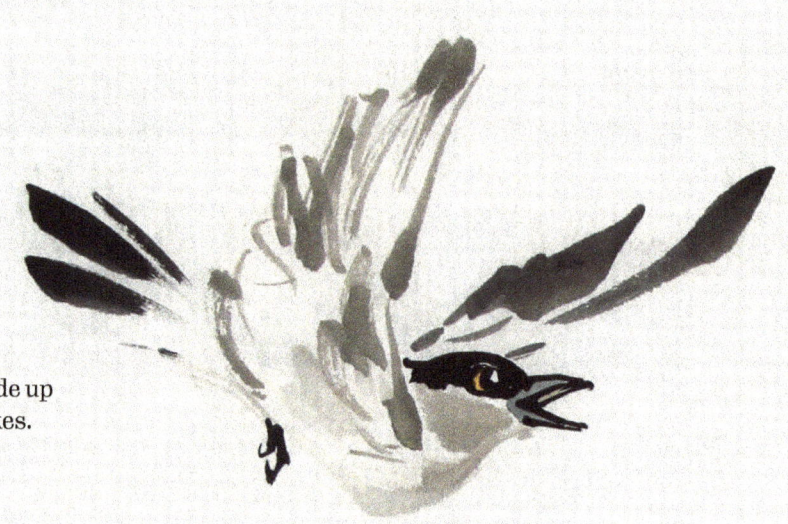

Here's another flying bird made up of loose, impressionistic strokes. Let your brush fly!

If your strokes are strong and confident, you can get away with (almost) anything!

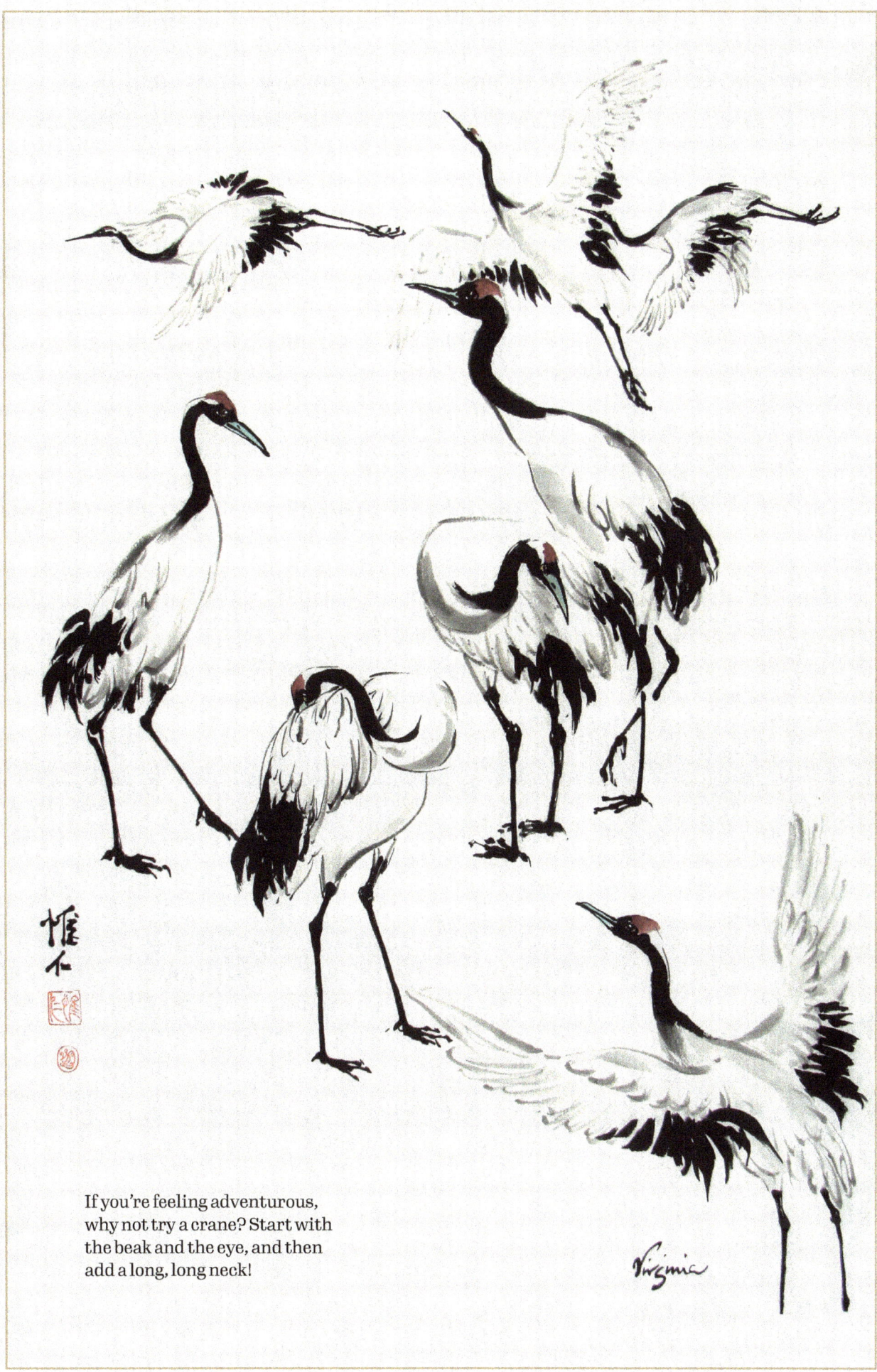

If you're feeling adventurous, why not try a crane? Start with the beak and the eye, and then add a long, long neck!

The Black Ink Gang

Meet Lord Horty and his Black Ink Gang. Their feet often go in the wrong direction, their eyes are far too big, and they were great fun to create. See what happens when you try your hand at the Black Ink Gang. If you get frustrated, take a deep breath and create the ugliest bird you can imagine!

Lord Horty, the boss of the Black Ink Gang

Sir Smooth, the card shark, has nothing up his sleeve!

Salsa Chick is always up for a good time!

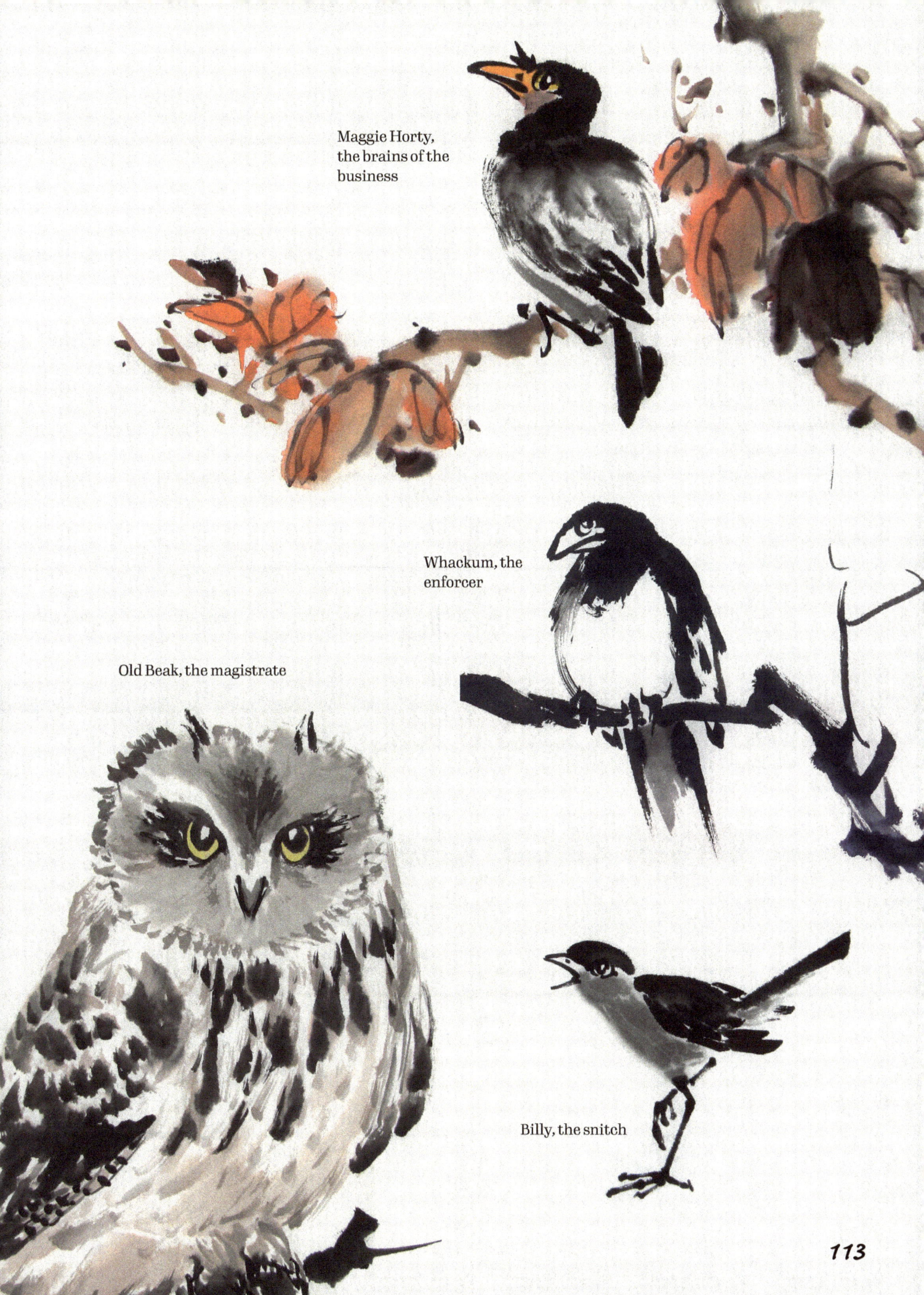

Maggie Horty, the brains of the business

Whackum, the enforcer

Old Beak, the magistrate

Billy, the snitch

Rocks & Waterfalls

Like many experienced sumi-e artists, I don't plan out my landscape compositions, as I enjoy the surprise that emerges from the dance of the brush. But if you're just starting out, I recommend following a painting model to help you understand composition.

In this introductory chapter to a lifetime of exploration, I will show you how some of my paintings evolved and give you helpful tips on how to create different effects on raw xuan and mulberry paper. Raw xuan, which I used for the other subjects in this book, readily absorbs moisture and clearly shows brushstrokes. Mulberry paper is semi-sized and resists moisture a little, allowing you to create more impressionistic paintings, such as misty landscapes.

Unlike Western-style landscapes, Asian-style landscapes illustrate states of mind, not geographical locations. Asian-style brush artists are encouraged not to paint directly from nature, but to observe nature and then go back to their studios and create scenes that distill the essence of what they've seen through the lens of their feelings.

TIPS ON COMPOSITION

In Asian art, perspective is not the same as in Western photographic or linear perspective. Even though the trees in the foreground are closest to you, they should not dominate in a sumi-e painting. An Asian-style landscape describes a journey that starts off with a human's-eye view at the bottom and becomes a bird's-eye view the higher you look. Mist obscures certain areas, hinting at hidden details, and this pushes the mountain layers back.

Rocks

Waterfalls consist of rocks and spaces in between that represent water. Rather than outlining your rocks, aim for volume. Let your brush dance on the paper—sometimes using the point, sometimes the side—so you see cracks, clefts, and folds emerge within the rocks.

Some rocks have hard edges, while others look like friendly animals. With an orchid next to it, a rock is clearly small. If a waterfall gushes out from behind a rock, you can see that it is large. If the rock reaches to the top of your painting, it may be a huge cliff or mountain. It might be the same rock, but the perspective is different.

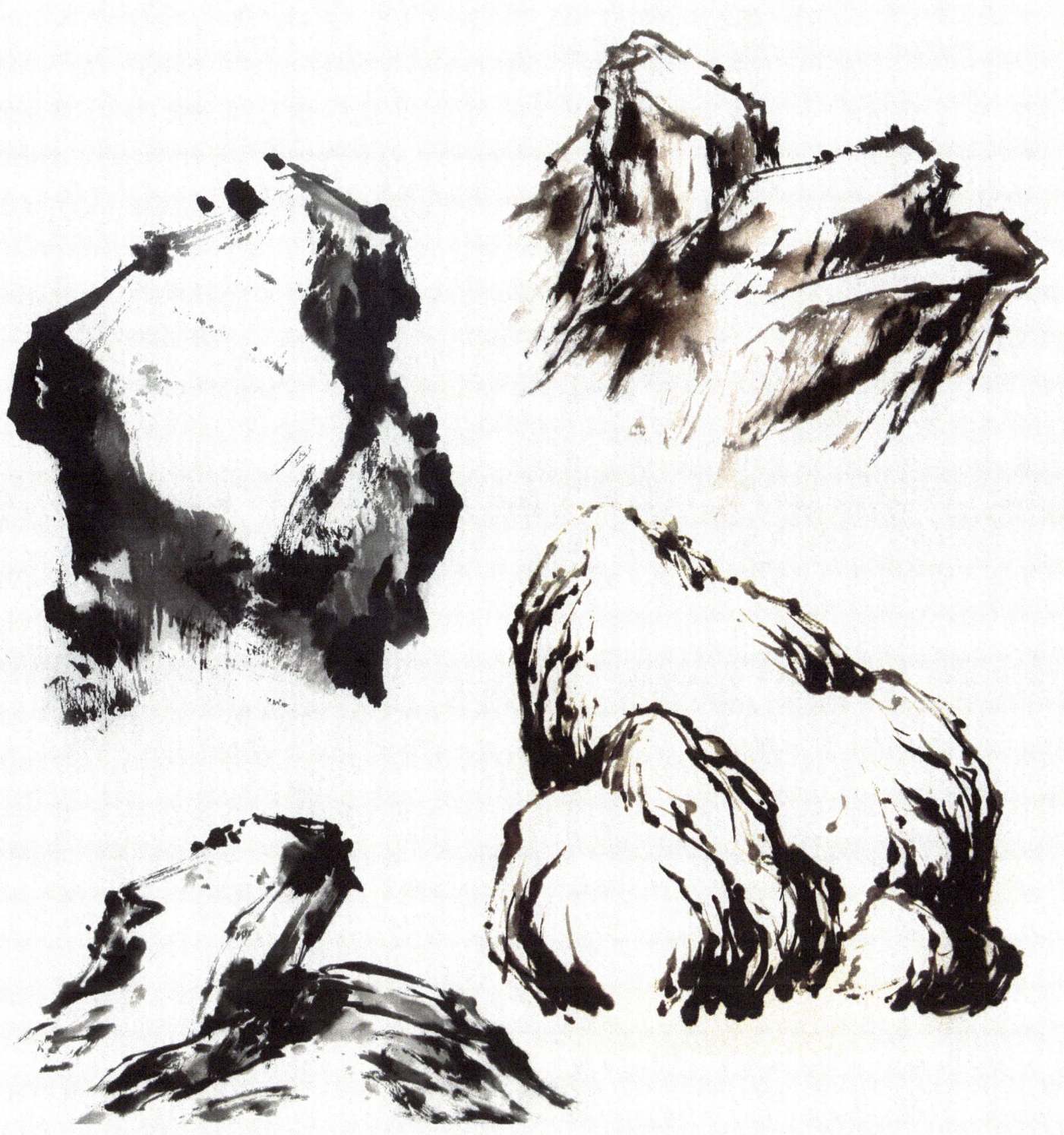

Waterfall Painting Progression

1 Using raw xuan paper, create your scene in light gray; then add accents of black ink to make certain areas more prominent. Shade the rocks to indicate volume, and use light gray curves to show the water's movement.

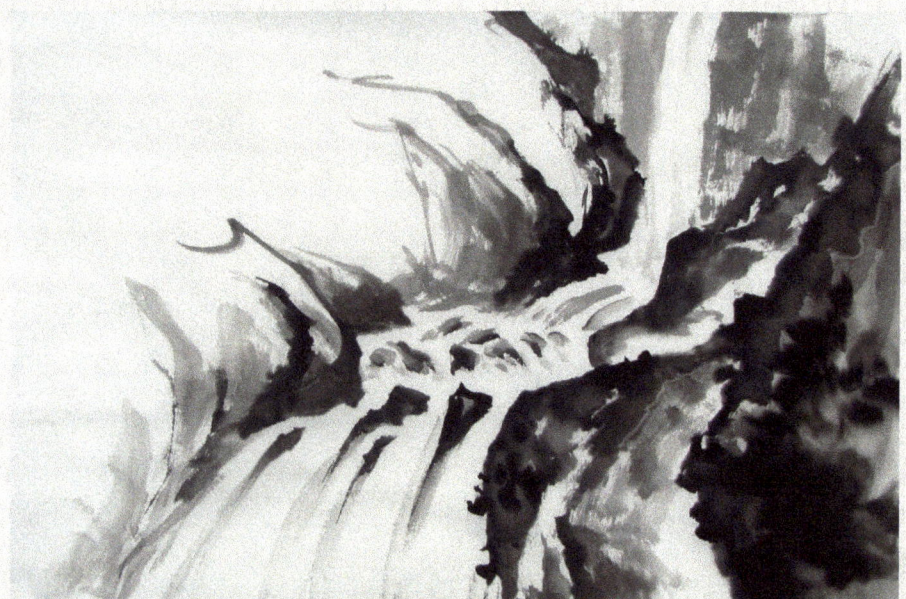

2 Develop the scene, showing several layers of rocks. Shade the rocks to indicate volume, using darker ink in the foreground. Use light gray curves to show the movement of the water.

3 Add color to the rocks, leaving some areas open for mist. Soften the water with light blue-gray.

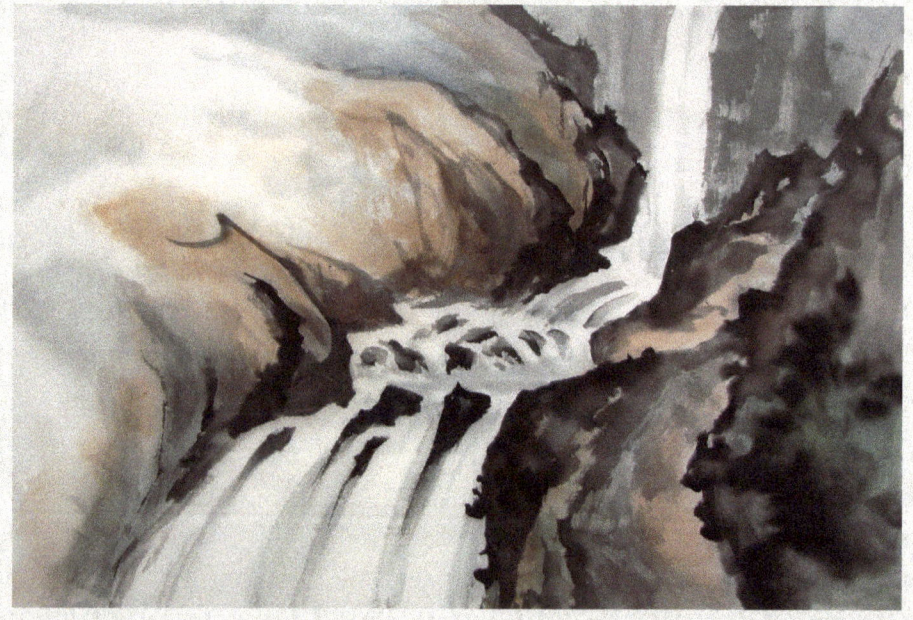

Compare that with the raw power of this close-up waterfall done on semi-sized mulberry paper. You can see the undigested mulberry fibers in the paper; these add action to the painting. Create a diffuse border of blue-gray at the edge of the water; then wet the sky and apply a light wash of brown so that the white in the water stands out.

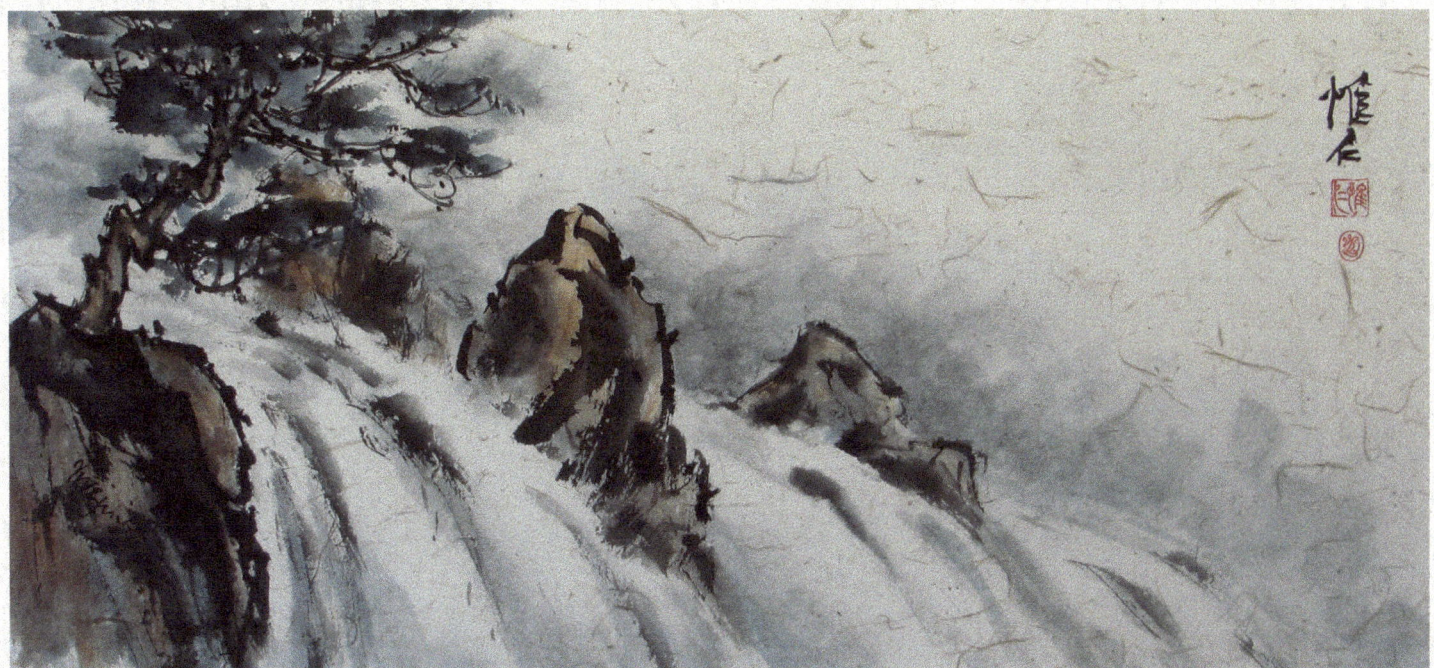

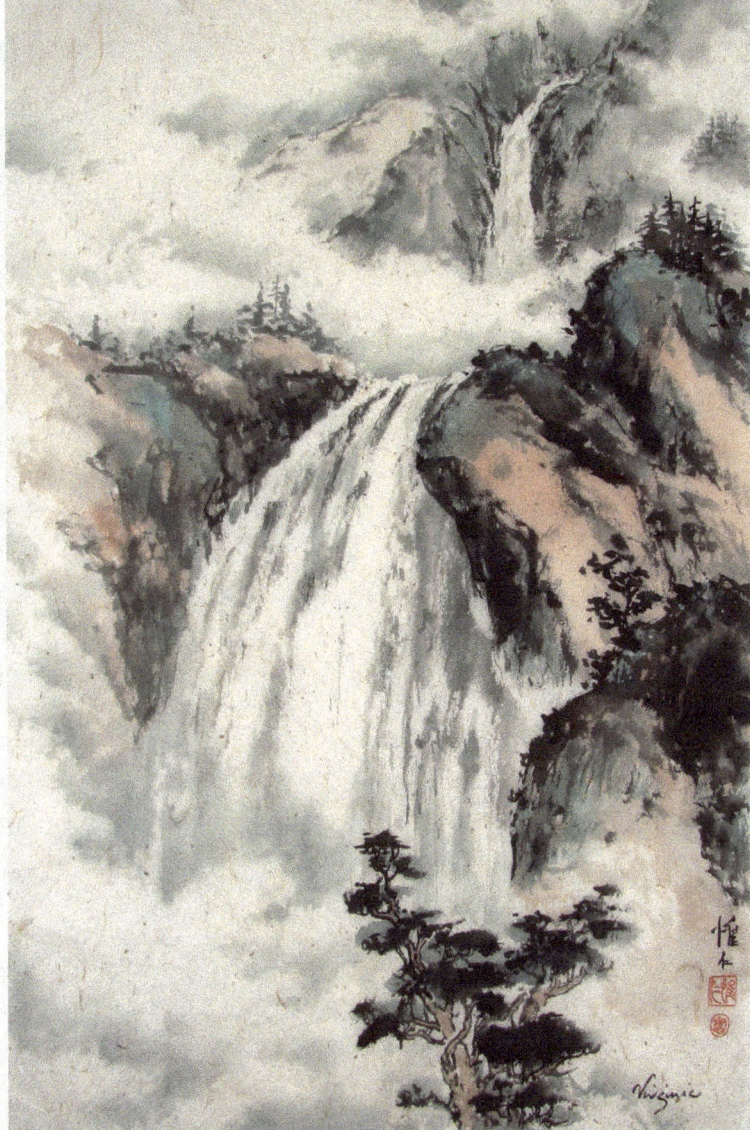

Using mulberry paper, you can create interesting mist effects without wetting your paper.

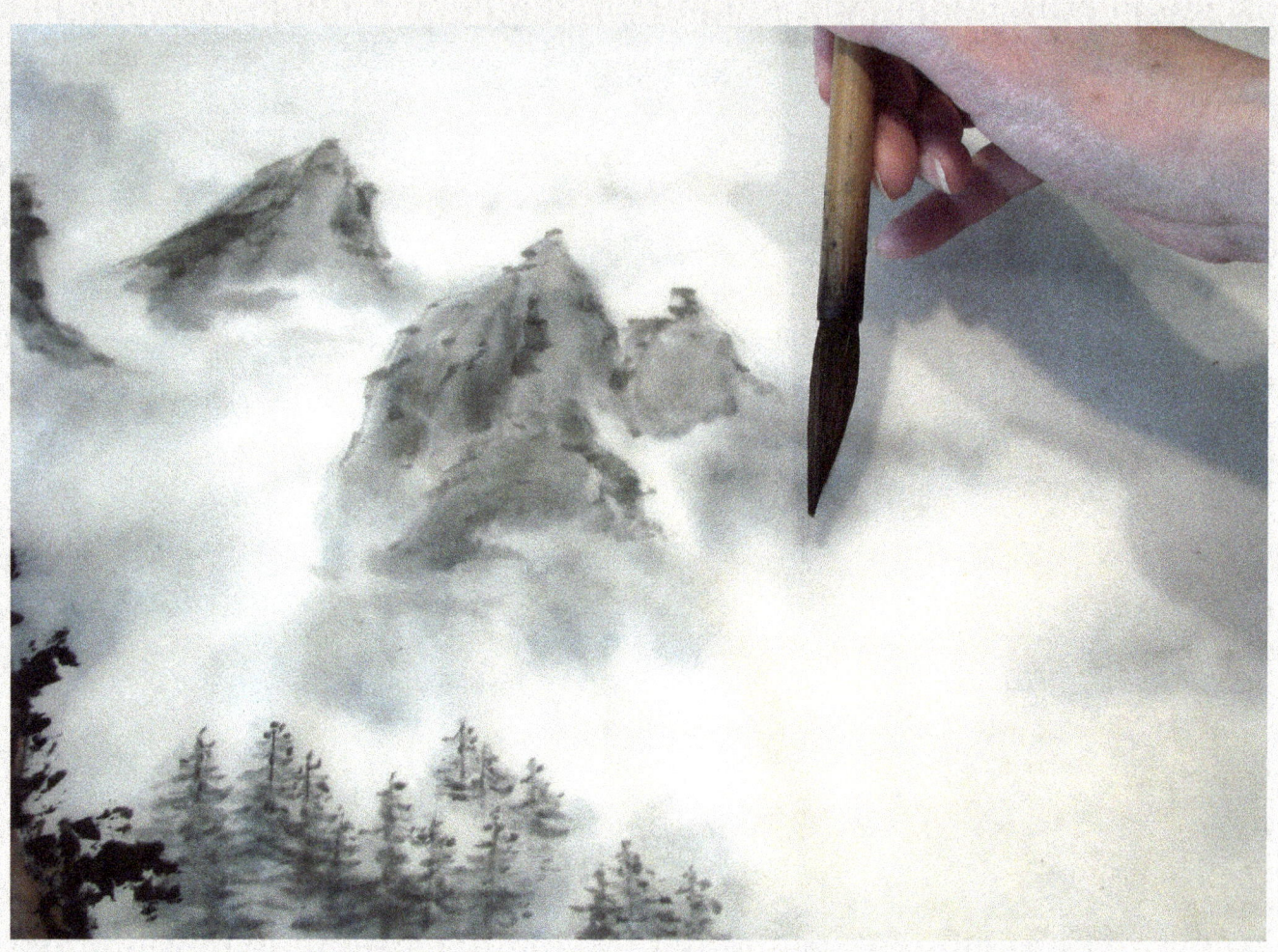

You can add the mist on the front or back of single xuan. Dampen the paper; then add a dilute wash on the back using either a wide "hake" brush or a round brush with the tip slanting toward the bottom of your paper, indicating the shadows.

When painting on xuan paper, dampen it before adding blue-gray for the mist so that the edges are soft.

Rock as Observer

In Asian-style paintings, birds, trees, and rocks often feature as observers and commentators.

As a challenge, I started with a single rock as an anchor in the lower-left corner of my semi-sized mulberry paper, and then I developed the scene down from the top. See how the many diagonal lines add movement to the finished composition, as well as how the trees in the foreground are more detailed, while the pines at the top of the waterfall blend into a mass.

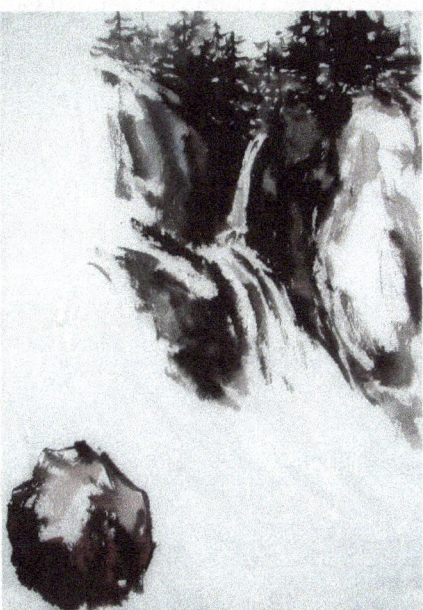
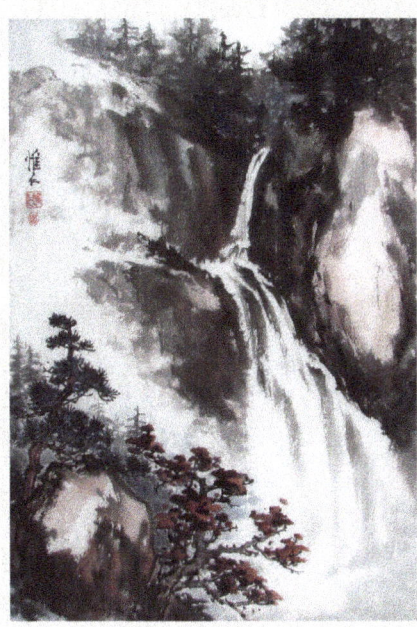

To create a simple waterfall with rocks and mist on single raw xuan, paint the rocks in gray and black; then add color once the rocks are dry. Add the mist last.

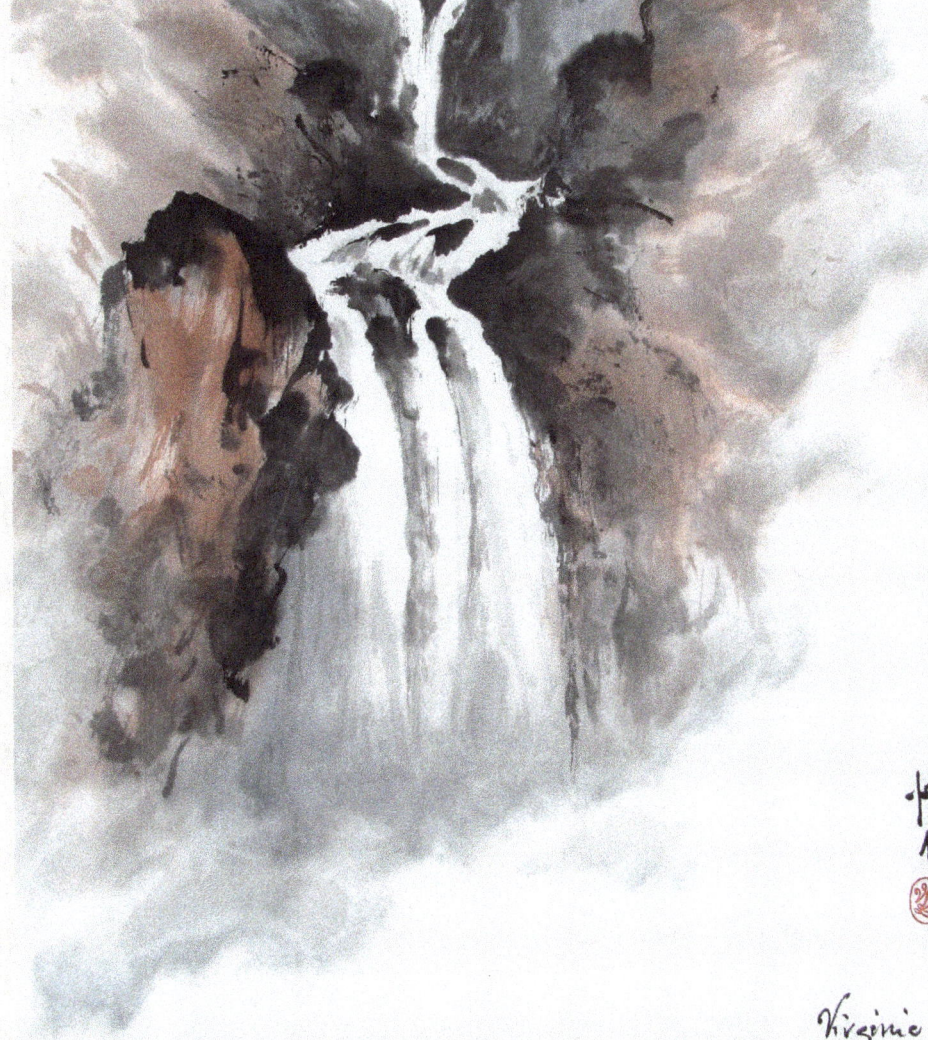

Trees

Foreground trees can include detail to add texture and emphasize their closeness to the viewer. As you create more background layers to show depth in your piece, add fewer details and use less black so that the scene naturally recedes.

Two simple trees in close relationship can anchor your foreground, or you can choose to sign the painting and you have a finished painting of two trees.

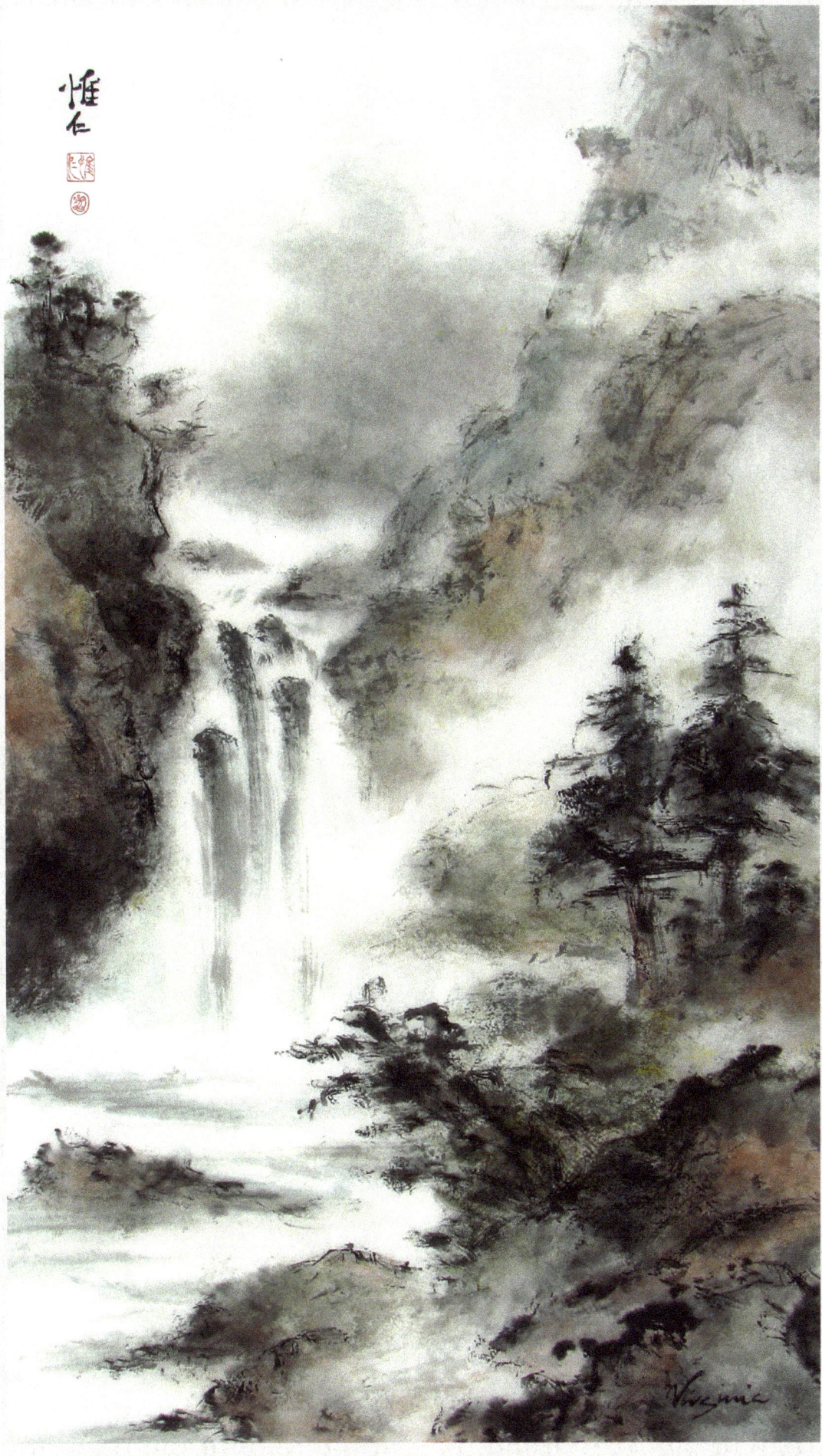

Do painters of Asian-style artwork always use a brush? No! Some alternatives through the centuries have included twigs, bird feathers, long fingernails, hands, feet, and forearms. A piece of wadded-up xuan paper or a cloth will work too. This painting was created while cleaning up my dirty painting dishes using a piece of damp paper towel. Whatever you use, feel the ch'i dancing!

Irma Falls

In September 2017, Hurricane Irma made landfall in the United States. As high winds and torrential rains battered my studio, I went to work on a large sheet of raw single xuan, channeling the power of nature into my composition.

1 I started with the big rock on the far left, allowing the basic composition to flow from the brush and creating different levels and planes with the rocks.

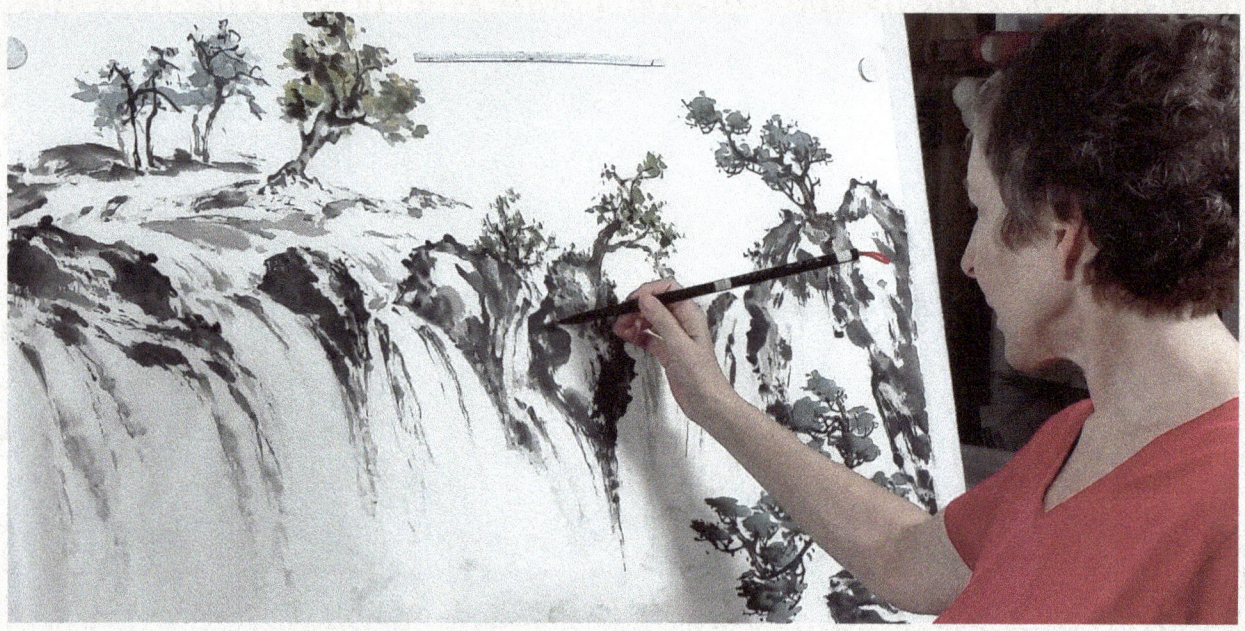

2 Coloring in the trees and rocks created volume and showed me the current balance of light to dark. More solids (trees and rocks) will be needed to dramatically offset the water. The mist layer at the bottom made the waterfall recede behind the cliff on the right, and the dancing edges of the spray added movement.

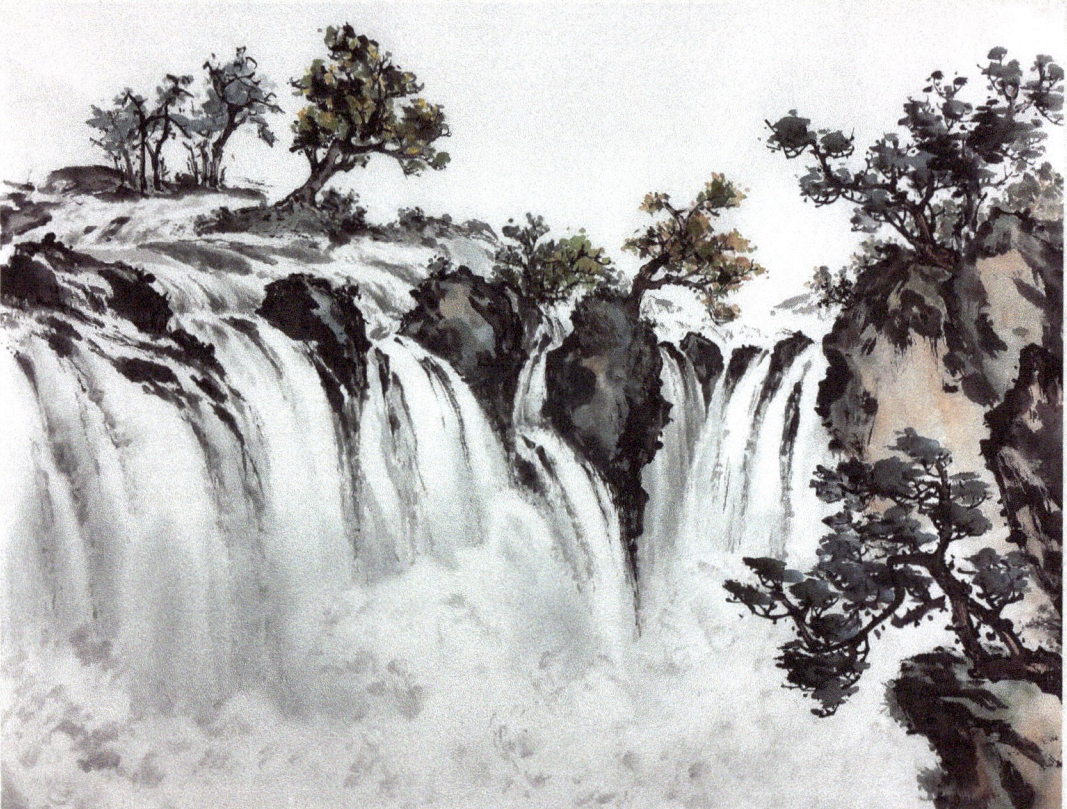

3 This close-up detail shows how adding gray created the curves of the water flowing over the rocks. A light green-gray wash softened the effect. Then I added a dark gray boundary of trees on the far left to make the water stand out. Add more trees or layers of light strokes several times until the tone and depth of color look right. Remember that you can always add more, but you can't subtract!

4 Adding trees on the right increased the height of the cliff and established its foreground prominence. I then turned the paper over and sprayed it lightly with water. A dilute wash of brown applied to the sky emphasized the brightness of the falls.

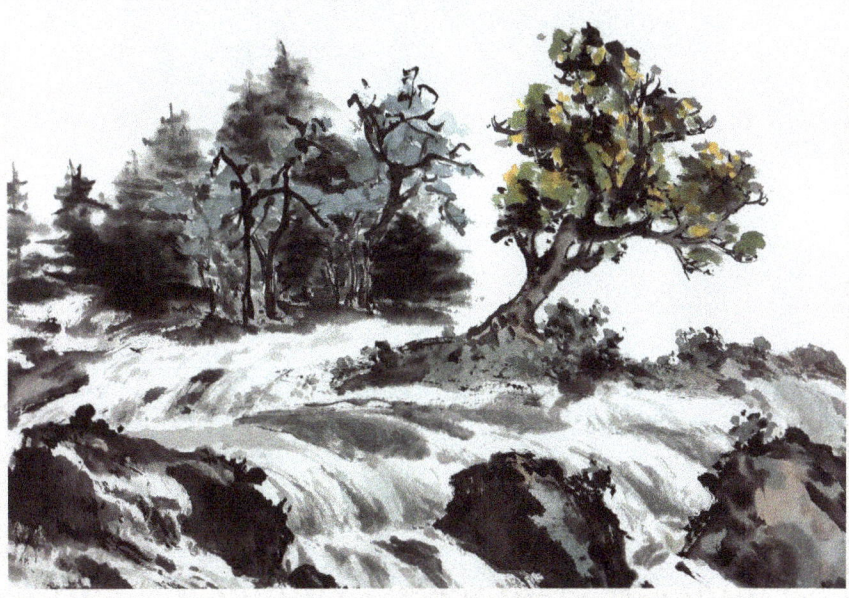

I hope you enjoy creating your versions of these paintings and inventing your own. There is so much to explore with landscapes!

Signing Your Painting

Traditional Chinese and Japanese artists sign their art name vertically in black ink, followed by one or two personal seals or chops applied with red seal paste.

Your teacher may create your art name in Chinese characters, basing it on the phonetic sounds of your name or as a reflection of certain qualities that you wish to embody. In my case, Chinese master painter I-Hsiung Ju based my art name phonetically on my real name, Virginia. It sounds like "Wei Jen" and translates to "nothing but benevolence and the virtue of the human heart." I describe it as "nothing but love" when I translate it loosely into English.

Outside of Asia, some artists also sign their Western name in cursive on their Asian-style paintings. I personally like to sign "Virginia" in addition to my Chinese name since I am a Westerner and my art embodies qualities from both cultures.

If you want an art name, ask a native speaker for suggestions. Online Asian-art suppliers can also create a name for you, show you how to write it, and carve it into a stone chop. If you live near an Asian neighborhood, look for professional calligraphers and carvers.

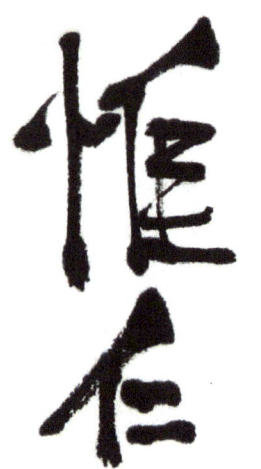 Wei

Jen

 Wei Jen seal

 Western initials: VLD

You can also purchase ready-made mood seals which express artistic qualities, poems, and even the Chinese zodiac symbol for the year you were born. These are usually placed on the opposite side of the painting from your signature.

Practice your signature many times before adding it to a painting. Try out your chop on scrap paper first. Apply a sticker reading "top" or featuring an arrow so you know which way is up on your chop.

Suggestions from My Library

These books and videos have been my companions for many years. Take a look at these and other sumi-e resources to discover your own favorites.

Books on Sumi-e & Chinese Brush Painting

The Book of Bamboo (Art Farm Gallery, 1989), *The Book of Orchid* (Art Farm Gallery, 1989), *The Book of Plum* (Art Farm Gallery, 1988), and *The Book of Chrysanthemum* (Art Farm Gallery, 1984) by my master I-Hsiung Ju. These books provide in-depth instruction in English, with copious illustrations. There are also many videos available.

Sumi-e, a Meditation in Ink, written by my first teacher, Paul Siudzinski (Drake, 1978). This book includes many mindfulness exercises, humorous and thought-provoking images, and instruction in black-ink technique.

The Mustard Seed Garden Manual of Painting, edited and translated by Mai-mai Sze (Princeton University Press, 1978). The manual is a collection of woodblock prints from the 17th and 18th centuries and features models of flowers, birds, insects, animals, people, buildings, and landscapes.

Sumi-e: The Art of Japanese Ink Painting by Shozo Sato (Tuttle Publishing, 2010). This book includes materials, calligraphic strokes, and step-by-step instructions on how to paint flowers and landscapes.

A Copybook for Japanese Ink-Painting, edited by Reiko Chiba and illustrated by Shutei Ota (Charles E. Tuttle Company, 1964). Features simple, easy-to-follow models of classical images.

The Laws Guide to Drawing Birds by John Muir Laws (Heyday, 2015)

Books on Mindfulness

The Miracle of Mindfulness by Thich Nhat Hanh (Beacon Press, 1999)

Wherever You Go, There You Are by Jon Kabat-Zinn (Hachette Books, 2005)

Be Here Now by Ram Dass (Harmony, 1978)

Painting Videos in English

Search YouTube for I-Hsiung Ju, Virginia Lloyd-Davies, Henry Li, and Ning Yeh

Painting Videos in Other Languages

Search YouTube for painting subjects using key phrases like "sumi-e" and "Chinese brush"

About the Artist

Born in Washington, DC, to British parents, Virginia Lloyd-Davies grew up in Britain and France. She studied sumi-e and mindfulness meditation in New York City and painted in black ink for ten years until she became apprenticed to master painter I-Hsiung Ju. Virginia accompanied Professor Ju on many trips to China and Taiwan, where she studied with master painters and exhibited her paintings. She has frequently demonstrated live on television in the United States, Europe, and China, and her paintings are in collections around the world.

Virginia spent six years on the staff at the Findhorn Foundation in Scotland as the community's publicity director, where she also taught workshops in sumi-e paired with sacred dance and Zen meditation.

Virginia's YouTube painting channel (www.YouTube.com/virginiald) has received more than four million views. Her website, www.joyfulbrush.com, features her flower, bird, and landscape paintings and many mini-tutorials and painting DVDs. She welcomes questions and suggestions for new blog posts.

Because she has studied both sumi-e and Chinese brush art and traveled extensively in Europe and Asia, Virginia's personal style is an amalgam of those experiences. As a dancer and singer, Virginia is frequently struck by the relationship of rhythm and melody in the execution of the brushstroke.

Virginia lives in Virginia with her husband, Dennis DiVito. She is an anal cancer survivor.

Dedication

This book is dedicated to my wonderful husband, Dennis DiVito, without whose loving support, keen technical skills, and all-around caring I never would have made it through cancer treatment or writing this book.

It is also dedicated to I-Hsiung Ju, my painting master, friend, and mentor for 26 years.

Acknowledgments

Appreciation and thanks are due to my friends around the world and on social media who have encouraged me on my painting journey. My team of "first readers"—whose skills range from painting, writing, calligraphy, and philosophy to common sense and humor—include Anne Allen, Charlene Fuhrman-Schulz, Helen Knight Farrar, Louise Lynch, Meredith McPherson, Teresa Mitry, and Karen Sagstetter. I would also like to acknowledge my mother, Margery McClelland Lloyd-Davies, who taught me at an early age not to paint a lampshade growing out of my head.

www.ingramcontent.com/pod-product-compliance
Lightning Source LLC
Chambersburg PA
CBHW041924180526
45172CB00014B/1373